THE FILM DEVELOPING COOKBOOK

The Film Developing Cookbook

Stephen G. Anchell
Bill Troop

**Focal
Press**

Boston · Oxford · Johannesburg · Melbourne · New Delhi · Singapore

Focal Press is an imprint of Butterworth-Heinemann.

Butterworth–Heinemann supports the efforts of American forests and the Global ReLeaf program in its campaign for the betterment of trees, forests, and our environment.

Library of Congress Cataloging-in-Publication data

Bill Troop.
 The film developing cookbook: Bill Troop, Stephen G. Anchell.
 p. cm.
 Includes index.
 ISBN 0-240-80277-2 (alk. paper)
 1. Photography – Processing. 2. Photography – Developing and developers. 3. Photography – Equipment and supplies. I. Anchell, Stephen G. II. Title.
 TR287.T76 1998 98–41649
 771.4—dc21 CIP

British Library Cataloging-in-Publication data
A catalogue record for this book is available from the British Library.

The publisher offers special discounts on bulk orders of this book.
For information, please contact:
Manager of Special Sales
Butterworth-Heinemann
225 Wildwood Avenue
Woburn, MA 01801

For information on all Focal Press publications available, contact our World Wide Web home page at http://www.bh.com

10 9 8 7 6 5 4 3 2 1 0

Printed in the United States of America

INTRODUCTION

It's all because of the little yellow box. This book owes its existence to T-Max film. As author of *The Darkroom Cookbook* I have heard from many associates and students about the difficulty they have obtaining quality images with T-Max film. Many solutions have been put forth; all are compromises.

Finally, I called my friend and photo-chemist, Bill Troop, and asked if he had any suggestions. Bill has designed many fine formulas for developing both films and papers; many are referenced in this book. Bill's reply was, "No, but I have some ideas." Not only ideas. Bill had a manuscript he had begun on film processing as early as 1980 which was floating around his home somewhere. He dug it out, sent it to me, and we began the collaboration which led to this book. —*Steve Anchell*

"Technique should be transparent."

— ELIE SCHNEOUR

When this book was conceived in 1980, photographic engineering was still an important field. But by 1982 photographic manufacturers were moving from traditional silver halide science to digital as fast as they could. They laid off thousands of photographic scientists and replaced them with electrical engineers and computer scientists. I had counted on seeing a lot of fundamental research completed before I finished my book: research into new developers, new films, and new fixing techniques. This was never to be. It was a depressing time for photography!

I put the book aside until I met Steve Anchell, four years ago. He proved to me that there are still countless dedicated photographers who are interested in exerting the greatest possible control over film processing. So Steve and I set about completely rewriting and re-researching my material. We have tried to include all the essential information yet make it interesting enough for photographers to enjoy reading. — *Bill Troop*

This book has three special emphases: how to use different developers to achieve a wide range of pictorial effects, how to mix and use solutions from scratch (and how to create new ones), and how to process film for maximum archival permanence. Although photographic processing is a chemical process, it is *not* necessary to know anything about chemistry. It *is* necessary to understand what photographic chemicals do, and why, just as it is necessary for a cook to understand what salt does and what pepper does. And, just as a cook has to learn how to use heat and sharp knives without getting burned or cut, so do photographers have to learn how to use processing chemicals safely.

This book's purpose is to help readers acquire a relevant knowledge of black and white photographic chemistry as painlessly as possible. We also hope it will serve as a reference and refresher for photographers at all stages of their skill.

Much of the technical information in this book has never been published before. This we owe to the generosity of the many scientists who shared research with us, determined that it should not perish. Progress in digital image quality has been infinitely slower than hoped. The silver halide is still with us, and doesn't look as if it's going to budge soon. Long may silver photography live.

> *"Above all, don't be one of those who learns everything so quickly that you never really learn anything well."*
>
> —J. Ghislain Lootens

INDEX OF FORMULAS

Where there are are two page numbers, the first is for the working solution and the second is for the stock.

ABC Pyro, *see* D-1
Acid fixers, 105, 120
Adams two bath, 84
Agfa/Ansco 14, 111
Agfa/Ansco 17, 111
ATF-1, 105
Beutler, 59
BJ Dilute DK-50, 63
BJ Pyro-Metol, 114
Bürki pyro 79, 113
D-1, 79, 113
D-23, 44
D-23 two-baths, 84
D-61A, 113
D-76, 41
 divided, 85
 variants, 43
D-89, 113
D-96A, 89
D-165, 62
DK-20, 112
DK-50, BJ Dilute, 63
Dalzell two-bath, 84
Delagi 8, 98
Edwal 12, 67
Edwal Super 20, 67
Farber's Split D-76, 85
FX 1, 59, 126–127
FX 1b, 59
FX 2, 59, 127–128
FX 3, 46
FX 4, 46
FX 5, 71
FX 7, 46
FX 8, 46
FX 9, 69
FX 10, 69
FX 11, 46
FX 15, 46
FX 18, 46
FX 19, 46
FX 37, 61

Ilford developer/replen., 112
ID-11, *see* D-76
ID-68
HC-110-related patent, 58
Hübl Paste, 116
High Definition Developer, 56
Hypo clearing agent, 105
Jacobson Pyrocatechin, 115
Leitz two-bath, 84
Low contrast developers, 99
Microdol, 69–70
MCM 100, 117
Microdol, 69
monobaths, 119
Muir Pyrocatechin, 116
Mytol, 89
PMK, 76, 114
POTA, 96
 modified, 97
Promicrol, 48–49
Rodinal, 117
Sease, 67
SD-1 pyro, 79
SD-4 two-bath, 85
SD-5 two-bath, 85
Stoeckler two-bath, 84
TD-101 pyrocatechin, 81
TD-102 pyrocatechin, 81
TD-103 pyrocatechin, 81
TD-107 metol-glycin, 117
TD-121 High Definition, 60
TD-145 two-bath, 85
TD-144 two-bath, 85
TD-200 two-bath, 84
TD-201 two-bath, 84
TDLC-101 Phenidone-glycin, 97
TDLC-102, Phenidone-glycin 97
TDLC-103 metol low contrast, 98
TF-2 Alkaline Fixer, 120
TF-3 Alkaline Fixer, 106
TH-5 Hardener, 121
Vestal's divided D-76, 85
Windisch Pyrocatechin, 59, 80, 116
Windisch metol-sulfite, 118
WD2D, 114
XTOL-related patent, 49

CONTENTS

v **Introduction**

vi **Index of Formulas**

CHAPTER 1
1 **Developer Categories**

CHAPTER 2
11 **Films**

CHAPTER 3
19 **Developer Ingredients**

CHAPTER 4
31 **Development Procedures**

CHAPTER 5
39 **Solvent Developers (Fine Grain)**

CHAPTER 6
51 **Non-solvent Developers (High Definition)**

CHAPTER 7
65 **Super-fine Grain Developers**

CHAPTER 8
73 **Tanning Developers**

CHAPTER 9
83 **Special Developers**

CHAPTER 10
91 **Increasing Film Speed**

CHAPTER 11
95 **Document Films**

CHAPTER 12
103 **After Development Processes: Stop Baths, Fixers, Washing**

APPENDICES

111 I: Reference Formulas

123 II: Mixing Solutions

129 III: Chemical Safety

137 Bibliography

139 Sources

143 Developing Time Chart

161 Temperature Conversion Chart

162 Index

ACKNOWLEDGEMENTS

First and foremost we must acknowledge the contribution Grant Haist of Eastman Kodak made to this book. His *Modern Photographic Processing* is the one book no researcher in this field can afford to be without. More than that, Dr. Haist has answered thousands of our questions over eighteen years with unfailing diligence, authority, patience, and humor.

We were also fortunate to have much personal help from several legendary Kodak scientists whose work stretches back to the 1920s: C.N. Nelson, R.W. Henn, T.H. James, and H.D. Russell.

Finally, the youngest of Kodak's black and white greats, Dick Dickerson and Silvia Zawadzki, have been remarkably generous in making sure we were in touch with the latest research and giving us the benefit of their special approach to black and white photography.

Geoffrey Crawley, for many decades the editor of the British Journal of Photography, and the author of the famous FX developers, is perhaps this century's most distinguished independent researcher in black and white photochemistry. For almost two decades he has unreservedly given us the benefit of his expertise.

David Vestal, Henry Wilhelm and Ed Meyers have provided valuable advice and information over many years. The late Bob Schwalberg made available his unrivalled technical library, and caused countless cartons of film and paper to be made available to us.

The US Navy's Marilyn Levy, whose POTA formula continues to cause waves in photochemistry, has been very generous with both her expertise and her wit.

Safety engineer Howard Etkind provided valuable help with our safety appendix.

Paul Lewis, freelance photochemist and photographer carefully edited the final manuscript, and tested many of the experimental formulas, especially those found in the document film chapter.

Five researcher/photographers have made major contributions: Gordon Hutchings, the world's authority on pyrogallol, Elie Shneour, Maxim Muir, John Douglas and Francisco Juan Cortés.

Without the help of Rudolph Ellenbogen and his colleagues at Columbia University's Rare Book and Manuscript Libary, this book could not have been written.

Andreas Rochlitz of Agfa, John Placko of Ilford, Steven Hedges and David Valvo of Eastman Kodak, were each generous with their support and knowledge.

Bill, Helen, Bud and Lynn Wilson of Photographers Formulary have encouraged and assisted us at every turn during our research.

We have received valuable assistance from chemist Ira Katz of Tri-Ess Sciences. We also owe a special thank you to his daughter Kim.

Finally, we would like to acknowledge the friendship and wisdom of four great photographers who helped us become better photographers, better chemists, and better people: Berenice Abbott, Ansel Adams, Lisette Model and Brett Weston.

SPECIAL THANKS

In a project that has been ongoing for eighteen years, there is of necessity an unusual number of people to thank. Perhaps Karen Speerstra of Focal Press should come at the top of the list. It is unusual, in today's publishing climate, for anyone to wait as long for a manuscript as she has.

Constance Huttner, Linda Soohoo, Jane Baum, Pam Grant and many other friends at Skadden Arps have provided invaluable support.

Without the help of many persons in the computer industry, the manuscript could never have been prepared, nor could the book production have gone so quickly and simply once the manuscript was finally done. Steve Wright was my first and wisest computer guru. More recently, the help of Rick Wulff and many other friends at Adobe Systems has been greatly appreciated.

Without the generosity and trust of Barbara Krasnoff of Ziff–Davis and Cathy Cloud of Maclean, nothing would have been possible. Many friends at Motorola, Lexmark, Intergraph, Toshiba, Eizo/Nanao, Olympus, and UMAX provided invaluable support, with special thanks to Jonathan Gandal of IBM for his generosity and tact.

We owe a special debt to Kathleen Tinkel for providing a design template for the book which I then typeset—thus no lapse of style or error in taste can be attributed to her; and to Matthew Carter, whose Miller typeface, perhaps the best implemented of all digital typefaces, has made my type labors so light.

Mike Adams, with his encyclopedic knowledge of photographic equipment and Ken Hansen, the prince of camera dealers, have been pillars of support. Phillipe Laumont, of Laumont Color Labs in New York, kindly provided professional densitometers when we were most in need of them.

Richard Simons provided much good advice. The librarians of the Amagansett Free Library provided invaluable help during the last stages of the manuscript preparation.

Finally, Ana Luisa Morales provided the anchor without which the ship would have foundered on many reefs.

—Bill Troop

A special thanks to Donna Conrad who spent many hours editing this book. To the extent we have achieved readability, we owe it all to her.

—Bill Troop and Steve Anchell

ABOUT THIS BOOK

There are a few things you need to know to get the most out of this book. Formulas which appear in the text are almost always given in working solutions. If, for some reason, the formula is a stock solution, it will be noted as such.

This does not mean we are opposed to stock solutions. It is simply that formulas can only be accurately compared with each other when they are broken down to working solutions. Trying to compare stock solutions is difficult, at best. We print what we think are the most useful stock solutions in Appendix I.

We have found certain developers and techniques that we feel are significantly superior to others in their class. We have placed these in what we call Quck Guides. If you want to know how we came to our conclusions, and the alternatives, read the rest of the section or chapter.

Not every chapter contains a Quick Guide. This means we have not identified any formula or technique which we like more than the others, or, as in the case with Chapter 1, there is nothing to recommend!

Different developers will produce different EIs on different films. With very few exceptions we do not attempt to give corrected EIs with the developer/film combinations.

All quantities are in grams and liters.

The abbreviation g/L means grams per liter.

BIBLIOGRAPHICAL NOTE

The following books and articles are cited so frequently that only a short citation is given in the chapters.

1. **Henry:** Richard Henry, *Controls in Black and White Photography,* Focal Press, Boston & London, 1986, 2nd edition.

2. **Haist:** Grant Haist, *Modern Photographic Processing,* John Wiley & Sons, New York, 1979, Volumes 1 and 2.

3. **Crawley 60/61**: "Notes on Present Day Monochrome Emulsions and Their Development", *British Journal of Photography,* v. 107, p. 651 (8 parts).

4. **Adams, The Negative:** Ansel Adams, *The Negative,* New York Graphic Society, New York, 1981.

5. **Focal Encyclopedia:** *The Focal Encyclopedia of Photography,* 3rd edition, ed. Richard Zakia and Leslie Stroebel, Focal Press, Boston & London, 1993.

6. **Hutchings:** Gordon Hutchings, *The Book of Pyro,* 3rd (revised) printing. Granite Bay, CA: Bitter Dog Press, 1998.

7. **BJ:** The British Journal of Photography.

All private communications give the initials of the author to whom the communication was made, for example: "Grant Haist to BT, 1989".

MATERIALS USED

In the course of researching this book we chose certain materials, formulas, and equipment to use as standards. These include:

1. Cachet graded paper

2. Agfa Neutol Plus print developer

3. D-76H film developer

4. Formulary TF-4 Alkaline Fixer

5. Omega D5 enlarger with cold light

6. Schneider Componon-S enlarging lenses

7. B+W camera filters

8. Ilford FP4 Plus film

9. Hanna Instruments and Orion pH meters

10. Macbeth densitometers

11. EG&G sensitometers

Chapter 1

DEVELOPER CATEGORIES

Each combination of a particular developer and film yields a unique negative. Differences may be great or small, but there will be differences. And it is in those differences that as photographers we create our unique signatures.

This chapter outlines the main developer types, and suggests how to match them to particular films, formats, and pictorial situations. There are four key qualities to consider: sharpness, graininess, contrast, and speed.

Definition in photography

Definition in photography is the *subjective* impression of how clear the detail in a photograph appears. Definition includes many interrelated factors: graininess, contrast, resolving power, and sharpness.

Sharpness is the most important of the four. Sharpness has an overwhelming effect on viewers. On a gut level, we can forgive a photograph nearly any technical fault, as long as it appears to be sharp. But what does sharpness actually mean? Subjectively, we all seem to know. But sharpness is as hard to define as it is to measure: distinctness of outline or contour, abruptly or strongly marked—these are some of the ways people have attempted to pin down the concept of photographic sharpness.

Acutance is an objective measure of sharpness. Developers which enhance sharpness are often called *acutance, high acutance,* or *high definition* developers. Different developers, as well as agitation techniques, have an enormous effect on how sharp negatives will appear.

Resolution or *resolving power* is measured by examining a target comprised of parallel black bars on a white background, set up in a lines per millimeter arrangement. The smallest set of bars that is discernible equals the resolving power of the film or lens at hand. Decades of experience have shown that resolution is a poor guide to perceived sharpness—see the illustration at the right.

Graininess

Basic *grain size* is predetermined by the manufacturer. Slow films have finer (smaller) grains, fast films have coarser (larger) grains. *Graininess* is the *subjective perception* of grain. *Granularity* is a theoretically objective measurement which correlates with our subjective perception of *graininess*.

The top photo shows good resolution but poor sharpness. The bottom photo shows poor resolution but good sharpness. For Geoffrey Crawley's definitions of sharpness and definition, see Chapter 5, page 46.

Graininess can be significantly altered by the developer and by the time film spends in the developer. Moreover, each developer creates its own unique grain pattern: tight; fuzzy; soft; hard-edged; or somewhere in between. The grain pattern can make or break an image. For a portrait or a commercial photo you will probably want a virtually invisible fine grain pattern. However, a photographic essay on junkies in a shooting gallery might have greater impact if the photos are sharp with an obvious grain pattern.

As a general rule, solvent developers emphasize fine grain at the expense of sharpness; non-solvent developers emphasize sharpness at the expense of fine grain.

Contrast and gradation

There are three kinds of contrast: macro, local and micro. The curve we measure with a densitometer and usually see in film tests and manufacturers' literature is the *macro* characteristic curve—the contrast of large areas of the negative. These curves are generally measured by a device which covers a 2mm diameter area, a substantial portion of a small negative.

The *micro* characteristic curve is measured over a much smaller area. The micro characteristic curve of a film is always greater in contrast than the macro characteristic curve. A range of tones in a small area is reproduced with higher contrast than a similar range of tones in a large area. However, an area that was micro characteristic on a 35mm negative may be almost macro characteristic on an 8x10 negative of the same scene. Therefore, the larger the film, the truer will be the reproduction of micro contrast.

Macro-contrast refers to the big effects that will tell us what grade of paper we will need to print a negative, or whether we can print a negative at all. A high contrast negative will need a low paper grade or filter; a low contrast negative will need a high paper grade or filter. In most cases, macro contrast depends not so much on the developer but how long the film is developed. The greater the development time, the greater the contrast.

When Zone System photographers expand or contract their negatives (N+1, N-1, etc.) they are manipulating macro contrast.

Local contrast is a synonym for gradation—a term we often use to discuss tonality and tonal differences.[1] It refers to macro contrast, but only over small parts of the characteristic curve. For example, when we refer to midtone gradation, we mean the separation between Zones III and VI.

A developer with "rich midtone gradation" increases separation in the midtone part of the curve (Zones III to VI). A developer with high toe contrast has a short toe (Zones I and II). The straight line starts almost at once, and midtones might be compressed. A "brilliant developer" has a steep shoulder: highlights (Zones VII and higher) are widely separated but could be hard to print. A *compensating developer* has a smooth, long shoulder. Highlights can be dull, but easy to print.

Macro gradation characteristics are built into the film, and can be determined by testing with a densitometer. However, different devel-

oper formulations, dilution techniques, and agitation methods, have a significant effect on local contrast/gradation.

Micro contrast effects are not as well known, but they are just as important as macro and local contrast when evaluating image quality. These areas, though not apparent to most viewers, play a great role in the emotional response to the image. They can be emphasized through the choice of developer *and degree of agitation.*

The micro-contrast characteristic curve is steeper than the macro-contrast curve. How much and where depends on the film, the developer, and the *size* of the film. In practical terms, when you are using a film/developer combination with high micro-contrast, you will notice that small areas, like specular highlights, may be hard to print. Since micro-contrast relates to *size* it is automatically lower with larger film sizes. That is the main reason photographers interested in capturing the finest highlight detail use the largest sheet film they can.

While it is possible to make a good, sharp landscape photo with 35mm, the same scene with a 4x5-inch view camera will reproduce micro areas with infinitely smoother gradation. On the other hand, as long as there is no camera shake or excessive movement by the subject the high micro-contrast of smaller negatives can give the impression of biting clarity to a negative. But this impression is achieved at the expense of smooth gradation in small areas.

Speed

Developers can be divided into three speed categories:
- those which decrease the film's rated speed
- those which maintain the film's rated speed
- those which increase the film's rated speed

In general, developers that decrease speed produce lower graininess, while those that increase speed produce higher graininess. In addition, developers that increase speed usually have less latitude for incorrect exposure than developers that maintain or decrease speed, while developers that decrease speed sometimes provide more latitude.

Negative quality

If there is any secret to obtaining high sharpness and fine grain, it is to ensure that the negative has a low density range. Maximum density should not exceed 0.9 above base+fog. This means that 35mm and medium format negatives of normal contrast should ideally be developed so that they will print well on a grade 3 paper. Large format negatives should be developed to a slightly higher contrast to print on a grade 2 paper.

Developer interlocks

In photography, you never get something for nothing. Every time you increase quality in one area, you lose it in another. Nothing better illustrates these interlocks than a discussion of fine grain developers.

Generally speaking, a fine grain, solvent developer causes a loss in film speed. A developer that offers both fine grain and good speed, such as undiluted D-76, has poorer sharpness than a non-solvent developer

Micro-contrast explains why we can experience difficulty printing fine highlight detail with tabular grain films. Even though they have fine grain and high sharpness, tabular grain films have too much micro-contrast in highlight areas. The reason is that the lateral dimensions of flat tabular grains (which face the light) are so much larger than conventional grains. Because they do not scatter light as well as conventional grains, when there is an abrupt change in exposure level, there is also a tendency to high contrast in micro areas. The visual result is high sharpness but poor gradation.

such as FX 1. By the same token, when a super-fine grain developer is used to develop a negative to high contrast the fine grain effect is usually lost.

Choosing a developer

So how do you choose a developer? Maybe the easiest question to ask is whether you want fine, smooth grain, or the ultimate in sharpness. Once you answer that, you can choose from one of the two main developer groups: solvent (fine grain) or non-solvent (high sharpness).

Solvent developers (fine grain)

A solvent developer etches the silver halide crystals in the emulsion, giving finer silver halide grains to work on and providing a source of silver ions to compete with the chemically reduced silver particles, which are coarser. But solvency alone is not enough to obtain fine grain. It is just as important to maintain low alkalinity—which for developers means between pH 7.5 and 8.5. D-23 and D-76 are solvent developers.

Another name for solvent developers is *solution physical developers*, a term which indicates that some of the silver dissolved by the solvent is replated back onto developing sites on the film. There is generally, but not always, some loss of perceived sharpness as a result of this, but also a further smoothing of the appearance of the grains. There are at least four mechanisms at work in a solution physical developer to produce fine grain:
- the etching of the grains
- the replating of dissolved silver back onto the grains
- low activity resulting in less developed and therefore smaller grains
- low activity resulting in less clumping of large groups of grains

Non-solvent developers (acutance)

Non-solvent developers are also called *chemical* or *surface* (as opposed to physical) developers. *High definition* or *high acutance* developers belong to this class.

In a solution physical developer like D-76, silver density builds up both by the chemical action of the developer and by the physical action of dissolved silver replating itself onto the silver image. Though all developers have some solvent effect, a true non-solvent developer has minimal solvent action.

Although the grain structure produced by a non-solvent developer is *coarser*, it usually appears to be *sharper*. This sharpness often effectively masks the appearance of the increased graininess.

Some developers can belong to both the non-solvent and the solvent categories, depending upon how they are used. For instance, undiluted D-76 is a solvent fine grain developer. But diluted 1:3, it becomes a non-solvent high definition developer.

The table below categorizes several developers. "D" or "DK" indicates Kodak, "ID" Ilford, "FX" or "Acu-" Geoffrey Crawley formulas.

Commercial developers versus published formulas

All developers start deteriorating from the moment they are mixed with

Low alkalinity means low activity, and practical experience throughout this century has shown this is a prerequisite for fine grain. But why that should be so is controversial. At a low pH, grains tend to develop only partially. In Geoffrey Crawley's view, there is less swelling of the gelatin, which preserves the power of the gelatin to protect against grain clumping. It is actually clumps of grains, not individual grains, that are visible to the eye as graininess. Others theorize that the development process affects grain clumping less than hitherto supposed, except in the rare case of infectious development used in some lithographic processes. Whatever the reasons behind it may be, if you want fine grain you must have low alkalinity.

SOLVENT SPEED DECREASING	SOLVENT SPEED MAINTAINING	SOLVENT SPEED INCREASING
D-25	Adox MQ-Borax	Acufine
DK-20	Rodinal + 6% sodium sulfite	FX 3, 4, 7, 8, 9, 10, 11, 15, 18
FX 5	Ansco 14, 15, 47	ID-68
Microdol-X, Perceptol	D-23	Microphen
All phenylenediamine developers	D-76/ID-11	XTOL
	FX 1b	
	Microdol-X/Perceptol 1:3	

NON-SOLVENT SPEED DECREASING	NON-SOLVENT SPEED MAINTAINING	NON-SOLVENT SPEED INCREASING
Beutler Low Contrast	D-61a, DK-50	Beutler, Neofin Blue/Red
Most pyro developers	D-76/ID-11, D-23 1:3	FX 1, FX 2, FX 37
Most glycin developers	HC-110	PMK
Universal/D-72	Rodinal	Edwal FG7
	Unitol	Acutol, FX 39
	pyro-metol & metol-glycin	Windisch, TD Pyrocatechin

water. For this reason, developers packaged as a liquid are the least reliable. No matter how carefully they are preserved and packaged, their shelf life is limited. Some manufacturers compensate by making them about 10% stronger. D-76 is the one significant exception. Up to a certain point, it becomes more active after mixing.

For the same reason, powder developers, which have good shelf life, should not, whenever practical, be mixed as stock solutions to be kept for many months. Ideally, a developer should be mixed as a working solution and used as soon as possible.

Even unmixed powder developers are not indefinitely stable. Dry chemicals, placed in contact with one another, react and change their characteristics. It is a manufacturing feat to package a stable, single-powder developer. Two-packet developers, with the alkali in one packet, and the acid or neutral chemicals and developing agents in the other, will invariably have a better shelf life. Best of all is to keep all chemicals separate until just before mixing, and to use fresh chemicals.

Proprietary versus published formulas

A problem with proprietary formulas is that the manufacturer can make "improvements" without notifying the public. There is no law on the books that requires photo manufacturers to notify users when there is a change in a developer, paper, or film. Photographers who have spent years getting used to a developer may suddenly find it has been significantly changed. Even worse, a favorite proprietary formula may be taken off the market completely, leaving the photographer high and literally dry.

The simple cure for this problem is to find a published formula (or several) that meets your needs, and mix it yourself as necessary. Its properties will never change, it will never become obsolete, and you do not have to worry about it losing potency.

The problem with proprietary formulas was summarized by Richard Henry. He states that it is scientifically abhorrent to use secret chemical formulas. He noted that Rodinal, HC-110, and Kodak's packaged D-76 had all changed formulation several times, making it impossible for anybody to check anybody else's results or know where you stood at any given time. "We could solve this problem by refusing to use secret formulations and make up our own solutions from chemicals of known purity." In cinema film development, where a mistake could cost countless thousands, "secret" formulas are never used.

Manufacturers often counter that their proprietary formulas are periodically "optimized" to conform with improvements in films. We do not subscribe to this reasoning. The "optimizations" manufacturers are most interested in are new cost-cutting techniques. In addition, no manufacturer can afford to make a black and white film that will not perform reasonably well in D-76, the world's most popular developer. For this reason, many published developers that worked well with films 30 years ago work just as well with current films. Indeed, according to Kodak and Ilford, T-Max and Delta films are optimized for D-76.

Finally, each film developer has a unique "personality". Commercial developers are formulated to balance a number of qualities to suit the taste of the "average" photographer. In any case, always suspect any developer that claims to be "optimized" for a wide range of films. *It is possible to optimize for one film; it isn't possible to optimize for all films.*

The appearance of prints

Just how different will prints look, depending on whether a solvent or a non-solvent developer is used? To begin, the difference is tied to the degree of enlargement. Differences between the developer types become more apparent as the degree of enlargement increases. If you contact print an 8x10-inch negative, it should look sharp and fine grained with smooth gradation, no matter what kind of developer you use. With enlargements from 120 and 35mm film different developers have a much greater effect on the final print.

In general, solvent developers give smoother midtone gradation, and finer grain. Non-solvent developers produce a clarity that is visually effective, but at the expense of increased grain and less smooth gradation. The increased graininess of non-solvent developers becomes especially apparent in out-of-focus areas, or areas with large expanses of untextured tone. For this reason, they are ideal for highly detailed subjects with great depth-of-field.

Film size

With small and medium formats, the principal goal is to obtain a negative that will print with good sharpness first, fine grain second, and good gradation third. In the larger formats we do not have to worry about sharpness and fine grain. We can concentrate on using the developer to coax the best possible gradation from the film.

With 4x5 and larger film, image quality will be good even if the developer does not enhance the film's inherent grain and sharpness. Even if we were to enlarge a 4x5 negative 10x (to 40x50), it should appear sharp and grainless *if* the viewer stands at a normal viewing distance of about ten feet, much further away than for an 8x10 print. If the viewer stands only two or three inches away from *any* print, it may appear fuzzy. However, only teachers, and students who are trying to learn spotting techniques, should look that closely. Anyone else is not appreciating the photograph.

35mm and roll film
With small formats, it is necessary to give the least possible exposure

that will still record adequate shadow detail. This means the negative needs to be as thin as possible. The thicker the negative, the more grain and the less sharpness when you enlarge. However, the penalty for minimum exposure is slightly poorer shadow gradation in the negative. Special printing techniques like dodging and burning are often the only way to get a thin negative to show shadow gradation as rich as a thick negative.

Developers for small format films
Most small format films today have fine grain, high sharpness, and fairly long-scale gradation. The fine grain and high sharpness are essential since the film will often be enlarged at least 8x. The ability of the developer to produce long-scale gradation is important because development of individual frames on a roll of film is not possible. The developer must provide a large margin for a wide range of exposures, including incorrect ones, at a single developing time.

Three types of developers work best with small formats:
1. Fine-grain developers
2. High definition developers
3. Dilute fine grain developers

Fine grain developers will produce the finest grain and lower, smoother, micro-contrast, with some loss in sharpness. High definition developers will produce excellent sharpness with increased grain and less smooth micro-contrast. The world's most popular developer, D-76 1:1, does not excel in either department. But it is an unbeatable compromise developer for a wide range of situations. That is a valuable feature when you cannot develop negatives one-by-one.

Large format
The primary concern of large format photographers is gradation, which is controlled by developing sheet film individually for different times or with different developers.

With large format films, we have the ability to overexpose by one or more stops with minimal loss in grain and sharpness. We therefore gain easily printable shadow detail. The Zone System, as it is largely practiced, has a built-in overexposure safety net.

Developers for large format
The development control which large format photographers seek can best be achieved when the developer is reasonably slow. This is especially true when tray developing several films since you can not hope to achieve uniformity with short development times. Glycin developers are particularly valuable for developing sheet film in a tray or in a rotary processor, because glycin is highly resistant to the two major problems associated with each of these processes, aerial oxidation (trays) and bromide streaking (rotary processors).

Large format users often choose a developer exclusively from the point of view of contrast control. Many use HC-110, because it can be used to create a wide range of micro- and macro-contrast effects through dilution. Others prefer Rodinal, and some will use only PMK or

another pyro developer, because of pyro's unrivaled highlight separation. Then there are excellent photographers, like Arnold Newman, who never use anything but D-76 1:1, but know how to get the most out of it.

Applications

The suggestions below are our subjective opinions, but they may help you decide what developer to use to obtain a specific effect in portraiture, landscape, photojournalism and street photography.

Portraiture

Studio portraits allow close control over the photographic process. Lighting can be adjusted so all tones reproduce as desired, and a perfect exposure can be made.

With large format sharpness will be assured no matter what developer is used. When desired, some softening might be possible using a super-fine grain developer.

With smaller formats you must decide whether you want the revealing clarity of a high acutance developer, or the more flattering smoothness of a solvent developer like D-76. Rodinal would be an excellent choice between the two extremes, although we do not recommend Rodinal for fast 35mm films except Agfa 400 and T-Max 400. In medium and large formats Rodinal is fine with Tri-X and HP5+, and outstanding with Agfa 400.

In a portrait the most significant specular highlights are the catch lights in the subject's eyes, which usually reflect the shape of the primary light source. Many portraits have hard, bright white, unpleasant catch lights. A compensating developer can help to print these more naturally. A very high acutance developer, like FX 1 or FX 2, might actually increase the density of these areas, especially if they are very small. Once again, a compensating developer with less of an acutance effect, such as Rodinal, would be a good choice.

We recommend conventional films for portraiture. They seem to capture highlight detail more naturally.

Landscape photography

The most frequent problem encountered in landscape photography is how to record a greater than normal subject range on film. Our recommended developers for landscapes are PMK, FX 2, Rodinal 1:75 or 1:100, or most two-bath developers. All produce printable highlights in high contrast natural light situations. For extreme subject ranges, 12 stops or more, we suggest experimenting with one of the ultra-low contrast developers in chapter 11.

For low contrast scenes (fog, mist, rain), a stronger developer like D-76 or FX 15 undiluted, Rodinal 1:25, or Diluted DK-50 would all be good choices. Interestingly, although PMK is often recommended for high contrast subjects, it has been found to be outstanding for the reproduction of delicate low contrast subjects in fog and mist, because of its outstanding midtone separation.

35mm or roll film will often have a wide mix of contrasts on one roll. Our best suggestion is a compensating developer such as FX 1, FX 2,

D-76 1:1, PMK, Rodinal 1:50 or a two-bath formula. The wide range of today's graded and variable contrast papers will do the rest.

Developers for press and street photography

Developers for press and street photography must be fault-tolerant. You need as much latitude as possible, since you often do not have time to measure exposure carefully. The ideal developer should not emphasize acutance too much because high acutance developers actually magnify motion and camera shake effects.[2]

D-76, undiluted or 1:1, has long been the press photographer's developer of choice.

A speed increasing developer can give a small gain in underexposure latitude in exchange for a loss in overexposure latitude. Two developers which give a 60% speed increase without losing much latitude are FX 15 diluted 1:1 and XTOL 1:1 or more.

Press photographers also need fast development times and some insurance against accidental overdevelopment when processing is rushed. Two-bath developers can be useful in this respect.

Our final advice to street photographers is to use a film with as much latitude as possible. Throughout the past four decades, Kodak's conventional films have had far greater latitude than any others, with Tri-X being the hands-down favorite of press and street photographers. Tri-X has earned, and continues to deserve, its prominence in this time-honored style of photography.

NOTES

1. Focal Encyclopedia.

2. Crawley 60/61 was the first to explain why this happens. A high acutance developer works by increasing the contrast of minute portions of the negative. But this only works if the negative is sharp to start with. If there are blurred or out-of-focus areas, the increased contrast actually magnifies the blurriness. In other words, a high acutance developer gives you more of what you've already got: it will make a sharp negative sharper; it will make an unsharp negative appear more unsharp.

Chapter 2

FILMS

This chapter covers the continuous tone, pictorial films available today, along with our personal recomendations.

Speed classification

Black and white film can be divided into two different groups: speed and type. For this discussion, speed is based on the manufacturer's ISO rating, not personal exposure indexes.

Slow — ISO 64 and below

Slow films have the finest grain and highest sharpness. They often have a shorter tonal scale than faster films.

Medium — ISO 80 to 250

Still the best for all-round photography, these films have long-scale gradation, fine grain, and reasonable speed.

Fast — ISO 320 to 800

Fast films are best for street photography, action, wildlife, sports, news or anything that requires hand held cameras. Tonal scale is long, exposure latitude is very good. But because of obtrusive grain, they aren't usually a good choice for landscapes and scenics unless you use sheet film 4x5 inches or larger.

Ultra fast — ISO above 800

Ultra fast films are ideal for extreme low-light, law enforcement, fine art (where you want to exploit graininess for aesthetic effect), sports, street photography, and photojournalism. Although four 35mm films fit this category, none has a true speed over ISO 1000, despite manufacturers' claims. However, all three can be pushed one or two stops to reach EI 1600 to 3200 with acceptable results.

Film types

Speed aside, pictorial films can be divided into six types: conventional, tabular, chromogenic, document, infrared, orthochromatic, and transparency. Many of today's films include the ISO rating in their name. Where this is not the case, we have noted it in parentheses next to the film's name.

Conventional films
Agfa APX 25, 100, and 400
Bergger BPF200
Ilford Pan F+ (ISO 50) FP4+ (ISO 125), HP5+ (ISO 400)
Kodak Plus-X (ISO 125), Tri-X (ISO 400), Ektapan (ISO 100),
 Verichrome Pan (ISO 125), and Recording 2475 (ISO 1250)
Cachet Macophot UP100 and UP400
Neopan 400 and 1600

Tabular films
Kodak T-Max 100, T-Max 400, P-3200
Ilford Delta 100, 400, 3200

Chromogenic films
Ilford XP2 (ISO 400)
Kodak T400CN
Konica VX 400

Document films
Kodak Technical Pan (Tech Pan) (ISO 25)
Cachet Macophot ORT25

Infrared films (ISO ratings without filtration)
Ilford SFX 200
Kodak High Speed Infrared (ISO 200)
Konica Infrared (ISO 32)

Orthochromatic films
Ortho Plus Copy (ISO 80)

Transparency
Agfa Scala (ISO 200)

Conventional films

This category includes all films before the introduction of black and white tabular grain films in 1988. Though there have been many changes in conventional film design and structure over the years the basic technology has remained much the same.

Conventional films run the gamut from short scale, slow speed, fine grain emulsions such as Agfapan 25, to long scale, fast emulsions with medium grain such as Kodak Tri-X.[1] Most have thin emulsions. Their low gelatin-to-silver ratio allows these modern films to be sharper and finer grained than older thick emulsions.

Legend has it that thin emulsion films were discovered in the early 1950s when the German film manufacturer Adox accidentally coated a large run of film with too much gelatin. In an attempt to rectify their costly mistake they scraped off a micro layer, going too far in the other direction. Hoping to be able to sell the film, they tested it and discovered that it produced sharper images, with finer grain, than had previously been possible. Whatever the truth of the matter is, the 1950s

soon saw "thin" emulsions from every manufacturer. Emphasizing the difference between thick and thin emulsions appears to have been more marketing hype than fact. Independent researcher Gordon Hutchings has measured the relative thicknesses of thick and thin emulsions and has not found any substantial differences.

As a marketing ploy, the emphasis on thin emulsions backfired with the fine art community. Zone System users came to believe that the older thick emulsion films had allowed them more ability to change contrast (expansion and contraction in Zone terms) than the newer films did. This does not appear to be quite true. Both Tri-X and Verichrome Pan, for example, are thin emulsions. But they are both double coated to provide latitude both in exposure and in development. Double coating itself does not guarantee these results, however. It all depends on what the manufacturer wishes to achieve with double coating. It is possible—and we may now never know the truth—that some of the flexibility Zone System users thought they were achieving with the older films was due to measuring artefacts that were common in the 1930s and 1940s due to the imprecision of the light meters, sensitometers, and densitometers of the day. Even Kodak found that many of the sensitometric measurements it performed in the 1940s were incorrect. This was only discovered many years later.

The simplest way to improve sharpness, fine grain, and gradation of small areas is to use a larger film size. This may not always be convenient or economically feasible.

Still and all, there are three films made today which seem to retain much of the flexibility of the films of the "good old days". These are Kodak Ektapan and Verichrome Pan, and a new film manufactured in France, BPF200. Ektapan is designated by Kodak as a large format black and white studio film. It has a complex double coating of two emulsions with different speeds and different contrast. The goal is to provide ideal tone reproduction in low flare settings. This does not, however, mean it cannot be used in the field for a variety of subjects.

One of the best "thick" emulsion films was the now discontinued Kodak Super XX. This film was widely used for Zone System work, and many alternative or darkroom processes such as gum printing, platinum/palladium, cyanotypes, dye transfer, enlarged negatives, and separation negatives. It responded beautifully to pyro developers such as ABC, SD-1, and PMK. Our preliminary tests indicate that, while not identical, BPF200 is similar to Super XX. BPF200 is available in film sizes from 4x5 to 20x24 (see Sources). Based on our initial experiences with the new film, we strongly recommend BPF200 to large format photographers and those involved with alternative processes.

For landscapes, still lifes and portraits, we strongly recommend Kodak Verichrome Pan. Its beautiful, long-scale gradation is in the tradition of the old thick emulsion films. Once popular, this double coated film is now hard to find in the US, though it is readily available in some other parts of the world, particularly South America. Nonetheless, many professional US dealers carry it, though it is only available in medium format. It easily pushes to EI 200, making it useful for some street photography. Kodak Plus-X, a film with the same speed as Verichrome, is available in a wide variety of sizes, but is inferior to Verichrome. Plus-X is grainier, less sharp, and has more constricted gradation than Verichrome. We would like to see Kodak make

Verichrome in 35mm and sheet sheet film sizes.

We like all three Agfa films for their overall spectral response and gradation. Agfa films are carefully designed to give best quality near their rated ISO. APX 25 is as sharp and fine grained as a full-scale panchromatic film can get without crossing the line into document films. APX 100 is a fine medium speed film, and APX 400 has the most beautiful gradation of any fast film. Agfa films are silver-rich, yet generally cost less than other films.

Ilford Pan F+ is not as fine grained as APX 25, but due to its lower contrast and longer scale, is much easier to handle in a broad range of developers. Its tonal scale is longer than the old Pan F. Ilford FP4+ is another favorite of ours. FP4+ responds well to a wide range of developers and techniques. It produces a full tonal scale, fine grain, and high sharpness and works beautifully with XTOL 1:3. It is an excellent film to use as a standard for measuring the qualities of other films.

Kodak Tri-X has been the most popular fast film since it was introduced in 1954. For its fast speed it has moderately fine grain, high sharpness, and excellent tolerance to underexposure and overexposure. Of all the fast films this one is the most versatile. It can be pushed as much as three stops with acceptable results. Tri-X's unrivaled flexibility ensures its continued popularity.

Even so, we prefer HP5+ when it is used near EI 400. HP5+ does not respond to push processing as well as Tri-X. A one stop increase seems to be the practical limit.

The Neopan films have not been available long enough in the US to carve a niche for themselves. Our limited use of Neopan 400 indicates that it is a good, general purpose fast film.

Neopan 1600 is an interesting film. It appears to be an ISO 400 film with as much gelatin and hardener removed as possible. This allows the film to be developed for a shorter time with a slight gain in speed. The true speed of this film is close to EI 650, and the tonal scale is similar to Tri-X. However, it responds well to pushing.

Kodak Recording 2475 has extended red sensitivity, which makes it particularly suitable for surveillance photography at night. It has acceptable sharpness for its intended purposes, but large, mushy grain.

Tabular films

Tabular films take advantage of new technology for growing thinner silver crystals so they have more surface area and less depth than conventional silver crystals. It is like comparing flagstones (tabular grain) to boulders (conventional grain). Tabular grain films use approximately 30% less silver than conventional films (perhaps making them more popular with manufacturers than photographers). As noted in chapter 1, the larger size of the crystals causes higher contrast in minute areas, resulting in higher sharpness but poorer gradation of fine detail.

Kodak's name for tabular films is T-Max; Ilford's is Delta. Delta films are slightly grainier than their T-Max siblings. The aspect ratio (height versus width of each T-grain) of the T-Max films is about 1:8: a thin, long, flat grain. The aspect ratio of Delta films is about 1:5, shorter and thicker. However, the thicker grain of Delta films still has far more light

gathering surface than any conventional film. Because the grains in Delta films are smaller, they are potentially able to hold fine highlight detail better than T-Max films.

Tabular films are not a replacement for conventional films; they are an addition to the palette. Like everything in photography, improvements in one area lead to compromises in another.

Tabular films are harder to process because they are sensitive to very slight changes in development time and temperature. For example, most conventional films require at least a 30% increase in development time to produce a noticeable change in contrast and density. Some tabular films will exhibit a significant change with only a 10% increase in development time.

All tabular grain films provide finer grain and higher sharpness than conventional films of the same speed. But if you value smooth gradation of fine highlight detail, a conventional film will provide more satisfactory results.

Of the three T-Max films we think P3200 is the most useful. For general photography there are several conventional films which can be used to rival T-Max 100 and T-Max 400. But for low light photography, only Delta 3200, another tabular film, can rival its high speed. P3200 seems to respond particularly well to development in XTOL 1:2.

P3200 has a realistic EI rating of 800 to 1000. Our early testing indicates that Delta 3200 has an EI of 1000 to 1250, albeit with higher grain. Manufacturers could easily make conventional grain films faster while maintaining overall image quality, if they chose.

It is our opinion that tabular grain films are inferior to conventional grain films. It appears to us that their only reason for existence is to maximize profits for Kodak and Ilford by reducing silver content through the use of tabular grains. Should you use these films, we suggest you try overexposing by up to two stops and developing for 20-30% less time. Following this recommendation should improve results by making more development centers available, thereby reducing microcontrast.

Chromogenic films

Chromogenic films are black and white films based on color technology and should be developed in C-41 chemistry. The resulting dye images have fine grain, excellent gradation, high sharpness, and wide exposure latitude, especially to gross overexposure.

Some believe that chromogenic films are the only modern films to offer the exceptional wide-scale, "straight-line" gradation of pre–World War II films. That makes them particularly valuable as an aesthetic choice.

Ilford XP-2 and Kodak T-Max T400CN are fine films. We recommend both with equal enthusiasm. However, because, like all C-41 films, they are not archival, and because development control is so limited, they are not discussed further in this book. For those who wish to process their own chromogenic films we recommend a JOBO automated processor and Tetenal C-41 chemistry.

Document films

Document films have ultra fine grain and extremely high-contrast. They are designed to copy line drawings and text. In the 1960s it was discovered that they could be used for continuous tone pictorial photography when developed in special low contrast developers (chapter 11).

Document films produce the finest grain and highest sharpness the photographic process is capable of. These are the films to use for 40x enlargements. But even with the most advanced development tech-

niques, their tonal range is limited compared to other films. When using document films, image quality is more dependent upon developer choice than with any other film type.

Two document films are readily available: Kodak Technical Pan (Tech Pan) and Cachet Macophot ORT25. Tech Pan has extended red sensitivity. ORT25 is orthochromatic—it has no red sensitivity.

Because of Tech Pan's increased red sensitivity it is difficult to assign it an ISO, as its actual speed changes with the amount of red light present. When red is missing, the film speed slows. For example, the film's speed is much slower when used in the shade where there is less red light present and more blue ultraviolet. Conversely, in bright sunlight the speed of the film may double. It has poor sensitivity to green, unlike the human eye, which is very sensitive to green. As a result, green foliage will often appear underexposed. ORT25 is not sensitive to red, so, as with all ortho films, blue skies will always look washed out because they will overexpose in the time it takes for the rest of the scene to appear.

Despite these provisos, both Tech Pan and ORT25 are excellent choices for interpretive landscape work. They are also good choices for portraiture, though for entirely different reasons: Tech Pan bleaches out skin blemishes and texture with its extended red sensitivity; ORT25 produces the rich, dark skin tones typical of portraitists like Karsh and Disfarmer. With all ortho films, red tones in makeup, especially lipstick, will print as flat black.

Infrared films

Edward Weston said, "The camera sees more than the eye." But with infrared, the film sees more than the camera. These films offer photographers an entirely new way of seeing. While these films certainly have applications in aerial, scientific, law enforcement, and advertising photography, they also have special applications for fine art photographers.

Three black and white infrared films are currently available from Kodak, Ilford and Konica. Kodak High Speed Infrared has the greatest infrared sensitivity; Ilford SFX200 has the least. The Kodak film is the only one that must be loaded and unloaded in total darkness—the price you have to pay for its true infrared sensitivity. In the field, use a light-tight changing bag.

To get the most infrared out of these films, expose through a red filter. Infrared images made without a filter appear to be black and white photos missing key tonal values—an effect that can be either interesting or dull.

Yellow, orange and red filters can be used for a mix of pictorial and infrared effects. The stronger the filter, the more infrared will be recorded. The lighter the filter, the less. We recommend B+W filters for their high optical quality. The two filters most commonly used with infrared film are Wratten 25 and 29 red. The B+W equivalents are 090 and 091. To achieve full infrared effect requires B+W 092, a true infrared cut-off filter. However, the filter factor is high, 5-10X.

The speed of infrared films depends on the filter and the amount of

infrared light in the scene. For example, the lower the sun is on the horizon, the more infrared light in the scene. Ilford SFX 200 film, without a filter, is rated at ISO 200. At midday with a No. 29 filter the effective EI will be 50, but at sunrise or sunset the EI will be greater.

For all types of photography, portraiture, landscape, and architecture we like SFX 200. We like Konica Infrared for portraiture. Neither of these two films requires the special handling of Kodak High Speed Infrared. Both can be loaded or unloaded in open shade (avoid bright sunlight with all films as a matter of course).

Orthochromatic films

Continuous tone ortho films were once the most popular for celebrity portraits, especially of men. Look at any vintage poster of Elvis, James Dean, or Bogie and notice the rich, grey skin tones, dark lips and brooding eyes. They were taken with ortho film in the heyday of Hollywood's black and white glamour photography. Karsh of Ottowa used ortho for his famous images of Winston Churchill, Ernest Hemingway, and many others. In recent years, Tri-X Ortho was the preferred ortho film, but like so many fine Kodak films, it has been discontinued.

The only continuous tone ortho film still being manufactured, as far as we know, is Ilford Ortho+. It is only available in 4x5-inch and 8x10-inch sheet film sizes. With the right choice of developer this film is capable of pictorial contrast, producing a full tonal scale, minus red.

As a practical matter, it is easy to give panchromatic films an ortho look by moderately filtering out red. An 80A or 80B blue filter will accomplish this with minimal speed loss.

Transparency films

The best way to achieve a full scale black and white image is to produce a high quality transparency and display it on a light box. No other black and white process, negative to print, can compare with the tonal scale and luminance of a transparency.

Any film can be made to produce a black and white transparency. However, there are two that are specifically recommended for this purpose. The first is T-Max 100, the second is Agfa Scala. T-Max 100 is a full scale, panchromatic negative film. However, by using the specially formulated reversal processing kit available from Kodak, it can be made to yield a transparency. Agfa Scala is an ISO 200 black and white transparency film designed solely for that purpose.

There is not a lot to be said about either of these vis-a-vis development. T-Max 100 is developed in the kit from Kodak. Buy the kit, follow directions, get results. Agfa Scala should only be developed by designated labs.

Uncommon roll and sheet film sizes

New film specially cut for old roll film sizes such as 101, 103, 116, 112, 124, 127, 616, 620 and 828, as well as custom sheet film sizes, is available from Film for Classics (see Sources). Standard sheet film sizes from 4x5 to 20x24, as well as custom sizes, are available from Bergger (see Sources).

NOTES

1. Although most slow films have short tonal scales and most fast films have long tonal scales, it doesn't have to be this way. Kodak's discontinued Panatomic-X was a slow, fine grain film with a remarkably long scale.

Chapter 3

DEVELOPER INGREDIENTS

If photochemistry is a science, it must certainly be the least scientific of all the sciences. It sometimes seems harder to establish a scientific truth in photochemistry than in psychology or sociology. Reviewing the photographic literature we note near certainty on a number of fundamental issues from the turn of the century through World War II. After that point the tide turns to progressive uncertainty on virtually every aspect of photographic science.

In the old days chemists habitually made broad assertions concerning photo chemicals which may have owed more to witchcraft than to reasoned science. Today, careful scientists shroud even conceptually simple procedures such as pH measurement in disclaimers. This makes it difficult to discuss developing chemicals authoritatively.

In our discussion of chemicals used for film development we have attempted to find a viable middle ground between the freewheeling half-myths of the early photo chemists and the uninformative silence of today's best scientists. In doing so, we have culled the most valuable insights from more than a hundred years of accumulated observation by scientists and artists, which has an aggregate value of its own. We have tried to emphasize information that is consistent between the present and earlier eras. But we have found it necessary to discard many familiar characterizations, such as reduction potential, which modern chemists have rightfully rejected. Above all, we have kept in mind the best wisdom of contemporary scientists who say that it is not so much the developing agent, but the formula in which the developing agent is placed.

Ansel Adams remarked, "Variations in developers are, in truth, so small that with certain adaptations of exposure and use, almost any developing formula can be used with almost any negative material." In truth, tests can be arranged to show that differences between formulas are trivial. But most experienced chemists and photographers know that individual formulas have unique characteristics and each developing agent has its own visual personality.

Developing agents

Many natural substances are capable of developing film including, as reported by Grant Haist, "polluted lake and river water, old red wine, citrus fruit juice, and even human urine."[1] Of the thousands of chemical compounds that have been studied, only eleven are commonly used in

"…it does not appear correct to commence a description of a developer with the actual developing agent for the simple reason that it is the composition of the solution that plays the dominant part in determining the photographic properties of the developer."

C.I. Jacobson

19

Properties of the Major Developing Agents

Common Name	Hydroquinone	Chlorhydroquinone	Catechol	Pyrogallol	p-Aminophenol	Amidol	Metol	Glycin	p-Phenylenediamine	Ascorbic Acid	Phenidone
Scientific Name	1,4 dihydroxybenzene; para-di-hydroxybenzene	2 Chloro- 1,4-di-hydroxybenzene; 2-chloro-1,4,-benzenediol	1,2-Dihydroxybenzene; ortho dihydroxybenzene	Pyrogallic acid; 1,2,3 trihydroxybenzene; 1,2,3-benzenetriol	4-Amino-1-hydroxybenzene hydrochloride; para-hydroxy aniline	2,4-Diaminophenol dihydrochloride	Monomethyl-para-aminophenol sulfate; para-methyl-aminophenyl sulfate	para-(Hydroxyphenyl glycine; para-hydroxyphenyl-amino acetic acid	para-Diaminobenzene; 1,4-diaminobenzene	L-Xyloascorbic acid; hexuronic acid	1-Phenyl-3-pyrazolidone; 1-phenyl-3-pyrazilidinone
Commercial Names	Quinol, Tecquinol, Hydroquinol	Adurol, Chlorquinol	Pyrocatechin	Piral, Pyro	Activol, Azol Kodelon, Para, Rhodinal	Acrol, Dianol	Elon, Enol, Genol Graphol, Pictol, Photol, Rhodol	Athenon, Monazol, Iconyl	Diamine, Paramine Metacarbol (free base); Diamine H, P.D.H., p.p.d. (hydrochloride salt)	Vitamin C	Graphidone
Form	Needle-shaped crystals	Needles or leaflets	Needles from water	White crystals	Free base: plates from water; HCl salt: crystalline	Crystals	Crystals	Leaflets from water	White crystals	Crystals (plates or needles)	Leaflets or needles from benzene
Solubility in water (g in 100 ml at 20C)	8	92	30	40	Free base: 1.2; HCl: salt 145.5	25	4	0.02	1	30	2

black and white photography today. The chart to the left does not include the phenylenediamine derivatives used in color developing and occasionally in black and white (see chapter 7), aminophenol derivatives, Phenidone derivatives used in commercial products, or ascorbic acid derivatives that are becoming popular.

Ascorbic acid and derivatives

Ascorbic acid is vitamin C. It is the least toxic developing agent on the photochemist's shelf. Researchers have known of its value in photography for decades. However, it has found widespread commercial use only since the 1980s. Researchers do not seem to agree on any of its practical properties. Some claim that ascorbates can only be used at high alkalinity; others believe that moderate alkalinity is not only tenable but desirable. Ascorbic acid *per se* is not used in most modern formulas. Current researchers seem to agree that the "most preferred" form is sodium isoascorbate. More detailed information will be found in chapters 5 and 9.

Amidol

Amidol is the only common developing agent that functions well at a neutral or acid pH. During the 1930s it had some vogue as a low contrast developer used in a water bath process. Ansel Adams used an amidol water bath for his most famous picture, *Moonrise Over Hernandez*. But that was in 1936. With modern films amidol developers have a tendency to produce streaking.

In spite of extreme instability, amidol has sometimes been used in both low temperature and high temperature developers, and has recently been suggested by Gordon Hutchings as a speed enhancer for PMK (see *The Book of Pyro*). Although amidol has largely been discredited as a film developer, it still has many adherents as a print developer.

Because of the unique ability of acid amidol developers to develop the bottom layer of the film emulsion first, rather than the surface as is normally the case, they have been used for the development of very thick nuclear-track films used to photograph radioactive particle tracks.

Chlorhydroquine (CQ)

CQ has a number of characteristics which make it desirable as a negative developer. Used alone it is said to be more active than hydroquinone; used with other agents, it is reported to be less superadditive than hydroquinone with metol and Phenidone—a potentially valuable characteristic. It is more soluble than hydroquinone and was used in the past to formulate concentrated developers.

Until the 1960s CQ was used mostly in print developers where it can produce brown to red tones by direct development. No commercial developers based on CQ exist today. The manufacturing process is both dangerous and expensive. The only grades available are either brown mush or reagent grades costing upwards of $50 per gram. Crawley was probably the last chemist to formulate a film developer with CQ: FX 9 (see chapter 7); he also used the Phenidone-CQ combination in his FX 12 print developer.

"The camera never lies, but it is possible to be selective amongst the many statements it makes."

—MICHAEL GILBERT

Glycin

Glycin is one of the most undervalued developing agents. It is additive or superadditive with Phenidone and metol. Since glycin's speed is poor it is rarely used alone.

Although once quite popular, especially in combination with *p*-phenylenediamine (PPD) for fine grain developers and with metol or Phenidone for high sharpness, it is now almost entirely ignored in favor of MQ and PQ combinations. This is partly due to its greater cost. But it is also due to the fact that in powder form, glycin does not keep as well as other agents. (Fresh glycin should be a delicate tan color; the lighter the better.)

However, in solution glycin is stable and resistant to oxidation, even in low sulfite solutions. Furthermore, it confers resistance to oxidation on other agents that it may be used with, such as PPD, Phenidone, and metol. Resistance to aerial oxidation and fog makes it especially desirable for developing sheet films in trays.

In practice, glycin is often used in formulations with a low amount of sulfite since, according to Crawley, it becomes excessively solvent when placed in a high sulfite solution. This tendency can be mitigated when glycin is combined with other superadditive agents, such as the PQ combination. Crawley uses this triple combination in his high speed negative developer FX 11 (chapter 5).

In modern formulas glycin is almost always combined with metol or Phenidone. These mixtures are less active than the PQ or MQ combination. Such developers can be very sharp, with excellent speed and grain characteristics, as well as lower contrast than MQ or PQ combinations (see FX 2, chapter 7).

Paterson Unitol uses the Phenidone/glycin/Kodalk combination. This developer has particularly beautiful midtone gradation. The FX 2 metol-glycin combination features strong midtone gradation, translucent highlight discrimination, and high acutance.

Glycin has a reputation for preventing bromide streaking when using continuous agitation.

An excellent grade of glycin is available from Photographers Formulary, which makes fresh batches every two weeks.

Hydroquinone

Hydroquinone is a high contrast developing agent. Its reaction products accelerate development. It is rarely used alone, except in special formulas for technical applications. Its main value is in MQ and PQ formulas (see superadditivity).

Hydroquinone is sensitive to cold and should not be used at temperatures below 60F/15C. It requires a pH of at least 9 to be active, but can still efficiently regenerate metol or Phenidone below that pH. The first reaction product of hydroquinone, hydroquinone monosulfonate, is widely used in commercial developers.

Metol

Metol is the most versatile developing agent. Developers as disparate as fine grain D-23 and high acutance FX 1 can be made using metol alone.

No other developing agent can achieve these effects so reliably, and with full utilization of emulsion speed.

Part of metol's value is that its reaction products slow down development. This results in lower contrast, and easier to print negatives. The reaction products of most other developing agents accelerate development.

Metol is considered to be a *sharp* developing agent because of the ease with which it creates adjacency effects. Metol can produce either high sharpness or fine grain images—though not both in the same developer.

Metol has been known to cause an acute skin irritation known as metol poisoning. Metol poisoning often manifests itself only after years of exposure. Once the skin has become sensitized it usually remains so. Avoid direct contact. As with all photographic chemicals, always wear surgical or neoprene gloves (see Appendix III).

para-Aminophenol

p-Aminophenol was considered by the redoubtable Bob Schwalberg to be the finest developing agent. He had two reasons for this opinion: the first was the century-long success of Agfa Rodinal, the most famous developer to use this chemical. Rodinal is the oldest continuously manufactured proprietary product in photographic history.

The second was *p*-Aminophenol's reputation for low fog. Schwalberg reasoned that anything which caused less fog had to have a beneficial effect on the photographic process.

p-Aminophenol is considered sharp due to the edge effects it produces at high dilutions. On the other hand, Schwalberg did not believe that this entirely explained its sharpness: he believed the low fog level was just as important. Notably, Crawley believes that metol is sharper. Outside of Rodinal, there is now little commercial exploitation of *p*-Aminophenol.

Moderate pH *p*-Aminophenol developers have not been adequately investigated with modern films. Although Agfa-Gaevert scientists actively studied aminophenol derivatives in the 1950s and 1960s, especially in connection with superadditivity, it is not known how much commercial success these enjoyed. Much of their research was published in the *Journal of Photographic Science and Engineering*.

para-Phenylenediamine (PPD)

Because of its low activity, PPD has a special ability to maintain delicate highlight detail. However, it is almost impossible to make PPD or PPD-derivative black and white developers that create sharp images, due to the highly solvent effect of these chemicals (see chapter 7).

All PPD-related developers are considered to be highly allergenic and toxic, although they may not be more so than other developing agents. Since PPD and some aminophenols are still used widely in hair dyes, apparently without reported long-term health consequences, these developing agents/dyes may not be as dangerous as some have feared, but we suggest approaching them with caution, nonetheless.

Phenidone

Phenidone is an economical, efficient substitute for metol in many developers with hydroquinone, since approximately a twentieth as much Phenidone is needed to obtain similar activity. Phenidone is rarely used alone, since it has exceedingly low contrast, and is poorly preserved by sulfite.

In general, PQ developers yield 1/3 to 2/3 of a stop speed increase over similar MQ developers, as long as development is kept to a low or moderate contrast, as noted in Chapter 10. The speed advantage disappears when development is "pushed" to a higher contrast.

Phenidone has low bromide sensitivity in highly alkaline solutions. However, Phenidone is sensitive to bromide in moderately alkaline solutions (borax or buffered carbonate).

After the initial enthusiasm for Phenidone/hydroquinone (PQ) developers in the 1950s and 1960s, it was realized that most PQ developers are not sharp when compared to their MQ equivalents.

The fine grain developers in the FX series were, as Bob Schwalberg noted at the time, the first PQ developers that were as sharp as or sharper than their MQ equivalents. Schwalberg also noted that Paterson Acutol was the first high definition developer to use Phenidone.

Although successful fine grain Phenidone developers have been designed (chapter 5), very few successful formulas for non-solvent PQ developers have been published—for one of the few, see FX 37 in chapter 6.

Phenidone (or its derivatives) has been used in proprietary developers, such as Kodak HC-110, Edwal FG7, and Paterson Acutol and Unitol. The PQ developer concentrates published by Wiederman (Jacobson) are of no practical value today.

It is essential to know that Phenidone does *not* keep well in stock solutions. But hundreds of derivatives have been synthesized, many of which keep better in liquid. Successful commercial PQ developers use these later generation derivatives. Apparently the best is 4-Hydroxy-methyl-4-methyl-1-phenyl-3-pyrazolidone, tradenamed Dimezone.

Phenidone has been experimentally combined with pyrogallol—a strongly superadditive combination. It has also been used alone or with small amounts of other agents in super-low contrast developers that are mostly used to obtain pictorial gradation on high contrast document films (chapter 11).[3] It is also superadditive with ascorbic acid and its derivatives (chapter 5). Derivatives of Phenidone seem to have superadditive properties that are similar to the parent chemical.

Phenidone and its derivatives have long had a reputation for low toxicity compared to most other developing agents. Recent studies on animals indicate that oral ingestion of Phenidone and its derivatives may be much more toxic than hitherto supposed—as the new MSDS sheets for Phenidone developers reveal. However, these studies have been criticized, and it is not yet known whether they apply to humans. The amount of Phenidone or its derivatives used in a developer is typically so small that the possibility of toxic exposure is minimized. Until further studies are made, it will not be possible to give a clearer picture.

Pyrocatechin (Catechol)

This high contrast agent has sometimes been used in place of hydroquinone. In very small amounts, it can even function as a low contrast developing agent. It does not appear to be strongly superadditive with other developing agents. The most important feature of pyrocatechin is its ability to tan images (chapter 8).

One interesting attribute of pyrocatechin is that this toxic benzene chemical is a constituent of human urine. How or why the human body manufactures pyrocatechin is something we will leave to future generations of scientists—or theologians. Perhaps the Creator foresaw a time when developing agents would be in short supply but film would be plentiful?

Pyrogallol (Pyro)

Pyro is photography's oldest developing agent still in use. In recent years it has regained popularity due to the efforts and formulas of Gordon Hutchings and John Wimberly. Because of its tanning/staining effects, pyro can create unique negatives. It is often combined with metol in modern formulas (chapter 8). This is considered a mildly superadditive combination. Pyro is strongly superadditive with Phenidone and ascorbic acid.

Developing agent combinations

Superadditivity is defined by Grant Haist as "the cooperative action in which two developing agents produce more silver from exposed silver halide materials than the sum of the silver developed by the agents used individually. The primary developing agent of the pair is thought to be strongly adsorbed to the silver halide grain and to be regenerated by the second agent."[1] More simply, superadditivity is where two combined agents produce more silver together than they would produce separately.

Additivity is where two combined agents produce precisely the same amount of silver together that they produced separately.

Subadditivity is where the two combined agents produce *less* silver than they produced separately.

In practice, the degree of super-, sub-, or additivity a developer combination shows depends heavily on the experimental conditions.

Superadditivity

Some combinations of developing agents, such as metol-hydroquinone (MQ), Phenidone-hydroquinone (PQ), and Phenidone-pyrogallol, are highly superadditive. This means that the sum of their activity is greater than would be expected.

This discovery had a transfiguring impact on manufacturers. It meant savings in chemicals on an enormous scale. But did it really benefit photography?

On the face of it, stronger developer combinations should be good for everybody. Using less chemistry means less exposure to hazardous chemicals, and less toxic wastes.

Yet there are some real problems with superadditivity. The phenom-

Although pyrocatechin is a highly toxic chemical in large amounts, Japanese researchers have found that the minute amounts of catechin and related chemicals that are naturally present in green tea appear to have anti-mutagenic and anti-carcinogenic effects.

How much, or whether, a developer combination is superadditive, depends on the pH. At pH 9 or above, the MQ combination is highly superadditive. But at pH 8.5 or below, MQ is barely additive, due to hydroquinone's low activity at this pH. However, the PQ combination is strongly superadditive even at lower pH, because hydroquinone regenerates Phenidone so efficiently.

enon itself is still imperfectly understood by scientists, but the more it is studied, the more complex it appears.

From a practical standpoint, the problem with highly superadditive combinations is that, because of the unpredictable ways in which developer byproducts are regenerated, there can be unpredictable development of highlight details as development progresses. This is particularly noticeable with PQ developers. It accounts for what Crawley has called the tendency of PQ developers to let the "highlights run away," by which he means an almost random overdevelopment.

It also explains why single-agent developers like Rodinal, D-76 (which functionally is a single-agent developer, see chapter 5), D-23, FX 1 and ABC Pyro, have remained popular.

Although PQ is a less controllable combination than MQ, PQ solvent developers are popular because of their 60% speed increase over D-76. One method for dealing with PQ was proposed in FX 15. In this formula metol is added to the PQ combination. According to Crawley, this improves discrimination of fine highlight detail.

Recent research at Kodak hints that the superadditive combination of Phenidone derivatives with ascorbic acid derivatives may, like the PMQ combination, be more desirable than the traditional PQ combination.

We believe that rewarding future film developers may be based on single agents or weakly superadditive combinations. In this respect, it is worth noting that pyro-metol and metol-glycin have an excellent reputation for the ability to hold fine separation in the extreme highlights.

Accelerators, preservatives, restrainers & other additives

In addition to the developing agent virtually all film developers have three additional constituents:

- an alkali accelerator
- a preservative (usually sodium sulfite)
- a restrainer

Sometimes a single chemical may play many parts. For example, in Kodak D-23 sodium sulfite acts as the accelerator, preservative, and chemical solvent.

Alkali (Accelerator)

pH levels indicate the relative acidity and alkalinity of a developer. pH 7 is neutral; under 7 is acid, over 7 is alkali. The higher the pH the higher the activity of the developing agent. Only a few developing agents, such as amidol, can function in neutral or acid solutions.

An alkali is necessary to increase the pH of the formula, accelerating the activity of the developing agent. The most common alkalis are, in order of *increasing* strength:

- borax
- sodium metaborate
- sodium and potassium carbonate
- sodium and potassium phosphate
- sodium and potassium hydroxide

Some developers have buffered alkali systems, to maintain the pH at the same level over the course of the entire development process. Both metaborate and borax are "self-buffered" alkalis.

Borax is the mildest common alkali. It is used in low contrast and fine grain developers. The decahydrate is the preferred form.

Sodium metaborate (Kodalk or Kodak Balanced Alkali), the reaction product of borax and sodium hydroxide, has a pH between borax and carbonate. The octahydrate is the preferred form. The old maxim promulgated by Kodak in the 1930s, that varying the amount of metaborate would allow you to adjust the development time without affecting other variables belongs to a more innocent period in photographic science. It has since been discredited.

Sodium carbonate comes in three forms, crystalline, monohydrate, and anhydrous (also known as desiccated). The crystalline grade contains ten molecules of water; the monohydrated, one molecule. During storage the crystalline form loses water and the anhydrous absorbs it. Thus both tend to approach the strength of the monohydrated, which remains comparatively constant. For this reason the monohydrate is preferred, even though it is more expensive.

Potassium carbonate is available in both anhydrous and crystalline forms. The crystalline contains 1.5 molecules of water and a small amount of bicarbonate buffer, depending on the grade. The potassium salt readily absorbs water from the air and should be stored in airtight containers.

Potassium carbonate is more soluble than sodium carbonate, hence its use in highly concentrated solutions. The two should not be interchanged.

Phosphates come in many forms, all of which approach the pH of the hydroxides without being as dangerous to handle. Phosphates can be considered as replacements for hydroxides when high alkalinity is desired.

As powder, the phosphates are, apparently, less stable than the other alkalis.

One reason phosphates have been little used is that they can cause a scum if the film is plunged directly into a fixer that contains alum hardeners. Since the use of alum hardeners is waning, this need no longer be a major concern.

Sodium hydroxide and potassium hydroxide (caustic alkalis, potash) are the strongest common alkalis. They absorb both moisture and carbon dioxide and so must be protected from air. **Read the cautions in Appendix III before handling the caustic alkalis.**

The Preservative

Schwalberg's maxim is a tribute to the fact that sodium sulfite can act as a preservative, an alkali, a silver solvent in fine grain developers, and, in a pinch, even as a fixer. What it does, and when it does it, depends on the amount, the time the film spends in the solution, and the other ingredients in the solution. Its complex role in MQ and PQ developers has been extensively researched, but the full story on this multi-faceted chemical is not yet known.

"Sodium sulfite proves the existence of God."

— Bob Schwalberg

"If you've got too much fog, you've got too much alkali."

—Grant Haist

Modern formulas use anhydrous sodium sulfite. For older formulas which specify crystals, use half the amount of the anhydrous grade. For most developers, sulfite is dissolved first, then the developing agents, then the alkali. The one exception is developers containing metol. In this case, first add a pinch of sulfite to the water, then the metol, then the rest of the sulfite, and finally the rest of the chemicals.

Potassium sulfite is occasionally used in highly concentrated formulas such as Rodinal. We do not recommend its use elsewhere, except where it is unavoidable.

Sodium and potassium bisulfite

Bisulfites are weakly acidic. They are often used in A/B stock solutions to preserve the developing agent. When carbonate is added to the working solution, the bisulfite is immediately broken down into sulfite and bicarbonate, producing a useful buffering effect.

The Restrainer

A developing formula may not differentiate adequately between exposed and unexposed silver halide in the emulsion. In addition to developing the image grain, it may also develop non-image grains to produce an overall fog (non-image density).

Restrainers were once thought to be necessary in virtually all developers to reduce fog. It is now realized that restrainers usually impair image quality, and are often only necessary to correct too strong an alkali. Hence Haist's advice to reduce alkalinity instead of reaching for a restrainer. Although virtually all Phenidone developers contain a restrainer, two of the most important, POTA and XTOL, do not.

Potassium bromide is the most popular restrainer. It works well with all developing agents, including Phenidone at the moderate pH of borax or a carbonate/bicarbonate buffer. However, unless the developer has been carefully formulated, bromide tends to reduce film speed. Nevertheless, in carefully balanced formulas, potassium bromide does have a desirable effect (see the FX solvent developers in chapter 5).

Potassium iodide as a restrainer has not been thoroughly investigated. It may prove to be superior to bromide. If you wish to experiment, generally 1/10 to 1/100 the weight of bromide is used. Iodide is sometimes used in combination with bromide.

Benzotriazole (BZT) is primarily used to reduce fog found in high pH developers which contain Phenidone. It is commonly referred to as an "organic antifoggant," but its action in a developer is the same as any restrainer. Other important organic antifoggants include 6-nitrobenzamidazole and 1-phenyl-5-mercaptotetrazole.

Bromide and iodide are called *inorganic* restrainers or antifoggants. Benzotriazole and the other organics are called *organic* antifoggants or restrainers. Crawley explains that organic antifoggants work by insolubilizing the halide grains, while the inorganic restrainers work by rehalogenizing (thus selectively slowing development of) the grains that have been most weakly struck by light.

Pinacryptol Yellow is a desensitizing dye with some restraining action. It was specified in the formula FX 2 where it is said to offer

better image-to-fog discrimination than conventional restrainers, without impairing definition. In this role it is not recommended for tabular grain films.

Wetting agents

Wetting agents are highly purified detergents which are normally used as the final step in the development process, just before the film is hung to dry. They allow water to run off more evenly, preventing water spots.

Wetting agents such as Kodak Photo-Flo or Edwal LFN are sometimes added to a developer or used in a presoak. The theory is that they will smooth the flow of developer over the emulsion surface, producing more uniform development. Because even nonionic detergents can create unexpected results, we do not recommend using wetting agents except after washing.

Water

Water is a crucial, often overlooked, constituent part of all photographic formulas. If you do not think so, try developing and fixing your next roll of film in dry chemicals!

In general, the wide variety of impurities found in water are present in such small quantities that they have little effect on photographic solutions. However, bearing in mind that the mineral content of tap water can change from one day to the next it is always safer to use distilled water for mixing developers. Minute impurities in water are especially problematic with pyro and catechol. Distilled water is the cheapest way to ensure quality negatives.

With most tap water, a viable alternative is to boil it for three minutes, and let stand overnight. Boiling removes gases. Standing overnight allows particulate matter to precipitate out. Decant carefully.

Generally, stop baths and fixers are not as sensitive to water variations as developers. If a problem does appear, use distilled water.

Filters can help protect films from water impurities. If a filter is not available use several layers of an additive-free paper towel, such as Bounty Microwave, or a coffee filter. Water with any visible color should not be used in photographic processing.

Softened water should not be used in developers. If it cannot be avoided, use distilled water instead.

Sea water cannot be used for mixing most photographic solutions. Sea water *can* be used as a hypo clearing agent after fixing with acid hypo solutions, but a final rinse in fresh water is obligatory.

"If God had not invented water, I would have had to do it myself!"

—Dr. Erno Laszlo, Greta Garbo's cosmetologist

NOTES

1. Focal Encyclopedia.

2. Hutchings.

3. US Patent 3,772,019 (1972) is for an ultra-low contrast glycin-Phenidone developer by the H&W Company. It was intended for obtaining normal contrast on document films (chapter 11). US Patent 3,938,997 (1976) is for "Rapid access, air stable, regenerable iron chelate developer solutions" by Fisch and Newman of 3M. Many superadditive combinations are listed. One possibility includes EDTA, ascorbic acid, and glycin. This could be an interesting jumping-off point for further research.

Chapter 4

DEVELOPMENT PROCEDURES

Film size equivalents

The following film sizes are approximately equal to 8x10 inches, or 80 square (80²) inches. Throughout the text, whenever 8x10 inches of film is referred to, it will be considered equivalent to one of the following:

1—35mm roll, 36 exposures
1—120 roll
4—4x5-inch sheets
2—5x7-inch sheets
1—8x10-inch sheet

Developer volume recommendations for 8x10 inches of film

Although it is true, as Kodak claims, that 100 ml of *undiluted* D-76 is sufficient to develop 8x10 inches of film, *it may not always be enough to develop the film to its fullest potential. The amount of solution required to cover the film's surface should not be confused with the amount of developer required to fully develop a roll of film.*

For example, 100 ml of solution will cover one roll of 35mm, 36 exposure film in a JOBO CPA-2 processor. However, to *ensure* full development of *all* images on the roll at least 250 ml of undiluted D-76 should be used, no matter what any manufacturer says to the contrary.

To maintain quality and consistency use the following volumes for each 8x10 inches of film, regardless of the processing method—even rotary processing.

Undilute developers—at least 250 ml (D-76, Microdol-X, XTOL).

Dilute developers—at least 500 ml (D-76 1:1, Rodinal 1:25 to 1:50, FX 1, FX 2, HC-110 1:31 from concentrate, PMK).

Very dilute developers—1 liter (D-76 1:3, Rodinal 1:100, FX 2 1:1, HC-110 1:90 from concentrate).

These amounts may sound extreme to some. But saving on developer is penny wise and pound foolish. Do not try to make photography cost-effective by skimping on film developer. You will never be able to maintain quality and consistency, even if the results appear adequate.

Agitation

Agitation may be the least understood step in the development process. Agitation not only affects contrast, but also sharpness, film speed, and the total time of development. For example, continuous agitation

I was taught to agitate film as vigorously as possible, to prevent uneven development and bromide drag. For reasons I did not then understand, my photographs never seemed to have the tonality I saw in the work of more experienced photographers.

Several years later photographer Jim Goff asked me why I was agitating my film like a washing machine. He told me to use slow, gentle inversions, say one every two seconds, to improve the tonality of my images. I tried his method, and after several attempts to adjust the length of development, was able to achieve the tonality which had previously eluded me.

— ANCHELL

reduces development time by 15 to 20%. It also increases the rate of development in the highlights, suppresses the adjacency effects which enhance film sharpness, and can cause bromide streaking. We do not usually recommend continuous agitation for black and white films. For exceptions see the section below, on JOBO Rotary Processors.

Most defects due to uneven development appear within the first 30 to 60 seconds, and are magnified as the development process continues.[1] Clearly, then, agitation should be continuous for the first 30 to 60 seconds. But it must be intelligent. The goal is to break up standing waves and prevent laminar effects which prevent the developer from actually moving over the film even when agitation is intense. The only way to achieve this is to change direction frequently.

Finally, and perhaps most important, once you have established a satisfactory agitation method for a particular film and developer, always stick with that method to ensure consistent results.

Agitation recommendations for roll film

There is much conflicting advice on how often to agitate and for how long. We know we should agitate for 30 to 60 seconds for the first minute. But what about the rest? Should the next cycles be every 30 seconds or every 60 seconds? Should the cycle last for 5 seconds or 10 seconds. We will try to impose some order on this confusing situation.

Question: For the first minute, do you agitate for 30 or 60 seconds?

Answer: If you can fully immerse the film into the developer in less than 5 seconds, then 30 seconds for the first minute is enough. If it takes longer than 5 seconds to completely wet the entire film surface, agitate for the entire first minute. The bigger the tank, the more important this becomes.

Question: For the next minutes, do you agitate once every 30 seconds or once every 60 seconds?

Answer: It depends on the total development time. If your development time is less than 5 minutes, agitate for 10 seconds every 30 seconds. If your total development time is longer, agitate for 10 seconds every 60 seconds.

Question: For the next minutes, do you agitate 5 seconds or 10 seconds on each agitation cycle?

Answer: Agitate for 10 seconds. Five seconds is not enough to get any movement or flow breakup going.

To invert the tank, lift it in both hands, the right hand covering the lid to prevent the weight of the liquid from popping it off, and the left hand under the base. Twist the tank to the left as you turn it upside down. Twist it back to the starting point as you turn it right side up. One complete inversion should take about 2 seconds. Before placing the tank down, tilt it and gently tap the base on a hard surface to dislodge any air bubbles. For the next inversion, switch hands and twist the tank in to the left.

In sum, our recommendation for tank development with times over 5 minutes is to agitate for the first 30–60 seconds, then for 10 seconds every minute. For times less than five minutes, agitate once every 30 seconds for ten seconds.

Draining

The ideal draining time after development is 10 seconds. Within 10 seconds most of the developer will have drained off the film, leaving about 14 ml of developer either on the surface of the film or absorbed in the emulsion (for 80^2 inches of film). Increasing the draining time beyond this point does not appreciably increase the amount of developer that is freed from the film, but it does permit development to continue, and increases the probability of streaking. Adding a wetting agent to the developer does not materially alter this figure.

If tank development time is less than six minutes a two tank system should always be used. The first tank should contain the developer, the second tank should contain the stop bath or water rinse. Shortly before development is complete the lights should be turned off and the lid removed from the tank. At the moment that development is complete the film should be pulled out of the tank, drained for ten seconds, then immediately immersed into the second tank. If a water rinse is used instead of an acid stop bath it should be a running water rinse for at least one minute or five complete changes. This method will ensure against streaking and uneven development. It can also be used with longer development times.

Tanks and trays for sheet films

For hand inversion tank processing of 4x5-inch sheet films we recommend the JOBO 2521 tank and 2509N reel. The 2521 accepts up to 6 sheets of film. There are no tanks made for hand inversion processing of sheet film larger than 4x5 inches.

For tray processing of sheet film, use a tray at least one size larger than the film (e.g., 8x10 inch tray for 5x7 film, 11x14-inch tray for 8x10 film). The minimum tray size we recommend, even for 4x5 sheet film, is 8x10 inches. This will help ensure adequate developer volume.

Minimal agitation

This technique was rediscovered by Geoffrey Crawley in the 1960s[2] and enthusiastically adopted by Ansel Adams in the 1980s.[3] Its purpose is to provide maximum sharpness through the formation of extreme adjacency effects and to slow down highlight development as much as possible, which allows easier printing of extreme highlight details.

To use minimal agitation, agitate continuously for the first 60 seconds, then for 10 seconds every *third* minute. Increase development time by about 50% over normal.

This method should only be used with very dilute, non-solvent, high definition developers that take 12 minutes or more to develop film. Crawley recommended it for FX 1 and FX 2 with a 50% increase in development time. Adams recommended it for HC-110 1:90 from concentrate with developing times around 18 minutes. It can be used with sheet film in a tray if either one sheet is developed or multiple sheets are carefully kept separated between agitation cycles, as with a specially made sheet film rack in the bottom of the tray.

With this technique, Crawley emphasizes the "interesting internal contrast and acutance effects" that can be achieved. Adams emphasizes

For most of my career in the darkroom I have had a prejudice against plastic tanks. When I was starting out plastic reels had a reputation for absorbing chemicals, and they could not be loaded wet. Although the problem of chemical absorption has apparently been solved, many plastic reels still cannot be loaded when wet. A few years ago I was introduced to Paterson Super System 4 tanks and reels. I think there is no better tank or reel for manual film processing. Although the reels do not absorb chemistry and they can be loaded wet, that is not the reason I recommend this system. The reason is the wide mouth, for rapidly pouring solutions in and out. The only way to come close to the fill and dump speed of the Paterson tank with a metal tank is to turn off the lights, remove the lid, and fill (or dump) the tank in the dark.

— ANCHELL

the reduced highlight contrast with HC-110 at 1:90 from concentrate. This is the *only* technique Adams recommended for contracted development with modern films. This extreme contraction is a feature both of minimal agitation and high dilution. Even in a full strength developer, when agitation is minimal, there will be moderate contraction due to suppressed highlight development.[1]

JOBO rotary processors

Many photographers like to develop film with continuous agitation in a JOBO rotary processor. Unfortunately, continuous agitation interferes with the formation of sharpness-enhancing edge effects. Because continuous agitation exaggerates highlight development at the expense of shadow development it also results in lower speed and a shorter tonal scale. One way of compensating for this is to use a more dilute developer. Whatever developer you use, dilute it with at least 30% more water and increase your development time.

Loading film onto reels

Care is required when loading film onto reels. If the film is forced onto the reel it can buckle, leaving indelible marks on the negatives. (It's easy to recognize this effect from the characteristic crescent moon or eyelash shapes left on the film.) The best way to become expert in loading reels is to practice over and over again. Practice at first in daylight with film dedicated to this purpose, then with your eyes closed, or in the dark.

Loading plastic reels

Plastic reels are almost always more convenient than metal reels. However, whenever moisture is present on the film, the reels, or the photographer's hands, loading film onto plastic reels can become almost impossible, except with Paterson reels and even those become more difficult. The important thing with plastic is never to force the film.

To load a plastic reel, first clip the corners of the film to be inserted at a 45 degree angle. Do not clip too much or the film will not go in easily. One trick is to use a toenail clipper.

Hold the reel in one hand with the film in the other. The opening of the reel should be towards the film hand. Make sure that the openings, on either side of the reel, are lined up with each other. Gently push the end of the film (35mm should have the leader cut off) into the opening until slight resistance is felt. At this point it is safe to grasp the end of the film and pull it past the initial resistance point. Be careful to follow the curve of the reel so the film does not jump the track.

Once the film is started grasp the sides of the reel with either hand and slowly begin to rotate the sides forward and back. This will "walk" the film onto the reel. Continue until the entire film is on the reel and safely past the opening.

Loading metal reels

Although loading metal reels is not as convenient as loading *dry* plastic reels, with practice it is almost foolproof, and it is unlikely that film will be damaged, even if the film or reel is damp.

Hold the reel in one hand, feeling for the spiral opening. The opening should point towards the opposite hand holding the film. Very gently pinch the film between your index finger and thumb. This will create a slight bow towards the emulsion side of the film (the emulsion side is the inside curve of the film, facing the spool when it is rolled up). Insert the film into the center of the reel. It should engage a clip or "teeth" placed there to keep the film from slipping. (If there are no teeth, if the clip has fallen off, or if you cannot get the film to go under the clip, simply insert the film between two of the center bars that separate the sides of the reel; the clip or teeth are only an aid to keep the film from slipping—they are not required otherwise.)

While maintaining the gentle bow in the sides of the film, slowly rotate the reel, allowing the film to load from the center out. Stop occasionally and feel the back of the film (it is coated with an anti-halation and anti-scratch coat so do not worry about fingerprints, although hands should routinely be clean and dry). It should feel round and symmetrical within the reel. If anything feels odd, off, or cock-eyed, remove the film and begin again.

When the film is completely loaded, run your thumb and forefinger between the two outside edges of the reel. Feel all four quadrants of the reel separately. If you feel film pushing through the sides of the spiral remove the film back past the point where the film pushes through, all the way if necessary, and reload. If you fail to do this you will have irretrievable underdevelopment where the film is touching the back of the film in front of it.

As with plastic reels, practice, practice, practice.

Tray processing for sheet film

To avoid scratching do not process more than eight 4x5, six 5x7 or four 8x10 sheets at one time.

1. With the lights on, lay out the appropriate number of trays in two rows. The final number depends on whether or not you intend to develop sheets at different times. For example, if you have three sheets for normal development, three sheets for 40% more, and two sheets for 20% less, you will need a total of six trays.

The following is written for right-handers. If you are a southpaw, reverse the procedure. Working from left to right the trays should be arranged as follows:

a. Plus development holding tray. This tray should be placed on your left, against the back of the sink or against the wall if you are developing on a table.

b. Normal development holding tray. This tray should be placed in the middle, against the back of the sink or table.

c. Minus development holding tray. This tray should be placed on your right, against the back of the sink or table.

d. Developer tray. This tray should be placed on your left, at the front of the sink or table.

e. Stop bath or running water tray. This tray should be placed in the middle, at the front of the sink or table.

f. Fixer tray. This tray should be placed on your right, at the front of

the sink or table.

The three holding trays should be filled with water. With the lights off, separate the film into three light tight boxes (empty film boxes work the best) and place on a table, from left to right, with those to be developed longest on the left.

2. With the lights out, remove the plus development sheets from their box. Place each sheet, *emulsion side down*, into the left-hand holding tray, one at a time.

Gently submerge the first sheet and rock the tray for *at least* ten seconds before placing the second, and then the third, sheet on top, emulsion side down.

Repeat this procedure with the normal holding tray and finally the minus holding tray.

Note: It is important to wait before placing each successive sheet into the tray in order to avoid having them stick together.

3. Carefully lift the three sheets together from the plus holding tray and allow them to drain for 15 seconds. Carefully slide all three sheets, emulsion side down, into the developer tray on your left.

Immediately peel the far right edge of the top two sheets back from the bottom sheet with your left hand. Slide the bottom sheet *all the way out* from under, being careful not to scratch the base on the corner of the top two sheets.

Allow the two sheets held in your left hand to drop back into the developer by completely letting go of them. Drop the single sheet in your right hand on top of the two in the solution.

Immediately peel the far edge of the top two sheets back from the bottom sheet with your left hand, slide the bottom sheet out from under, and repeat the above. This procedure should be slow and orderly. It is not necessary to do it quickly.

Continue the initial shuffling process for 60 seconds. At the end of the first 60 seconds rock the tray for 15 seconds, shuffle *one sheet only* from the bottom, then rock the tray for 15 seconds, etc.

4. Approximately 15 seconds before the normal films are to be added to the tray of developer remove them from the holding tray and let them drain. You can stop rocking and shuffling at this time. At the moment they are to enter the developer use your left hand to pull back the three sheets already in the developer and carefully slide the three new ones under them.

Immediately peel back the top *five* sheets and carefully slide the bottom sheet out of the solution and begin continuously shuffling all six films for 60 seconds, as described above. After the 60 seconds return to the routine of moving only one sheet every 15 seconds with tray rocking in between.

5. Approximately 15 seconds before the minus films are to be added remove them from the holding tray and let them drain. At the moment they are to enter the developer use your left hand to pull back the six sheets already in the developer and carefully slide the two new ones under them.

Immediately peel back the top *seven* sheets and carefully slide the bottom sheet out of the solution. Continue shuffling for 60 seconds and

then return to the routine of moving only one sheet every 15 seconds with tray rocking in between.

6. 15 seconds before the end of the developing time, carefully align the sheets in the tray and then lift all eight sheets from the solution like a pack of cards. Place one hand under the bottom edge to prevent the ones in the middle from sliding out of the pack. Allow the sheets to drain for the remainder of the development time before moving them to the stop bath or water rinse.

7. Carefully place the films into the stop bath or water rinse and immediately begin shuffling for the entire time they are in this bath. There is no need to shuffle quickly or to rock the tray.

8. Align the sheets and carefully lift them to drain for at least 15 seconds then place them in either a rapid hardening fixer or TF-4 (chapter 12). Immediately shuffle the sheets for a minimum of one minute before turning on the lights. Shuffle the sheets, or rock the tray, for the entire fixing time.

9. After fixing, the sheets should be separately and thoroughly washed.

STAND DEVELOPMENT

Stand development is a technique which relies upon highly dilute developers and extremely long development times. This means film development times of thirty minutes to several hours with no agitation after the initial minute. This technique was popular in the early 20th century with glycin developers which are less likely to produce streaking than other developers.[2]

A speed increase can be expected with stand development because development of the highlights is suppressed by lack of agitation while the shadows continue to develop. One would therefore also expect a high degree of highlight compensation. But in practice, an almost normal macro gradation is obtained with modern films. This is because, even though there is no external agitation, agitation through interlayer effects in the film provides the necessary interchange between fresh and exhausted solution. However, although macro gradation may remain close to normal, micro gradation does not, and the combination of this plus exaggerated adjacency effects provides a refreshingly different kind of print. Extreme edge effects, and some haloing, are occasionally the result of such development.

The French photographer Atget used stand development. Berenice Abbott has described a visit to his studio: he would leave his visitor every twenty minutes to dash into the darkroom to inspect the negative and see if it was ready or not.[4]

FX 2 or TFX-2 diluted 1:1 (i.e., half-strength working solution, see chapter 6) is the ideal stand developer. The small amount of metol prevents the speed loss typical of straight glycin, and the presence of glycin as the primary developing agent inhibits streaking.

To avoid air bubbles give the film a two minute plain water pre-bath. After immersing the film in the developer, gently agitate for 60 seconds. With roll film in tanks use inversion and, in addition, if available, a twirling stick. Be sure to alter the direction of agitation throughout the 60 seconds. The film and developer must then be left alone. Using FX 2 1:1, 45 to 90 minutes is a good time for all slow to medium speed films. After the developing time is over, rinse for two minutes in running water, then fix.

If the room temperature of the darkroom is not within 5 degrees of 68F/20C, then the developing tank should be placed in a large water bath to maintain the temperature during the long period of development. Precise developing times are irrelevant with stand development, as a large difference in contrast only occurs with changes of at least ten minutes. It is nearly impossible to overdevelop conventional film with stand development, though tabular films are more sensitive.

Stand development is one of the safest alternative techniques you can use with modern films, although it is possible to experience dichroic fog with fast films. Stick to slow to medium speed films, and keep the development time under 90 minutes.

NOTES

1. Silvia Zawadzki to BT, 1998.

2. Crawley 60/61.

3. Adams, The Negative.

4. Berenice Abbott to BT, 1986.

Chapter 5

SOLVENT DEVELOPERS (FINE GRAIN)

The fine grain myth

At any given time in photographic history photographers have endeavored to achieve better image quality than they could get with the films then available. By the early 1900s, astronomers and other scientists were clamoring for better image quality. By the 1920s image quality had become an enormous concern for the emerging movie industry. By the 1930s, with the new popularity of 35mm cameras, still photographers became more vocal than ever on this score.

Enhanced image quality came slowly to still photography, because early researchers saw it in terms of finer grain, not higher sharpness. The method most widely used by still photographers to reduce graininess was a highly solvent developing agent, such as *p*-phenylenediamine (PPD) which dissolved part of the silver grains, thereby making them appear smaller—a kind of development we now call super-fine grain.

It is significant that this method was never adopted by the movie industry, as very early on Hollywood discovered that PPD destroyed image definition. Cinema production has always been so expensive and quality demands so high that no unsharp process could be tolerated. When a 35mm film is projected onto a cinema screen, it better have definition!

In still photography, sheet film users could use PPD developers without harm—there is not much that can ruin the sharpness of an 8x10 negative—and there were even some interesting effects that could be achieved with PPD on older, thick emulsion films. But few 35mm users could afford the loss of sharpness and speed.

The introduction of D-76 in 1927 was the breakthrough the movie industry was looking for. D-76 was the *first fine grain developer that did not destroy sharpness*. It was also the first fine grain developer to provide full emulsion speed. D-76 is what we would now call a *moderate fine grain* developer. It has a fine grain effect, but not a strong one. Though it was quickly superseded by more reliable developers for motion picture processing, it became the standard by which all future black and white developers would be judged, both for still and cinema photography.

It was not until the 1940s that traditionalist still photographers finally got the message Hollywood had accepted at once. Super-fine grain developers soon lost their mystique. Moderate fine grain develop-

**QUICK GUIDE
RECOMMENDATIONS**

■ D-76 undiluted or 1:1 is still the standard by which all other developers are judged. FX 15 and XTOL are sharper and offer a 2/3 stop speed increase. We particularly recommend these developers for Tri-X, Neopan 1600 and HP5+, especially in 35mm.

■ For tabular films, XTOL is the solvent developer of choice.

ers, exemplified by D-76, became overwhelmingly popular and retain their dominance to this day. The coup de grace for super-fine grain developers was the thin emulsion films pioneered in the 1950s which produce dichroic fog with highly solvent developers.

Solvent developers

Solvent developers are often called "fine grain" developers because chemicals are used to reduce the appearance of grain. As mentioned in chapter 1, solvent developers dissolve some part of the silver grains in the film, making them appear smaller and "less grainy."

It is generally recognized that solvent developers do not produce as sharp an image as non-solvent developers. This is due to a number of factors, even now not fully understood, of which dissolution of the grains by the sulfite in the developer is only one.

Physical development, typical of solvent developers, can also lead to a loss of sharpness. Even so, not all physical development is unsharp. In the 1950s and 1960s, during the heyday of monobath research, several sharpness-enhancing adjacency effects were observed as being exclusive to physical development.

Perhaps even more important than solvency *per se* is to keep the developer at a moderate pH between 7.5 and 8.5.

Moderate fine grain developers

When discussing fine grain solvent developers we refer to a developer of the D-76 or D-23 type, used undiluted. Unlike older fine grain formulas which used solvent developing agents such as PPD, modern fine grain developers rely on a high concentration of sodium sulfite.

One hundred g/L of sodium sulfite is the typical amount used for a visible fine grain effect. More sulfite can be used, but 125 g/L is the practical limit. This assumes a developer with no other solvent agent. Almost without exception, such developers use MQ, PQ, or metol alone.

As mentioned, developers of this class are called "moderate fine grain" developers to differentiate them from the older super-fine grain developers. What they offer for today's conventional films is appreciably finer grain than a non-solvent developer, full emulsion speed, and excellent gradation, with only a moderate penalty in sharpness.

Diluted fine grain developers

Diluting fine grain solvent developers offers many advantages. At a moderate dilution of 1:1, sharpness is increased while effective film speed is maintained. Graininess is slightly increased on dilution, since the solvent effect is not as great, but the increase is small, because the film spends a longer time in contact with the sulfite while in the developer. Moreover, using developers as diluted one-shots is the best way to ensure consistency and quality.

Dilution also affects gradation in important ways. D-23 and D-76 cannot handle high contrast subjects unless diluted. Ansel Adams believed that highlight blocking in undiluted D-76 was due to the solvent effect of sodium sulfite. This is a misperception. Sulfite is the culprit, but for different reasons: in undiluted D-76 and D-23, the

amount of sulfite is too high to permit the developing agent to exhaust in the highlights. Thus, the gentle shouldering-off of highlights typical of compensating developers does not occur. Dilution cures the problem.

When these developers are diluted between 1:1 and 1:3, they show as much or more highlight latitude than compensating developers of the HC-110 or high acutance type. Furthermore, at 1:3 dilutions they offer enhanced acutance characteristics as good as or better than HC-110 and similar developers.While acutance is not as high as specially formulated high definition developers such as FX 1 and 2 (chapter 6), graininess is not as high, either. In addition, some Phenidone-based solvent developers are capable of a 30% to 60% speed increase. Finally, tabular grain films seem to work best with well-diluted solvent developers, or with non-solvent developers.

D-76

D-76, introduced in 1927, is the most important developer of the 20th century. It is the overwhelming favorite developer of 35mm photographers.

How can a developer still maintain its popularity and offer optimum quality when films have changed so much in the intervening years? One reason is that no manufacturer will risk marketing a film that does not perform well in D-76. In fact, most films made today are optimized for D-76.

Not everyone is unanimous in agreeing that D-76 is the optimum developer for today's films, or even that it is the optimum developer of its type—a low pH, moderately solvent, fine grain developer. Geoffrey Crawley believes that D-76 does not fully exploit either the inherent sharpness or speed of modern films, nor does he feel it offers high enough definition to take advantage of the enhanced image quality available with today's lenses. And Kodak's XTOL can be seen as a radical update of the D-76 developer type.

Even so, D-76 will probably be manufactured by Kodak and others for as long as black and white silver halide photography is commercially viable. As a result, commercial modifications of MQ-solvent developers have been few because the safest course has always been to use D-76, and call it something else, as with Ilford's ID-11.

As sold today by Kodak in a single-powder package, D-76 contains a few agents not specified in the original published formula. They include chemicals for sequestering hard water, for preserving the developer in its package, and for aiding its ability to dissolve.

For the most part, the additional agents are included to ensure that the developer can be used in almost any geographical area, even though such precautions are not necessary in most parts of the US and Europe. Some D-76 experts believe these additions degrade image quality. They recommend mixing the developer from scratch. Demineralized or distilled water can be used when necessary.

Note: Although Kodak D-76 and Ilford ID-11 are ostensibly the same formula there are a few differences. Ilford sells ID-11 in two separate packages. The first contains metol, the second

KODAK D-76	
Water at 125F/52C	750 ml
Metol	2 g
Sodium sulfite anhydrous	100 g
Hydroquinone	5 g
Borax decahydrate	2 g
Cold water to make 1 liter	

sulfite. This eliminates the need for some of the additives which Kodak includes in their single package and may allow the Ilford formula to perform closer to the original.

D-76 and film speed

In theory, a developer like D-76 which dissolves part of the silver should reduce effective film speed. Yet D-76 is often cited as offering the best exploitation of a given film's speed/grain capability. One reason is that, in the first stages of development, the sulfite in D-76 dissolves a small amount of silver and uncovers latent image sites which would not otherwise be available for development. This amounts to an effective gain in speed, a serendipitous effect not planned by Capstaff when he formulated D-76 in 1927. It was well into the 1970s before researchers began to understand this mechanism.

D-76 modifications

A major problem with D-76 was discovered in 1929, just two years after its introduction. At the pH of fresh D-76, which should be about 8.3, the hydroquinone is essentially inactive. However, upon storage over a few months, the pH of both D-76 and the replenisher formula, D-76R, can rise as high as 9, enough to activate the hydroquinone. At that point D-76 creates higher contrast. Thus D-76 can be variable in use, a poor characteristic for a developer that is supposed to be a standard by which to measure all other developers.

To correct this situation variations such as D-76d have been introduced. D-76d includes a buffer of 8 grams of boric acid, with the borax also increased to 8 grams to match the original pH.

D-76c is a "low and normal contrast" variation intended for "photomicrography, metallography, and spectroscopy." It has the addition of 0.04 grams of potassium iodide and 1 gram of potassium bromide. The rationale is that base+fog with D-76 is somewhat higher than with many other developers, and it has been argued by some that it is desirable to have minimum fog with technical films.

Grant Haist studied the problem and devised a remarkably simple solution. Omit the hydroquinone! If either the metol or the borax is increased by half a gram per liter, a solution indistinguishable in working properties from D-76 will result, but without the inconsistency.[1] The pH will still rise upon storage, but without the hydroquinone, the effect will be negligible. This variation, which we designate D-76H, is strongly recommended to all users of D-76 who mix their own. We have adopted it as the standard against which we measure other developers. D-76H is easy to mix and is also available in kit form from the Formulary as TD-16.

Various versions of the ASA standard developer (the developer recommended by the American Standards Association, now known as ANSI, in which films were measured until 1993) resembled D-76 except that the alkali was replaced with a carbonate/bicarbonate buffer, and potassium bromide was added. None of these modifications precisely matched the image quality of the original D-76, but they were more consistent for testing purposes.

D-76 VARIANTS

	D-76c	D-76d	D-76H	D-76R
Metol	2	2	2.5	3 g
Hydroquinone	5	5	–	7.5 g
Sodium sulfite anhydrous	100	100	100	100 g
Borax decahydrate	2	8	2	20 g
Boric acid	–	8 g	–	–
Potassium bromide	1	–	–	–
Potassium iodide	0.04 g	–	–	–
Water to make 1 liter				

Among the most interesting variations of D-76 are those in the original disclosure by Capstaff[2] which have not been mentioned in the photographic literature since. Capstaff suggested that to raise contrast, the amounts of metol, hydroquinone, and borax should be increased slightly. To lower contrast, the amounts of these chemicals should be decreased slightly. He advised keeping the sulfite level always at 100 g/L of solution to maintain the fine grain effect. One assumption underlying this suggestion is that the extent of the desired fine grain effect is tied to the amount of time the film spends in the sulfite-rich solution.

When D-76 is diluted it becomes more sensitive to the pH of the water. If your water is not pH neutral, use distilled water to obtain consistent results. Distilled water is a good idea in any case with all developers.

Storing D-76 formulas

After mixing, the stock solutions will last up to six months if kept in a bottle filled to the top and sealed with a tight cap. However, for best results, all photographic solutions should be used as soon after mixing as possible. If the developer is to be diluted for use, be sure to dilute just before using, and discard the working solution after one use.

Penny wise, pound foolish

Although undiluted D-76 may be reused without replenishment we do not recommend this practice for small volume processing. Consistent quality can only be assured when *any* developer is used only once and discarded (one shot). However, if you choose to reuse D-76 without replenishment, develop a maximum of 7 rolls per liter. Increase development time approximately 5% for each additional roll developed in the used solution.

For those who wish to replenish the undiluted developer, especially commercial film labs, use D-76R replenisher. This is an acceptable procedure, but it must be re-emphasized that optimum results can never be obtained when a developer is reused. We make no apologies for this statement to those who try to save money by replenishing. There is *always* some compromise in image quality, including inevitable speed loss due to the build-up of bromide from previously developed film (a problem lessened but not eliminated with Phenidone-based developers). Where replenishment is essential, XTOL is claimed to give more consistent quality than D-76, and is designed to be self-replenishing.

D-23

D-23 was intended by Henn to be a simple to formulate replacement for D-76. Indeed, one of the stated functions of D-23 is to provide a more reliable alternative to D-76, especially when replenishment is obligatory (as in the commercial labs of fifty years ago).[3]

D-23 has acquired a reputation for being a low contrast developer. This reputation may not be deserved. True, the formula does not

KODAK D-23

Water at 125F/52C	750 ml
Metol	7.5 g
Sodium sulfite anhydrous	100 g
Water to make 1 liter	

A white scum of calcium sulfite may occur on films processed in high sulfite, low alkalinity developers such as D-23 (and D-25). This scum is soluble in acid stop baths and in fresh acid fixing baths, especially if the film is well agitated. It is slowly soluble in wash water, and may also be wiped or sponged off wet film, although light deposits may not be noticed until the film is dry. The non-swelling acid stop bath, SB-5 is recommended for its removal (i.e. 1% acetic acid plus 45 grams of sodium sulfate).

contain hydroquinone, considered to be a high contrast developing agent, but the hydroquinone is not active in fresh D-76, and would not be active at the pH of D-23 even were it included.

Photographers who consistently find that D-23 offers finer grain, less speed, and lower contrast than D-76 are probably underdeveloping their film. If development times are increased to normal, D-23 will be found to work almost identically to D-76. Thus, D-23 is not a low contrast developer unless it is either diluted or used as the basis for a two-bath developer (chapter 9).

Research on solvent developers

Not much useful research on solvent developers has been published since the introductions of D-76 and D-23. One of the main contributors to work on solvent developers with modern films has been Geoffrey Crawley, for decades editor of the *British Journal of Photography (BJ)*, who writes as follows on modifying D-76:[4]

It is possible to adapt Standard MQ Borax [the *BJ*'s cumbersome name for D-76; it is also occasionally referred to as the "Eastman Borax Developer"] to give better sharpness and definition, and this has been done in the ASA standard fine grain developer and in the Adox Standard MQ Borax formula, which is as follows: metol 1 gram, sodium sulfite anhydrous 80 grams, hydroquinone 4 grams, borax 4 grams, potassium bromide 0.5 grams, water to 1 liter. The concentration of sulfite is 20 grams lower than in D-76, which reduces the amount of physical development and improves sharpness. The sheen[5] referred to earlier in D-76 appears to be caused by the nature of borax [or Kodalk] alkalinity (in a sensitive carbonate developer the introduction of 0.1 grams per liter of borax will produce a slight sheen). The addition of potassium bromide to a borax developer suitably rebalanced will remove this sheen virtually entirely, and improve definition, for it appears to prevent discontinuities usually caused by borax. The buffering of borax with boric acid does not seem to improve definition, although the borax sheen is reduced and sharpness improved. Adox MQ Borax has slightly longer times than D-76, as the contrast rises more slowly. A further step away from the parent D-76 can be made by replacing the metol in the Adox formula with Phenidone; this necessitates a reduction in the borax content, and a doubling of the bromide, both due to the greater activity of the Phenidone. A resultant formula worked out by the author is FX 3.

Geoffrey Crawley and the FX series of developers

In 1960 and 1961 Geoffrey Crawley published an extensive series of articles on developers in the *BJ*, including many new formulas, which he dubbed FX. The formulas included D-23 and D-76–type developers that were optimized for modern films and lenses. Since then, Crawley has sporadically updated this information and published new FX formulas. As this is the most original (and continuous) research in recent photo-

graphic history into the nature of the development process it will be extensively discussed in this and the next two chapters.

To begin, Crawley found that classical super-fine grain developers based on PPD (Sease) or thiocyanate (Kodak DK-20) had a tendency to produce dichroic fog with modern films. Even so, he believed these developers might have uniquely useful characteristics (see chapter 7 for more detail). He notes that the older solvent developers had been optimized to exploit the speed/grain characteristics of films, but the question of sharpness had not been considered. It was the purpose of his FX series to offer the optimum balance of speed, grain, and sharpness for modern films.

Crawley feels that the "natural" speed of a film is about a third–stop higher than obtained with D-76, and that it is possible to gain this speed advantage, or slightly more, while maintaining high image quality. This can be achieved in several ways.

1. The use of the Phenidone/hydroquinone (PQ) mixture, often supplemented with a third agent to prevent problems that sometimes arise with the PQ combination.

2. Careful balancing with bromide to prevent loss of sharpness Crawley believes is inevitable with developers containing borates.

3. Careful adjustment of the alkali systems to provide optimum quality. This usually amounts to a slight decrease in the solvent effect, compared with D-76.

Originally, the FX developers were optimized for three distinct film groups which were defined according to their typical microscopic grain structure. By the 1970s, this classification was no longer thought by Crawley to be necessary as, prior to the introduction of tabular grains, all films had become more or less uniform.

Some FX developers are no longer officially listed in the BJ formulary. Some have been replaced by improved versions; others, such as FX 7, were not considered necessary after the film classification system was dropped. We have chosen to list them all, including excerpts from Crawley's notes, for photographers who may wish to experiment further.

FX solvent developers are designed to offer enhanced sharpness at full strength. Although it is unnecessary to dilute them to obtain maximum sharpness, dilution will improve highlight compensation.

The table on the next page shows the FX *solvent* developers, except for FX 5, FX 9, and FX 10 which are included in chapter 7. Non-solvent FX developers are discussed in chapter 6.

The FX developers are worth looking at by all photographers who would like improved versions of the D-76–type developer. If you do not want to wade through the whole series, FX 15 is the one to try. FX 15 is useful today as a speed increasing developer, and offers better image quality than D-76 and most commercial PQ developers.

Note: A problem with the FX formulas is that they have often been printed with errors, even in the *BJ Annuals,* throughout the 1970s and 1980s. Photographers who have used some of these developers with poor results probably were using incorrectly published formulas. Effort has been made to ensure that the formulas published here are correct. Each one has been checked by Mr. Crawley.

FX SOLVENT SERIES	FX 3	FX 4	FX 7	FX 8	FX 11	FX 15	FX 18	FX 19	
Metol	–	1.5	1.5	1.5	–	3.5	–	–	g
Sodium sulfite anhydrous	75	100	115	100	125	100	100	100	g
Phenidone	0.25	0.25	0.25	0.25	0.25	0.1	0.1	0.75	g
Hydroquinone	6	5	5	5	5	2.25	6	7	g
Glycin	–	–	–	–	1.5	–	–	–	g
Sodium bisulfite	–	–	–	–	–	0.5	0.35	–	g
Borax	2.5	2.5	–	–	2.5	2.5	2.5	–	g
Sodium metaborate	–	–	4	–	–	–	–	–	g
Sodium carbonate anhydrous	–	–	–	–	–	1	–	–	g
Disodium phosphate	–	–	2	–	–	–	–	–	g
Boric acid	–	–	–	–	–	–	–	–	g
Potassium bromide	1	0.5	2	–	0.5	1.5	1.6	–	g
WATER TO MAKE 1 LITER									

Notes on the FX Developers

(Remarks in quotation marks are by Crawley)

FX 3

"Development times about 10% shorter than D-76, speed increase of 30%, or a half stop in practice. An excellent general purpose negative developer, giving the full natural speed, gradation, sharpness, and definition characteristics of the film."

FX 3 is no longer listed, having been replaced by FX 15, which offers a 60% speed increase and better overall quality.

FX 4

"In FX 4 the metol-Phenidone-hydroquinone combination is used. This reduces overall contrast and allows the shadows to increase in contrast more than in FX 3 by the time normal gammas are reached. Speed increase over D-76 is now 50-60%, roughly equivalent to Microphen. The presence of metol also assists discrimination in the highlights, which in some PQ developers are liable to 'run away'...."

Crawley's uniquely expressed insight into some of the problems inherent in the classic PQ combination has continued to interest photographic chemists who are sensitive to the subtleties of black and white image quality. The 1998 patent for XTOL (discussed below) also alludes to these problems.

FX 7

Said to be similar to FX 4, but intended for use with Ilford films, as manufactured then. According to Crawley, the older Ilford films gave better results in developers based on a metaborate system. FX 7 is no longer listed in the BJ.

FX 8

"The other surviving member of the group of scientifically balanced fine grain developers we are examining is D-23. It gives excellent sharpness, but definition is not outstanding. It is very suitable for lenses of lower resolving power, as is the PMQ combination, FX 8. FX 8 develops the

Crawley has a particular and useful way of using the terms sharpness and definition. He defines sharpness to mean the acutance of major subject outlines. Definition he uses to mean the acutance of very fine detail. More technically, sharpness refers to low frequency information on a modulation transfer function (MTF) curve, while definition refers to high frequency information. More simply, sharpness means sharpness in large areas, while definition means sharpness in very small areas.

full natural speed of the emulsion, to give about a 30% increase over D-76. Times are similar; sharpness is good, but definition, as with D-23, is not exceptional. The low alkalinity favors the characteristics of Phenidone; granularity, perhaps due to lack of buffering (as with D-23) does not quite reach the best of the speed-grain interlock. Nevertheless, like D-23, it is a useful formula in practice, and keeps well in tanks."

FX 8 is no longer listed, having been replaced by a new formula, FX 19, which attempts to bring the qualities of D-23 to a Phenidone developer. In 1960, Crawley was attempting to provide developers to match different lens qualities. Today, nearly all lenses are so good that this is no longer necessary. But it is a point worth keeping in mind by photographers who deliberately use unsharp lenses, or for situations where subject motion and camera shake cannot be avoided.

Note: Crawley argued that with a poor lens, edge effects in the negative may obscure rather than enhance sharpness. Later researchers have come to similar conclusions.

FX 11

FX 11, using the combination of Phenidone, hydroquinone, and glycin, was intended to offer the maximum possible true speed gain, which Crawley felt was 100% over the film's ISO rating.

"FX 11 gives higher film speed than either Promicrol or Microphen. It probably gives the highest speed available at present in a solvent developer, with balanced toe contrast to ensure good gradation with thin enlarging contrast negatives. It has built in 'sheen' to mask granularity by slight diffusion; definition is not outstanding owing to the high rate of physical development, but sharpness is fairly good. Its sensitometry and sheen is such that with correct exposure and development, no marked rise in granularity should be noted over commercial formulae despite its higher speed exploitation."

Note: By Crawley's measurements Microphen and Promicrol offer only a 60% speed increase.

"In FX 11 a preference for thin negatives with a density scale of about 0.8 or 0.9 over fog and base, and normal contrast was assumed; the sensitometry of the developer is such that best quality is reached at that point, and it is not therefore very suitable for formats over 6x9 cm where a higher density scale is often required: By the time this higher contrast is reached, negative quality—granularity, sharpness and definition—will have fallen off. To obtain best quality at a higher contrast, with no effect on the increased film speed, increase Glycin by 0.5 gram/liter; development times will increase slightly."

This speed increase may still be obtained on conventional contemporary films, and to an extent with tabular films. However, with tabular films, which seem to respond less well to high-sulfite formulas, we recommend diluting FX 11 1:3 or more.

FX 15 (Acutol S)

FX 15 was available commercially for years as Paterson Acutol S. When Paterson discontinued it (probably due to long-term storage problems—over twelve months on shelves), Crawley published the formula, as

many photographers wished to continue to use it. It offers a 60% speed increase, with sharpness comparable to non-solvent high definition developers. It is a further development of FX 3, offering an improved characteristic curve.

Crawley notes that FX 15 is more flexible than the other FX developers when it comes to extended development of low contrast negatives ("expansion" in Zone System terminology). Crawley recommends it be used at full strength for portraits, and diluted 1:1 for landscapes. Zone System photographers may find it useful for moderate expansion and contraction. With tabular films it should be diluted 1:3 or more.

FX 18

In 1961 Crawley felt that it was impossible, no matter what "alchemy" was tried, to improve the speed/grain exploitation offered by D-76, though it was possible to improve the speed/grain/acutance exploitation. However, in 1966 he published a new formula, FX 18, that was also available commercially from Paterson (simply as FX 18).

FX 18 is said to offer slightly finer grain than D-76, and also a speed increase of 30% while maintaining or somewhat increasing the level of sharpness. As with D-76, use of FX 18 diluted 1:1 is encouraged.

FX 19

FX 19 was an improvement on FX 8. Both were designed as replacements for D-23, offering the advantage of slightly higher speed.

D-23 is said by Crawley to yield slightly finer grain than D-76, with about a 10% loss of speed, and somewhat poorer sharpness. The poorer sharpness is due to the relatively high concentration of metol which, in conjunction with the high sulfite content, allows little oxidation of the developing agent when the solution is used fresh.

Promicrol

The only solvent developer without either metol or Phenidone that ever achieved commercial success was May and Baker's recently discontinued Promicrol. Its only resemblance to the D-76 type of developer is its high sulfite content. It uses a different alkali, and completely different developing agents. The combination of agents was the subject of a special patent.

Although the patent specified that the developer was a super-fine grain type, Promicrol has almost always been used as a speed increasing developer, producing slightly higher graininess than D-76. It has been widely assumed that the formula for Promicrol was essentially identical to the one published in the patent. Crawley informed us that this assumption was correct.

Glycin has a slightly solvent effect, but when used in a high sulfite solution the rate of physical development can become very high. According to Crawley, "Glycin, by itself, with modern films, provokes dichroic fog as soon as the concentration of sulfite rises above about eight times its own. Results with PPD suggest that when a solvent developing agent is suitably energized, it is able to cope with a much more powerful solvent effect and will not then

PROMICROL

Hydroxyethy-o-aminophenol	6 g
Sodium sulfite anhydrous	100 g
Glycin	1.16 g
Sodium carbonate anhydrous	11.6 g
Water to make one liter	

provoke dichroic fog in a formula in which it would undoubtedly do so on its own. Consequently, the energized Glycin does not provoke dichroic fog in the excess sulfite...."

Other phenidone solvent developers

Although very little has been done to improve MQ-Borax developers, there has been considerable activity in the introduction of developers based on D-76 that use Phenidone instead of metol as the primary developing agent. Phenidone developers offer increased speed, but, unless very carefully formulated, also increased fog, and poorer definition.

The major commercial PQ-solvent developers have been Acufine and Microphen. Microphen seems to have been optimized for Ilford films. There are those who feel that it does not perform well on other films. This may no longer be entirely true as many of the differences in the way conventional films behaved in the 1960s have since become negligible.

Despite claims to the contrary, neither of these developers offers a true speed increase of more than 60%, or two-thirds of a stop. Graininess is higher than with D-76, although sharpness is better with Acufine. Neither developer has made great inroads on the popularity of D-76, perhaps because gradation is not as good. Certainly, highlight latitude is reduced with push processing, a technique recommended as a matter of course with both Acufine and Microphen.

Although Ilford and others have published formulas for PQ fine grain developers, they do not perform with adequate sharpness and "discrimination of fine details" unless some metol is added. It must be noted again that the speed increasing effect of PQ developers only occurs when developing to low or normal contrast. The moment the film is "pushed" the speed advantage of a PQ solvent developer over D-76 disappears. For this reason D-76 has been considered, until very recently, to be the best all-around developer for push processing.

XTOL: the latest evolution of the solvent developer

The most recent advance in solvent developers is Kodak XTOL. Recognizing the problems inherent in PQ developers with regard both to environmental and image quality, Silvia Zawadzki and her co-workers replaced the hydroquinone with sodium isoascorbate—successfully challenging some long-held assumptions about ascorbic acid derivatives in moderate pH developers. A close approximation to the formula for XTOL is published in US Patent 5,756,271 (1998).

XTOL is the current state of the art in solvent developers. Several things distinguish XTOL from earlier published developers.

1. The use of 4-hydroxymethyl-4-methyl-1-phenyl-3-pyrazolidone instead of plain Phenidone. There is general consensus among researchers that this is the preferred form of Phenidone.

2. The use of sodium isoascorbate, a vitamin C derivative,

US PATENT 5,756,271	
Part A:	
Sodium sulfite anhydrous	10
Diethylene-triamine-pentaacetic acid, pentasodium salt (40%)	1
Sodium metaborate (8 mole)	4
4-Hydroxymethyl-4-methyl-1-phenyl-3-pyrazolidone	0.2
Part B:	
Sodium sulfite anhydrous	75
Sodium metabisulfite	3.5
Sodium isoascorbate	12
Add Part A to 750 ml of water at room temperature; follow with Part B and water to make 1 liter.	

instead of hydroquinone. This seems to eliminate some of the unpredictabilities observed in PQ developers over the years. It is not as strong a combination as PQ, but seems more desirable from the standpoint of image quality.

In earlier literature, it has been suggested that ascorbic acid, like hydroquinone, is almost inactive under pH 9. Its primary use in XTOL would seem to be to activate and regenerate the Phenidone. But Zawadzki believes that the ascorbate is the primary developing agent in XTOL.

3. XTOL is the first viable ascorbate developer formulated to work at a pH as low as 8.2. Ascorbate has been characterized as a very "sharp", surface-acting developing agent. That, in combination with the low pH, results in negatives that achieve a better speed/grain/sharpness relationship than is possible with traditional developing agents.

4. A significant feature of this developer is that it is intended to be mixed at room temperature.

Interestingly, the developer serves as its own replenisher. This is possible for four reasons:

- the developer has no restrainer
- the developer is highly buffered
- the developer is not highly sensitive to bromide
- modern films release bromide but also release accelerators, which tend to neutralize the restraining effects

The patent for XTOL notes: "It has been observed that the properly replenished developer composition of this invention has less degradation by-products over time and can be used for a longer running time. It has also been unexpectedly found that the developing compositions provide up to one-third to one-half stop in real speed improvement over hydroquinone developing compositions. Granularity is also reduced, and most films show about 10% more enlargeability."

XTOL is thus the first patented developer formula from the US Kodak Research Laboratories to claim a speed increase. Fine grain and sharpness are also improved when compared to D-76 and T-Max developers. XTOL is now the developer most highly recommended by Kodak for T-Max films. It has been observed that dilution increases speed and sharpness with XTOL. Dilutions of 1:3 or more are frequently recommended. At these dilutions XTOL is effectively a nonsolvent developer, but because of its careful buffering, grain is still fine.

The future: economics versus innovation

Although XTOL points the way to several promising paths future formulators of black and white developers could follow, it may also be noted as the swansong for black and white chemistry at Kodak. Kodak is no longer supporting research and development of black and white developers. XTOL is for the foreseeable future the last film developer which will be researched with the monumental thoroughness that only Kodak has had the financial and intellectual resources to achieve. It seems that the future now belongs to individual innovators who will need to have much patience and luck on their side!

NOTES

1. Grant Haist to BT, 1987. An informative article in *Darkroom & Creative Camera Techniques*, Sep/Oct 1985 by Paul Schranz shows a small but measurable density loss when hydroquinone is removed from D-76, which Schranz suggests is due to loss of the superadditive effect. The density loss could be due to any number of artefacts, including failure to monitor pH of the experimental solutions. With a borax developer, pH can unpredictably rise even when the developer is being mixed, due to aeration. This increase can be sufficient to activate the hydroquinone. In addition, Schranz did not, as Haist did, test to see whether the differences could be eliminated by slightly increasing either the remaining metol or the borax. Finally, Schranz did not, as Haist did, conduct image evaluation tests on the resulting negatives.

2. *Eastman Duplicating Film, Its Properties & Uses*, Eastman Kodak, Rochester, NY, 1927.

3. R.W. Henn & J.I. Crabtree, *An Elon-Sulfite Developer and an Elon-Sulfite-Bisulfite Fine-Grain Developer*, J.PSA 10:727 (1944).

4. Crawley 60/61.

5. Author's Note: I've always been interested in the borate sheen phenomenon, and in the 1980s I asked every Kodak heavyweight I could find about it: Richard Henn, Grant Haist, Harold Russell, and T.H. James, all said they had never noticed it. Crawley's observations suggest that developer alkali may work in more complex ways than previously suspected. (BT)

Chapter 6

NON-SOLVENT DEVELOPERS (HIGH DEFINITION)

This chapter concentrates on *high definition* developers—the most important category of non-solvent developers. These are the developers which coax the utmost clarity out of the photographic process. (Most of the tanning developers discussed in chapter 8 are also high definition developers.)

All high definition developers are non-solvent, though all non-solvent developers are not high definition. While it is virtually impossible to formulate a developer without some degree of solvent action, non-solvent developers keep this effect to the practical minimum. However, what distinguishes a high definition developer from a plain non-solvent is the formation of adjacency effects which enhance sharpness.

Acutance and adjacency effects

The science of image evaluation grew out of research initiated by Kodak in the 1940s. Originally, two criteria were measured: resolution and graininess. Researchers soon realized that resolution was not a good index to perceived sharpness.

In the early 1950s Kodak scientists developed what they hoped was an objective test for sharpness, known as the *acutance* measurement. Revolutionary in its time, this test has since been widely criticized. It has to some degree been replaced by various modulation transfer function (MTF) tests. Though tremendously valuable for testing negatives, MTF values are often inconclusive and inconsistent.

Richard Henry noted that the acutance test does not measure adjacency effects.[1] Yet adjacency effects have the greater importance in determining the subjective impression of visual sharpness! A further problem with scientific measurements of acutance and MTF is that most researchers use continuous agitation, in a vain attempt to impose some measure of consistency on an inherently inconsistent process, yet continuous agitation suppresses adjacency effects.

Border and fringe effects

The two most common adjacency effects are known as *border* and *fringe* effects. These effects are most obvious at the border between two areas of strongly different density, for example, a tree silhouetted against a bright sky. The area of low exposure—the tree—has relatively little silver

to develop. As development approaches completion and slows down in the tree area, the relatively fresh developer remaining passes across the border into the sky area. There it produces a small region of increased density at the edge, on the highlight side. This is called a border effect.

At the same time *by-products* of development from the heavily exposed area—the sky—diffuse into the lightly exposed areas of the tree, and retard its development near the border. This creates a region of lower-than-normal density at the edge on the tree side. This is the fringe effect.

Occasionally two lines are produced as a result of border and fringe effects. These are called Mackie lines.

In sum, border/fringe effects work to make the edge of a *bright* object *brighter*, and the edge of a *dark* object *darker*. The result is enhanced sharpness.

Eberhard and Kostinsky effects

A special form of the border effect is the Eberhard effect, which describes the fact that the smaller an area, the greater its density. If there are two neighboring areas of equal exposure, each less than 4 mm in size, the smaller of the two areas will have higher density and greater edge contrast.

The Eberhard effect has often been confused with the Kostinksy effect. The Kostinksy effect describes the spatial distortion of two adjacent images of high exposure, for instance stars which are close together in astronomical photography. It is important to recognize that there do not have to be two adjacent high density images for the Eberhard effect to take place.

The Eberhard effect was defined before the relationship between micro- and macro-contrast was recognized. The Eberhard effect is primarily the recognition that micro-contrast is always higher than macro-contrast. It is the starting point for the study of micro-contrast.

Adjacency effects in perspective

If sharpness through adjacency effects were always desirable, all developers would be high acutance. It is not. As sharpness increases other image quality criteria—grain and micro-gradation—suffer. So before choosing a high definition developer, or any developer for that matter, you need to know what kind of image it will produce with the specific film you are using and whether the developer's effect is appropriate for the photographic statement you wish to make. The distinctions are not always clear. There is crossover where fine grain developers end and high definition developers begin.

In scientific photography it is often necessary to avoid adjacency effects because they can interfere with precise measurements. But their serendiptious appearance in general photography usually enhances the aesthetics of the image. Indeed, today's digital techniques for increasing image sharpness derive from the early studies of adjacency effects. A digital sharpness filter works to enhance edge sharpness by making the edge of a light object lighter, while making the edge of a dark object darker—just like a chemical adjacency effect. The practical application

of this effect can be seen every week on the color covers of the super-market tabloids.

An important point to remember is that adjacency effects are caused by dilute, partially exhausted developer, and minimal agitation. They can be achieved with both *dilute* solvent and *dilute* non-solvent developers

Granularity with high definition developers

Non-solvent developers, particularly high sharpness developers, make grainier-looking prints. There are three main reasons.

1. There is little solvent effect to dissolve the grain edges.

2. Their higher alkalinity encourages grain clumping, which the eye perceives as graininess.

3. Increased local density in small details (i.e., micro-contrast), a hallmark of high definition developers, also increases the appearance of graininess.

The increased sharpness usually *masks* the increased appearance of grain. However, where large areas of undetailed density appear—such as smooth faces, large sky or snow areas, or out-of-focus areas—the grain can be obtrusive. High definition developers may not be suitable for such scenes, particularly with 35mm film.

Adjacency effects, which produce sharpness, can also magnify the visual appearance of camera shake in the final print. When using a maximum sharpness developer like FX 1 or FX 2, either use a tripod or avoid slow shutter speeds.

Compensation and gradation

Virtually all high definition developers are *compensating* developers which produce a longer tonal scale due to reduced highlight contrast. In sensitometric terms, the shoulder is reached sooner, and its slope is more gentle than with normal development. Compensating developers are especially useful for high contrast scenes.

Speed increase with high definition developers

Many high definition developers, particularly FX 1, FX 2, and the Paterson developers, can produce a true speed increase of 50 to 100 percent with conventional slow to medium speed films—ISO 200 or lower. Other developers with this effect are the Beutler (including the Neofins) and the Windisch Pyrocatechin (under ideal circumstances). We have not seen this increase with conventional high speed films nor any tabular grain films.

This is a true speed increase—it should not be thought of as pushing. It is mainly a function of the dilution/compensation mechanism and works as follows: as the developer is very dilute, it exhausts quickly in the midtone areas, and more quickly in the highlight areas, where there is a lot of exposed silver to be developed. The film has to be developed longer than usual to obtain adequate density in these areas. At the same time, the developer does not exhaust quickly in the shadow areas, so these areas are free to develop much more than would be possible with an ordinary developer. The result is an increase in shadow density,

which amounts to a true increase in speed (push processing increases highlight density out of proportion to shadow density).

Buffering

Another contributing factor to the speed increase is poor buffering. High acutance developers are usually based on small amounts of carbonate or hydroxide as the alkali, which means they are poorly buffered. This tends to increase the local exhaustion of highlights, and thus enhance speed. A well-buffered developer gives a more proportional density growth.

Advantages of the speed increase

This speed increase can be useful in an unforeseen way: A slow film such as Pan F+, with an ISO of 50, can be exposed at EI 100 if it is to be processed in a high acutance developer. Compare this to a medium speed film like FP4+, processed in D-76 at EI 125. The effective speed difference between the two films is now only one third of a stop, due to the speed increase of the acutance developer. But despite the slight increase in graininess of Pan F+ processed in an acutance developer, overall image quality will be better than FP4+ processed in a fine grain developer. This is because a slow film almost always produces better image quality than a fast film, even when the slow film's speed is increased in a speed enhancing high acutance developer.

Likewise, FP4+ or Verichrome developed in FX 1 or FX 2 rated at EI 200 will give superior results to Tri-X rated at EI 200 and processed in a speed-losing fine grain developer like Microdol-X or Perceptol, even though both films now have the same EI rating.

Ignoring the speed increase

There is another way of dealing with the increased speed of high definition developers. Ignore it. Take advantage of the improved toe contrast to achieve enhanced shadow separation. This is the preferred technique of many Zone System photographers who strive for a thick negative (density range of 1.2 to 1.5). Technically, this is overexposure and overdevelopment.

While the Zone System technique works well with most large and medium format films it can ruin 35mm negatives. With tabular grain films, overexposure and overdevelopment are even more of a problem. Controversially, Crawley believes that with the current generation of tabular films, somewhat denser negatives give the best results. But for conventional films, thin negatives (density range of 0.9) will be sharper and less grainy, both objectively via measurement and subjectively.

Speed maintenance with high definition developers

Try adding 4 grams of sodium sulfite to a liter of Rodinal working solution. This may increase speed by half a stop.

Not all high definition developers increase speed. Rodinal, HC-110, Dilute DK-50, and D-76 1:3, do not.

In the case of Dilute DK-50 and D-76 1:3, the alkali may be too weak. In the case of Rodinal and HC-110 the sulfite content may be too low (some sulfite is necessary to uncover latent image centers that a pure surface developer would leave undeveloped).

Classifying high definition developers

The tables to the right summarize the different types of high definition developers. The list is not exhaustive and includes some developers for historical reasons only.

Formulating high definition developers

Generally, a true non-solvent developer contains less than 30 g/L of sulfite and no other agents that would promote solvency, like sodium chloride or an ammonia derivative. Though 30 g/L of sulfite will still produce some solvency, depending on the amount of time the film spends in the developer, it is not until about 50 g/L that the solvent action which marks the moderate fine grain developer begins to take effect.

The sharpness-enhancing effects of high definition developers are primarily due to the adjacency effects that occur when the developer is partially exhausted. Sodium sulfite preserves the developing agent in solution; reducing it lets the developing agent exhaust in a controlled manner. Controlled exhaustion is the underlying principle of all high definition developers.

The German photochemist Willi Beutler believed the main purpose of lowering sulfite was to reduce the solvency of the developer, thus increasing sharpness. We now know this is only a small part of why non-solvent developers increase sharpness. When a non-solvent developer has too much sulfite it does not create adjacency effects, and there is little apparent increase in sharpness. The overall image quality in such a developer will not be as good as D-76.

At its simplest, a high definition developer is a highly dilute metol-carbonate developer carefully formulated to keep a number of factors in balance. Key chemical considerations include:

1. Sulfite: approximately 5 g/L of working solution.

2. Alkali: sodium carbonate is the alkali of choice, usually at 2 g/L or more. Some experts on high definition developers, particularly Crawley, believe that borax and Kodalk impair definition, giving a "fuzzy" appearance to the grain.

3. Metol is the most preferred developing agent, followed by glycin, Phenidone, para-aminophenol, pyrocatechin, and pyrogallol, usually in total amounts between 0.25 and 1 g/L of working solution. A single developing agent is often preferred, except in the case of glycin and pyro, which are almost always combined with metol to increase speed, and Phenidone, which is usually combined with hydroquinone or an ascorbic acid derivative.

4. Restrainer: minimal or none. Potassium bromide and the organic antifoggants tend to decrease sharpness. Exceptions are Pinacryptol Yellow used in FX 2, and potassium iodide used in FX 1 and HDD.[3] Phenidone high acutance developers almost always require either potassium bromide, an organic antifoggant, or both, and careful balancing to prevent loss of sharpness.

Although this list provides practical guidelines, it should not be taken as gospel by those experimenting with their own developers. For instance, a distinction is often drawn between "chemical," surface, non-

Highest acutance, highest grain increase, engraving-like gradation, 2x speed increase

FX 1
Kodak High Definition Developer (HDD)
Beutler, Neofin Blue
Some pyrocatechin developers (Chapter 8)

High acutance, less grain increase, more pictorial gradation, slightly less speed increase

Paterson FX 39 & Acutol (FX 14)
PMK (Chapter 8)
FX 2, Formulary TFX-2, FX 37

Good acutance (visibly higher than D-76 but not as high as categories 1 or 2), normal speed, less grain increase, excellent midtone gradation

BJ Dilute DK-50
Kodak HC-110
Agfa Rodinal
Paterson Unitol
Edwal FG7

Solvent developers strongly diluted: good acutance but less than category 3, normal speed, flat highlight gradation, least grain increase

D-76, FX 15, D-23, Microdol-X, Perceptol, all diluted 1:3 or 1:4. Kodak XTOL 1:3 is a special case, offering a speed increase at that dilution and unusually high sharpness for a solvent developer.

solvent, high definition developers on the one hand, and "physical," solvent, fine grain developers on the other. Chemical developers are supposed to produce good acutance, while physical developers are supposed to produce fine grain but poor acutance.

This is not always the case. Physical development can produce many acutance-enhancing adjacency effects, while grain is not always fine with physical developers. Many monobath developers, where physical development is very high, show coarse grain as compared to D-76, but much higher sharpness. When chemicals to suppress physical development are added to these monobaths, sharpness is decreased considerably.

A high acutance developer does not have to have a minute concentration of developing agent if the sulfite is very low. In both Kodak HDD and Windisch Pyrocatechin, the developing agent is 2 g/L while the sulfite is less than 2 g/L, ensuring controlled decomposition of the developing agent. However, this approach is both more expensive and less environmentally sound than the more elegant technique used in FX 1, where the smallest possible amount of developing agent is used in combination with a higher amount of sulfite to maintain the desired protective effect.

Crawley suggests that HDD contained 2 grams of metol, 1 gram of sulfite, 0.5 gram of sodium hydroxide, plus a trace amount of potassium iodide, as in FX 1, to a liter of water.

Years of subsequent experience indicate that the most sensible starting point for formulating a high definition developer is the type of formula codified by Crawley: one-half gram of developing agent to five grams of sulfite, and the appropriate amount of carbonate, per liter of working solution. In tanning developers such as PMK, sulfite must be lower to ensure adequate imagewise staining.

Commercial high definition developers

The first high acutance developer marketed as such was Kodak's legendary High Definition Developer (HDD), introduced in the late 1950s. It attracted a great following, but was discontinued in the early 1960s. T.H. James, Kodak's principal research scientist, explained that due to changes in Kodak films HDD no longer gave optimum performance.[2] Others thought that poor shelf life was the real culprit.

Photographers in the UK and Europe have traditionally used high definition developers more than their American counterparts. HDD was never marketed in the US; and the high definition developers Crawley formulated for Paterson, among them Acutol (FX 14), the recent FX 39, and many others, have seldom been available in the US (see Sources for a current supplier). The Paterson developers are particularly noted for avoiding the midtone compression typical of most high acutance developers.

An important high acutance developer available for a short time in the US was Mallinkrodt's FR-22, which was similar to FX 1, a modern variant of the Beutler formula. Beutler formulated two well-known high acutance developers in the 1950s which are still manufactured by Tetenal: Neofin Blue and Neofin Red. Neofin Blue, optimized for medium and slow films, has always been the more popular. It is based on pyrocatechin, an agent more popular in Germany than the US. Both Neofins are packaged in individual glass ampoules, a good but expen-

sive way of dealing with the problem of decomposition in liquid concentrates. Both developers are still available on a limited basis but are not widely used. A formula published by Patrick Dignan as "Neofin Blue" is merely Beutler's old metol formula from the 1930s.

Phenidone and high acutance

It is difficult to formulate Phenidone versions of solvent developers like D-76 that display good sharpness—Crawley's FX formulas were the first, and remain the best, with the almost sole exception of XTOL. It is even more difficult to obtain good sharpness with non-solvent Phenidone developers. One reason is the too-efficient regeneration of PQ and other combinations, which inhibit the developer exhaustion products which enhance sharpness. Another reason is Phenidone's low sensitivity to bromide, at the medium to high pH levels typical of acutance developers. For a published formula, FX 37, on pages 61–62, is the outstanding choice in a PQ nonsolvent (especially with tabular films), but stock solutions should not be stored more than three months for best results.

The first commercially successful Phenidone non-solvent developer was Unitol, which has been popular for decades in the UK, and is still made by Paterson. This interesting developer uses glycin instead of hydroquinone, which helps both stability and sharpness.

The first successful PQ high definition developer was Paterson's Acutol, also called FX 14. It was an amazing achievement for 1961, and remains popular in the UK and Europe to this day. In the US, Edwal's FG7 had great popularity in the 1960s and 1970s. Although it is not the sharpest developer in its class, it has a pleasing balance of sharpness, grain, gradation and speed. A reformulation in the early 1980s did not affect its desirable image properties, but did cause shelf life problems, which caused many photographers to abandon it. It is still an excellent choice when you can be sure the developer was manufactured less than six months before you use it.

Good shelf life was a hallmark of Kodak's HC-110 when it was introduced in the 1970s, though subsequent tinkering with the formula by Kodak has caused much frustration among users.

The Paterson developers

The current range of developers from Paterson formulated by Crawley is Acutol, Aculux 2, FX 39, and Varispeed. All are used as one-shots. Acutol is the oldest, dating back to 1961. As might be expected, it is recommended for conventional films, more particularly, medium and slow films at or below ISO 200. Like FX 1, this developer is formulated for maximum sharpness, but midtone gradation is not flattened as with FX 1 and most other high sharpness developers. For slow and medium speed conventional films, Acutol is probably the sharpest developer available. Acutol is designed to be used as a compensating developer when desired, via greater dilution (1:20 rather than the normal 1:10). FX 39 is a recent introduction, especially designed to provide the highest possible sharpness with tabular grain films. Aculux 2, recently reformulated, is the fine grain entrant in the line. Although not as sharp as Acutol and FX 39, Aculux may be preferred for scenes where a

compact grain effect is desired. Finally, Varispeed is formulated especially for push processing.

Kodak HC-110

An important developer that offers good definition coupled with only a moderate increase in grain is HC-110, formulated by Henn, King, and Surash at Kodak. Although the formula has been changed from time to time, including the addition of pyrocatechin for at least one year, a rough idea of its composition can be gleaned from the example in US Patent 3,522,060, 1971.

The iminodiethanols are powerful ammonia-based forms of sulfite and bromide that are more active than the common forms. The PVP helps prevents undesirable solvent effects (for instance dichroic fog) that would otherwise occur in a developer with so much ammonia. The result is a product which is more environmentally friendly than most, because the ammonia derivatives allow smaller amounts of the developer chemicals to be used. It is thus also less expensive to manufacture.

US PATENT 3,522,060	
2,2'-Iminodiethanol-sulfur dioxide addition product	31 g
2,2'-Iminodiethanol	9 g
2,2'-Iminodiethanol hydrobromide	1.5 g
1-Phenyl-3-pyrazolidone	0.5 g
Hydroquinone	6 g
2-Aminoethanol	5 g
Ethylene glycol	10 ml
Polyvinylpyrrolidone (PVP)	0.25 g
Water to make 1 liter. Dilute 1:30 to 1:100 with water.	

Even with the PVP, HC-110 is a highly solvent developer. Yet it produces coarser grain than D-76, and is not as sharp as many high acutance developers. Nevertheless, it is convenient, economical and versatile.

Agfa Rodinal

Although Agfa Rodinal was introduced in 1881, it was not until the 1950s that it was understood how well-diluted Rodinal can function as an acutance developer. Brett Weston and Henry Gilpin, among others, have used it at 1:100 with Agfa 25 with excellent results, even though Agfa only publishes times for dilutions up to 1:50.

Today, Rodinal is both an Agfa proprietary formula and a group of published formulas. Traditionally, it consists of a saturated solution of *p*-aminophenol hydrochloride, potassium metabisulfite, and sodium or potassium hydroxide. (Formula in Appendix I.) We call the traditional formula *Rodinal*; we call the commercial product *Agfa Rodinal*.

Agfa Rodinal no longer corresponds exactly to the traditional formula. It still contains *p*-aminophenol and potassium hydroxide, but in smaller amounts. Potassium bromide has also been added, which would not be necessary if *p*-aminophenol were still the sole developing agent. Some photographers prefer the traditional version; others the commercial version. Dr. Elie Schneour believes that the differences are not photographically significant.

Working characteristics of Rodinal

Normally an increase in film speed is expected from an acutance formula. However, the practical working speed of Rodinal is usually slightly lower than with D-76. The reason is that the concentration of sulfite is too low. Film speed can be slightly increased by extending the development time, but overall image quality will suffer.

CLASSICAL HIGH ACUTANCE DEVELOPERS

	BEUTLER	FX 1	FX 1B	FX 2	WINDISCH	
Metol	1	0.5	0.5	0.25	–	g
Glycin	–	–	–	0.75	–	g
Pyrocatechin	–	–	–	–	2	g
Sodium sulfite anhydrous	5	5	45	3.75	0.3	g
Sodium carbonate anhydrous	5.0	2.5	2.5	–	–	g
Potassium carbonate crystals	–	–	–	7.5	–	g
Sodium hydroxide	–	–	–	–	1.5	g
Potassium iodide, 0.001%	–	5 ml	–	–	–	
Pinacryptol Yellow, 1:2,000	–	–	–	3.5 ml	–	
Water to make 1 liter						

See Appendix II for detailed instructions on how to mix the stock solutions for FX 1 & FX 2; Appendix I for Windisch stock.

FX 2 requires potassium carbonate crystals, not anhydrous: the crystalline grade contains some bicarbonate buffer.

Rodinal negatives possess a beauty and impact that is recognizably their own. Among commercially available developers Agfa Rodinal offers gradation that cannot be obtained otherwise. Many photographers prize it for this effect above all else. In practice, Rodinal-type formulas offer good, but not high, acutance.

Although acutance developers increase graininess, Rodinal can be used successfully with fast 35mm films as long as the cardinal rules of minimum exposure and minimum development are observed. It is most successful with Agfa 400, a film that exhibits noticeably finer grain, than Tri-X. Rodinal is also popular with tabular grain films.

Published formulas for high acutance developers

The only thorough discussion of high acutance developers is the legendary series of articles by Geoffrey Crawley published in the *British Journal of Photography (BJ)* where the FX developers were introduced.[3]

At about the same time, the Kodak scientists Henn and Altman published an analysis contrasting fine grain and high acutance developers.[4] This study was marred by the use of continuous agitation. As noted above and in chapter 4, continuous agitation causes a significant loss in edge effects resulting in a lower degree of sharpness. Richard Henry's otherwise meticulous research was also marred by this artefact.[1]

Crawley appears to be the only researcher to have recognized that high acutance developers cannot be properly evaluated unless intermittent agitation is used. Unfortunately, little else has been published on the subject, aside from a few vague references in the literature.[5]

The chart above contains the more important published high definition formulas. The Windisch formula is discussed in Chapter 8.

Special additions to FX 1 and FX 2

FX 1 requires the controversial addition of 5 ml of a 0.001% solution of potassium iodide. According to Crawley, this "homeopathic" amount is vital in making the difference between FX 1's performance as a mere acutance developer and a high acutance developer. This addition is not called for in FX 1b (originally published as FX 13), where, according to Crawley, it would not exert any visible effect due to the high level of

Try replacing the potassium carbonate in FX 2 with approximately 1.5x the amount of Kodalk. Sharpness will not be as high, but this developer is tremendously flexible and provides enhanced midtones. We call this version FX 2K (for Kodalk).

With FX 1, try using a 50/50 combination of sodium and potassium carbonate instead of straight sodium.

sulfite.[6]

With regard to FX 2, Crawley states that the desensitizer Pinacryptol Yellow offers slightly better fog-to-image discrimination than the usual antifoggants. It also helps prevent aerial fog, making FX 2 especially useful for sheet film development in trays.

Pinacryptol Yellow is expensive. But, since very little is used, it does not add appreciably to the cost of the developer. In addition, the stock solution of Pinacryptol lasts for years. Crawley suggests Pinacryptol should *not* be added to FX 2 when developing tabular grain films.[7]

Comparisons and modifications to FX developers

Though FX 1 and FX 2 were revolutionary when they were published in 1961, they have become the exemplars of modern high acutance developers. No method to improve on the principles they codify has yet been found. The only substantial additions to the palette of published high acutance developers are PMK, which is closely related to FX 2, and FX 37, which Crawley describes as a highly-evolved descendant of the Beutler formula.

FX 1 is intended to produce maximum sharpness. FX 1 prints have stunning impact, but gradation is not as subtle as with other developers. FX 2 is designed for a more pleasing, pictorial gradation, with slightly less sharpness. Both developers are at their best with conventional films rated at ISO 200 or less. FX 2 and the related Formulary TFX-2 are both popular with tabular grain films. (TFX-2 is a liquid concentrate based on FX 2 with some proprietary refinements designed to provide improved consistency and smoother gradation.)

FX 1, FX 2, TFX-2, and most other high sharpness developers, produce maximum adjacency effects, and therefore sharpness, when minimal agitation is used. Do not overexpose or overdevelop. Times for slow films like Pan F+ and Agfa 25, which are usually under 12 minutes, should be watched carefully. Agitating for only 10 seconds on every third minute lengthens development times by about 50%.

TD-121 is a buffered version of FX 1 providing somewhat better gradation and finer grain, with the sacrifice of slightly less acutance, and a little less speed increase.

FX 1b is Crawley's attempt to formulate a fine grain, high acutance developer. The method employed is to add 45 g/L of sulfite. This is not a successful approach. It is better to use one developer type, either fine grain or high acutance. For situations when neither extreme is desired, use a moderately diluted fine grain developer such as D-76 1:1 or 1:3. It is important to understand that adding sulfite to an acutance developer does not merely decrease grain by adding a solvent effect; it also preserves the developing agent so that fewer adjacency effects are formed. There will be some increase in highlight contrast, and possibly a decrease in speed. Adding additional sulfite to a non-solvent developer has also been recommended for FG7 and Rodinal—in neither case do we regard this as a desirable approach.

TD-121

Metol	0.7 g
Sodium sulfite anhydrous	5.0 g
Sodium bisulfiite	2 g
Sodium carbonate anhydrous	3 g
Water to make 1 liter	

A trace amount of iodide can be added, as in FX 1.

FX 37

Most of the FX developers discussed here and in chapter 5 were formulated before the advent of tabular grain films. Since then, Crawley has formulated new proprietary developers for Paterson, and has disclosed FX 37, a developer optimized for both T-Max and Delta films (BJ, March, 1996). Crawley makes it clear that FX 37 is not just for use with tabular films.

"This black-and-white negative developer is proposed for the processing of modern films, especially those using so-termed 'high-emulsion' technology, such as T-Max and Delta. But it may be used for traditional type emulsions when the finest grain is not the prime requirement. It is an independent formula, not a substitute for any commercial product."

FX 37 fully exploits Phenidone's speed-enhancing properties. For most films, true speed is a half to two-thirds of a stop more than the manufacturer's ISO.

Crawley has several interesting points to make about developing tabular films:

1. Traditional solvent developers such as D-76 do not work well unless diluted at least 1:1: "If grain is too fine, light scatter in the negative increases when a negative is enlarged, reducing edge contrast," resulting in decreased print impact. In Crawley's opinion, best results will be obtained by modifying a Beutler-family developer, rather than a D-76-family developer, and FX 37 can be seen as a highly evolved version of the Beutler developer optimized for modern films.

2. Nevertheless, Beutler-type developers have a tendency to compress tones excessively, especially when negatives are enlarged with a cold light head, which is becoming more common. Taking these two factors together, Crawley believes that tabular films and even some of the newest conventional films should be developed for a denser negative than has been considered desirable in recent years, especially with 35mm film. Too thin a negative will give coarser grain with these films. Modern films give best printed results with a richer negative, and Crawley notes, "modest overexposure does not increase grain."

3. As regards pushing tabular films, Crawley's advice is identical to the latest findings at Kodak: the best technique is to dilute the developer even further. This is completely different from what has been found to work with Tri-X and D-76. "Dilution 1+5 can be used when it is necessary to uprate a film further, especially those of ISO 400 and over: 50% to 100% the normal time may be tried—up to 4x EI on suitable subjects." By suitable subjects, Crawley means those of inherently moderate contrast—for instance, those in diffuse light. On high contrast subjects, pushing will result in blocked highlights.

4. Finally, Crawley notes that when tabular films came out in the late 1980s, there was a tendency to over-high contrast, especially with the least overdevelopment. Crawley thinks this problem has been overcome in what he designates the current, second generation tabular films. However, he warns that because of the short toe typical of all tabular films, underexpo-

Crawley's radical reassessment of the traditional suggestion for optimum negative density (thin as possible) takes both theorists and practitioners by surprise. Let it be noted that his language is moderate: he is talking about a SMALL degree of density increase.

FX 37	
Sodium sulfite anhydrous	60 g
Hydroquinone	5 g
Sodium carbonate anhydrous	5 g
Phenidone	0.5 g
Borax	2.5 g
Potassium bromide	0.5 g
Benzotriazole 1%	50 ml
Water to make 1 liter	
Dilute 1:3. Diluting 1:5 will lengthen developing time and increase film speed.	
See Development Time Chart for times.	

sure latitude is still low compared to conventional films.

FX 37 uses the highly buffered carbonate-borax system Crawley has championed for decades. It also contains potassium bromide, which Crawley has always believed is essential to maintain sharpness in developers which contain borax. It is interesting to see the evolution of his thinking regarding benzotriazole, a chemical he did not think worked well with the films of the 1960s.

In summary, to quote Crawley again, FX 37 is "designed to produce enlarging quality, very sharp, tonally rich negatives on modern films, with an EI speed increase. It is not a fine grain developer in the old sense, and assumes that the fastest films will not be used when big [more than 12x] magnifications are required."

Buffered non-solvent developers

Kodak DK-50, D-61a, and Unitol exemplify an important class of non-solvent developers which Crawley designates "buffered non-solvent developers." These developers provide the best midtone and highlight separation for negatives of limited contrast range, such as controlled studio photographs. Generally, they do not work well for long-scale natural light photographs.

Buffered non-solvent developers provide good sharpness (better sharpness than a fine grain developer, less sharpness than a high definition developer) and moderate grain (coarser grain than a fine grain developer, finer grain than a high definition developer), and snappy contrast. With the exception of Unitol, most of the developers in this category do not perform well with 35mm films, because graininess will be high without the compensation of enhanced sharpness. This is not a concern with larger film sizes.

The gradation of buffered non-solvent developers closely approaches straight-line characteristics without the high micro-contrast of high definition developers. As they do not exhibit compensating action, they should not be used when under- or overexposure is suspected, or where a high contrast subject has been recorded.

These developers are not as widely used as they once were. As a consequence, many photographers are unfamiliar with their qualities. Of well-known commercial developers, their characteristics most closely resemble Rodinal at 1:25, but they are by no means identical. Since they are less dilute, they are more consistent in use. Since their pH is moderate there is little risk of pinhole or reticulation damage to the film, especially when Kodalk is used.

It is easy to construct a buffered non-solvent developer. All that has to be done is to modify the alkali of an unbuffered non-solvent developer. For instance, one could take a standard metol-carbonate developer, such as D-165. Several things could be done to turn this into a buffered developer.

■ Replace the carbonate with Kodalk.

■ Create a carbonate/bicarbonate buffer system in either one of two ways: (1) Add 10 to 15 grams of sodium bicarbonate to the formula, (2) Replace half the sulfite with sodium bisulfite, and raise carbonate to 50 g/L. This will create bicarbonate in the

D-165

Metol	6 g
Sodium sulfite anhydrous	25 g
Sodium carbonate anhydrous	37.5 g
*Potassium bromide	1 g
Water to make 1 liter	

Specified dilution is 1:3, but for modern films, up to 1:10 could be used.

final solution.

Additionally, the potassium bromide can be reduced or eliminated. This leads to lower contrast and increased speed. Less bromide is needed when the developer is buffered, since the pH is lower, and the tendency to fog is not as great. In a buffered, lower pH, slower working formula, physical development may be greater. A small amount of bromide may help reduce physical development.

If this developer is used with a very high speed film with a tendency to fog keep the bromide to at least 0.5 g/L, the same amount as in DK-50. In fact, the buffered D-165 developer is similar to DK-50, except that it contains no hydroquinone. This in combination with a low sulfite level, results in a lower contrast developer. This means that if developed to the same gradient as with DK-50, there will be a slight gain in speed.

Buffered D-165 can be quite useful. Diluted it can function as an acutance developer. Indeed, if the sulfite is increased to 50 or 60 grams, and the developer is diluted 1:10, we have an acutance developer almost identical to FX 1.

Various other modifications could be made:

■ The bromide could be replaced with a small amount of potassium iodide (between 1/10 and 1/100 of the amount of bromide).

■ A small amount of Pinacryptol Yellow could be added to reduce aerial fog and possibly overall fog.

■ The pH could be lowered further by replacing all the carbonate with sodium bicarbonate. The result would be a very slow working developer with finer grain than usual in a high definition developer.

BJ Dilute DK-50

Crawley's Dilute DK-50 is a special case in the buffered non-solvent category. It is balanced for one-shot, high sharpness use.

In this formula, DK-50 has been diluted 1:4, but the sodium metaborate content has been kept the same as at full strength, to maintain reasonably rapid development times. With this developer it is possible to obtain good sharpness, and excellent gradation on nearly all films. Although sharpness is less than with FX 1 and FX 2, and there is no speed increase, it is possible to use this developer successfully with all fast films.

In general, this developer brings out a good balance of all the inherent qualities in a film, without giving emphasis to any one in particular. It is in the same category (acutance, non-speed increasing) as HC-110, Unitol, and Rodinal.

Experiment: It might be possible to improve sharpness and speed by replacing the potassium bromide with one-tenth or less the weight of potassium iodide. Also try replacing the metaborate with a sodium carbonate/sodium bicarbonate buffer. For instance, instead of 50 g/L of metaborate in Solution B, try 40 g/L of sodium carbonate and 10 g/L of sodium bicarbonate.

BJ DILUTE DK-50 STOCK

Solution A	
Metol	2.5 g
Hydroquinone	2.5 g
Sodium sulfite anhydrous	30 g
Potassium bromide	0.5 g
Water to make 1 liter	
Solution B	
Sodium metaborate	50 g
Water to make 1 liter	

Working Solution: 1 part A, 1 part B, 3 parts water. With current films, especially tabular films, we suggest 1 part A, 1 part B, 6 parts water.

NOTES

1. Henry.

2. T.H. James to BT, 1982.

3. Crawley 60/61.

4. J.H. Altman and R.W. Henn, *Phot. Sci. Eng.* 5:129, 1961.

5. Thomas, *SPSE Handbook of Photographic Science and Engineering*, p. 956, references a modulation transfer study which shows vastly higher sharpness at all frequencies for DK-50 1:10 with no agitation compared to D-76 undiluted with continuous brush agitation.

6. Although some photographic scientists doubt that such a small amount of iodide could have any visible effect with modern films, it is certain it cannot hurt. It is true that the role of iodide in developers—as an antifoggant, a speed enhancer, and as used here, a sharpness enhancer—has not been adequately studied. Crawley clearly stated that this addition was only effective in dilute, low-sulfite metol developers. Informal confirmation was published by Arthur Kramer in *Modern Photography* 42, No. 10, Oct. 1978. This was contested by R. Henry who, being unaware of Crawley's publications, tested iodide in D-76— precisely the kind of developer Crawley asserts it would *not* work in.

7. G. Crawley to BT, 1998.

Chapter 7

SUPER-FINE GRAIN DEVELOPERS

Super-fine grain developers such as Kodak Microdol-X, Ilford Percep-
tol, Edwal 12, and the Sease series, still have many loyal adherents
although many technical problems arise when using them with modern
films. In this type of developer the solvent effect is extremely pro-
nounced, with loss of both speed and sharpness. If these developers are
"pushed" to normal speed, the fine grain effect is lost, and sharpness is
still poor. In this chapter we will try to help you overcome these
obstacles and find new ways to adapt super-fine grain techniques for
modern films.

The "ancient" approach to super-fine grain developers

In the earliest super-fine grain developers, two approaches were taken
to create a high solvent effect (that is to say, more than would be
obtained with D-76).

1. The use of a developing agent that has a high solvent effect, such as
p-phenylenediamine (PPD).

2. The addition of extra solvents, such as hypo, ammonium salts (e.g.,
chloride) and derivatives such as the ethanolamines or thiocyanate (the
technique used in Kodak DK-20).

Both approaches shared the same disadvantages: two to six times
normal exposure; poor sharpness, long developing times, and the
danger of dichroic fog even with thick emulsion films. In fact, the
instruction sheet for Edwal 12 contained information on how to remove
dichroic fog, which was almost inevitable when such a developer was
used with modern film. Further, the use of a reducing solution as
recommended by Edwal has a terrible effect on film sharpness.

Another super-fine grain technique was to combine hydroquinone or
pyrocatechin with PPD. The proprietary agent Meritol was an equimolar
mixture of pyrocatechin and PPD. It had some vogue in Britain until the
1960s. (See MCM–100 in Appendix I.)

In a 1952 patent, John and Field claimed a combination of hydroxy
ethyl-o-aminophenol (itself patented in 1927) with glycin as a super-
fine grain developer. The patent stated that whereas the aminophenol
gave excellent fine grain images of good speed, the development time
was inconveniently long. The addition of glycin was said to speed the
development time without altering other characteristics. This combina-
tion is claimed to have characteristics similar to PQ developers (i.e.,

increased toe speed and contrast, with the straight line and shoulder portions of the film curve being of somewhat less contrast than an MQ developer). However, these effects are observed only when the negative is developed to a low contrast. Even this claim is, at best, exaggerated. But one advantage of the combination is a lower fog level than with PQ. The example patent formula corresponded to the proprietary May & Baker formula Promicrol which was, paradoxically, used as a speed-increasing developer with graininess comparable to D-76 (see chapter 5 for more information and the formula).

Classical PPD developers

PPD is the classical developing agent used in super-fine grain developers. With the right formula, the right film, and the right conditions, it can produce extremely fine grain negatives with beautiful gradation, and, on occasion, sharpness-enhancing edge effects.

Caution: Although PPD and its derivatives are still used in contemporary hair dyes, by photographic standards of toxicity, and in the photographic literature, these chemicals are considered to be highly toxic. Early researchers believed PPD was less toxic in solution; we doubt contemporary toxicologists would agree, As PPD derivatives are more water soluble than the parent compound, they are thought to be more toxic.

There have been many attempts to refine PPD. An early attempt was o-phenylenediamine, which had some limited hobbyist use. The exemplars of the modern PPD derivatives are mostly used in color developers including those used for developing chromogenic black and white films. These include:

Kodak CD-2: N,N-diethyl-2-methyl-p-phenylenediamine, monohydrochloride

Kodak CD-3: 4-(N-ethyl-N-2-methanesulfonylaminoethyl)-2-methyl-phenylenediamine sesquisulfate monohydrate

Kodak CD-4: 4-(N-ethyl-N-2-hydroxy ethyl)-2-methyl phenylenediamine sulfate

The use of modern PPD derivatives is not common for the development of conventional black and white films. Nonetheless, exceptionally useful developers could still be formulated with these agents, perhaps with the potential to overcome some of the contrast problems tabular grain films exhibit.

Perhaps the best classical PPD developers were the four Sease formulas and two related commercial formulas, Edwal 12 and Super 20. All were called "compromise formulas" in the nomenclature of the day because they contained a second and sometimes third developing agent in addition to PPD.

The Sease formulas were published by DuPont in 1934. Edwal Super 12 and Super 20 came out some years later. Super 20 has only recently been discontinued by Edwal.

Ripening

PPD developers work best when they have been ripened, that is, aged or slightly used. The technique is to fog a roll of film by unwinding it and

exposing it to light. Let it soak for half an hour in the freshly mixed PPD developer, then discard the film. You are now ready to use the developer. Every time you make a new batch, "season" it with about 5% of the old batch. This advice is based on years of practical observation by experienced PPD photographers. Crawley was the first to explain why this technique works: a partly exhausted or "ripened" PPD developer will slightly enhance sharpness through the formation of edge effects.

Modern PPD developers

While Crawley noted the disadvantages of classic PPD solutions, he also believed that these developers might have some useful characteristics that could not be otherwise obtained.[2] He observed that the physical developers which were somewhat popular before WWII "…had the ability to preserve subject tones with exceptional faithfulness."

Crawley wrote about negatives that were "for no apparent reason just right … with an especial transparency and outstanding preservation of clarity in the highlights, together with exceptional retention of small tonal differences even in very minute areas of the negative.…" He suggested that this effect could be encouraged by the use of very slow acting developers (developing times of 45 to 80 minutes) with at least some physical developing action. This effect would only be noted in photographs with intrinsically complex lighting effects, usually those taken by daylight, not tungsten or flash.

In particular, he recommended using FX 2 as a stand developer (chapters 4 & 6) but noted that the effect sometimes occurs with ripened PPD developers. In the course of this discussion, he makes some interesting remarks and speculations that deserve to be quoted in full.

The other advantage claimed for pre-war physical processes [the principal advantage was fine grain, which Crawley found to be without much justification] was exceptional preservation of the subject tones; to some extent this seems justified, but also seems true of conventional developers under certain conditions. Since this effect apparently conflicts with rational sensitometry, some explanation is necessary. The characteristic curve of a developer is established of necessity by standardized exposure to a step-wedge, and subsequent analysis. In practice, however, an actual photograph consists of a kaleidoscope of areas of different illumination levels, sometimes hopelessly intermingled. On subsequent immersion in the developer, various factors come into play as this complex variety of contrasts builds up in density: superadditivity may cause various ratios of surface and depth development; presence or absence of a complex-forming solvent [such as sulfite] will cause various ratios of physical and chemical development; the presence of

SEASE SUPERFINE GRAIN

Water at 125F/52C	750 ml
p-Phenylenediamine (base)	10 g
Glycin*	0–12 g
Sodium sulfite anhydrous	90 g
Water to make 1 liter	

*The amount of glycin in Sease 1, 2, 3 & 4 was, respectively, none, 1 gram, 6 grams, and 12 grams. As glycin is increased, speed goes up, but fine grain goes down.

Develop 15–30 minutes at 68F/20C

EDWAL 12

Water (distilled)	750 ml
Metol	6 g
Sodium sulfite anhydrous	90 g
p-Phenylenediamine (base)	10 g
Glycin	5 g
Water to make 1 liter	
15–18 minutes at 70F/21C	

EDWAL SUPER 20[1]

Solution A	
Water (125F/52C)	750 ml
p-Aminophenol	2.9 g
Sulfuric acid	1.9 g
Sodium sulfite anhydrous	100 g
p-Phenylenediamine	10.6 g
Glycin	5.3 g
Water to make 1 liter	
Solution B	
Water at 125C/52F	22 ml
Mono chloroacetic acid	3.7 g
p-Aminophenol	4.3 g
Sodium hydroxide	1.6 g

Mix the two solutions separately, then slowly add Solution B to Solution A.

12–15 minutes at 70F/21C.

The official formula for Super 20 has never before been published, though several popular authors have (incorrectly) claimed to know it.

bromide formed during development may affect internal negative contrasts in various ways; agitation will be renewing supplies of developer which, mixing in the emulsion with the exhausted developer, will be forming differently composed formulae in various parts of the frame area. In fact *each frame could be thought of as a separate chemical reaction proceeding according to its own internal dynamics*, and the net result can be expected to give some falsification of the subject tonal values. . . .

Much of what Crawley has to say here is in the realm of speculative observation, and as he points out, conventional sensitometry is powerless to prove or disprove these observations. Yet the concept that a fairly dilute developer can, in some cases, adjust itself to each frame in a roll of film, is fascinating. We would add that these effects have been reported by pyro users.

Crawley then goes on to make the following points about PPD and PPD derivative developers:

1. Because of physical development, PPD-developed negatives have a brown tint with higher printing contrast than their visual appearance would suggest (use the blue channel of a color densitometer for accurate readings, as you would do with tanned negatives).

2. To produce normal contrast with modern films, it would be necessary to formulate PPD developers with caustic alkali, but that would encourage dichroic fog and largely eliminate the fine grain effect.

3. When PPD is supplemented with another more active developing agent, that agent becomes almost entirely responsible for density. PPD is thus relegated to a minor role as a subsidiary solvent, along with the sodium sulfite. As a result the fine grain effect is lessened.

4. PPD cannot be used with chlorhydroquinone, as a precipitate invariably forms (this does not apply to derivatives).

After this preface we at last get to the PPD developers Crawley formulated for use with modern films. These developers employ some of the same PPD derivatives used in modern color developers, plus a supplementary agent, either hydro- or chlorhydroquinone. It is claimed that the PPD derivative contributes significantly to image formation. Interestingly, a 30% increase in speed is claimed, and Crawley expressed the belief that these developers probably produced the optimum exploitation of the speed-grain relationship with modern films, the penalty being somewhat decreased sharpness.

FX 9 and FX 10

Crawley experimented with all the PPD derivatives commonly available in 1960, and found that the most useful for black and white films was Genochrome, which is no longer available. In 1998 Crawley told us that Kodak CD-2 would be an acceptable substitute for those who want to experiment with these formulas. FX 9 is said to offer "exceptional retention of detail on overexposure." On the other hand, FX 10 is said to be very sensitive to overexposure or overdevelopment, but also more "reliable in use" presumably because chlorhydroquinone is avoided.

These solutions were meant to be reused without replenishment. For

each roll processed in a liter of solution, extend development time by about 5%. No more than 6 or 7 rolls should be processed per liter. The design of dependable replenishers is very difficult. Crawley never attempted them with his formulas.

	FX 9	FX 10
Sodium sulfite anhydrous	100	100 g
Kodak CD-2	7.5	7.5 g
Chlorhydroquinone	7.5	– g
Hydroquinone	–	6 g
Borax	–	4 g
Boric acid	–	4 g
Water to make 1 liter		

A 30% increase in speed is claimed for both formulas. Crawley believed they produced the optimum exploitation of the speed/grain relationship possible with modern films, the penalty being decreased sharpness.

These two formulas were discontinued in 1971. With convenient development times of only 5 to 11 minutes (much shorter than classical ppd developers), they may be worth looking at again, perhaps diluted 1:3 with tabular grain films.

Modifying FX 9 and FX 10
If the solvent effect of these formulas is found to be too great, and dichroic fog results, the sulfite content can be lowered. Alternatively, the pH can be raised to decrease physical development. In the case of FX 9, a gram or two of sodium carbonate could be added. In the case of FX 10, the boric acid could be reduced, the borax increased, or both. Development times would be shorter.

If a finer grained effect is desired, with an inevitable loss in film speed, the pH can be reduced, and developing times extended, by adding a few grams of bisulfite to FX 9, or by increasing the boric acid in FX 10. However, this would also increase the chance of dichroic fog.

Richard Henn, Microdol, and super-fine grain developers—the modern approach
In the 1940s Richard Henn, at Kodak, developed an elegant approach to the formulation of fine grain developers. He started with the simplest moderate fine grain developer of all, Kodak D-23, which consists of 7.5 grams of metol and 100 grams of sodium sulfite to a liter of water.

To convert D-23 into a developer with grain as fine as PPD developers, but with less inconvenience and better overall quality, he simply reduced D-23's pH by adding sodium bisulfite. The resulting formula was D-25. The lower pH meant lower activity and reduced grain through two mechanisms: less clumping (because of the lower pH) and more solvency (because the film spends more time in the sulfite-rich solution).

To obtain best performance with D-25, adjust the bisulfite level for the particular film you use. If you notice dichroic fog cut back on the bisulfite until you reach a safe level.

This was the discovery Henn published in 1944.[3] He refined his approach in the commercial developer Kodak Microdol and its successor, Microdol-X. Although the formula for this proprietary, super-fine grain developer has never been published by Kodak, it consists of D-23 with the startlingly simple addition of a small amount of common salt. Salt has the ability to decrease graininess without the penalty of increased developing time. This is the homey "secret" behind Microdol and Microdol-X. Though it cannot be officially verified, a close approximation to the Microdol formula is 5 grams Metol, 100 grams sulfite, and 30 grams sodium chloride to a liter of water.[4, 5, 6]

The increased solvent effect of developers with common salt is

proportional to exposure, since salt primarily affects silver that has been exposed. Many other compounds have been studied for obtaining reduced graininess but no one seems to have found a better or simpler way of designing super-fine grain developers than Henn.

In the 1960s, film emulsions became thinner, and more subject to dichroic fog. There was also an increased desire for better sharpness. Microdol was changed to Microdol-X by the addition of a weak anti-silvering agent. An anti-silvering agent works as follows: in developers such as Microdol or D-76, some of the silver dissolved by the sulfite or other solvent is replated onto the developing image. This is known as solution physical development. It tends to decrease sharpness. An anti-silvering agent prevents the solubilized silver from replating back onto the image.

The agent used in Microdol-X is probably a benzophenone, referred to as an "anti-stain" agent (this class of chemical is also used in many sunscreen products). Such anti-silvering agents might be useful if you would like PPD to work with modern films. Still, they are not as effective as mercapto compounds. Polyvinylpyrrolidone is another additive that appears to prevent the undesirable side effects of highly solvent developers (see HC-110 in chapter 6).

A mercapto compound was used as the anti-silvering agent in ID-11 Plus, a modification of D-76 formulated by Peter Krause and introduced by the US branch of Ilford in the 1980s. Apparently its main purpose was to eliminate sludging in automatic processors, but many photographers thought it produced better sharpness. It was quietly taken off the market for reasons that have not been verified to our satisfaction.

Microdol-X at full strength requires an extra stop of exposure, but speed becomes normal when it is diluted 1:3. There are two reasons why *diluting* Microdol-X increases speed.

1. At full-strength the solvent effect is great enough to dissolve away so much of the latent image that some of it is lost altogether. But when the developer is diluted, the solvent effect is not as great.

2. When a metol developer is diluted, highlight development is restrained more than shadow development. This gives the shadows a chance to catch up with the highlights.

Microdol-X may be replenished when used full strength. Negatives have a typical brownish cast in areas of high exposure, indicating a high degree of physical development. However, Microdol-X is more commonly used at the 1:3 dilution. At this dilution it is less solvent, but sharper.[7] Speed becomes normal, although developing times are quite long, and Kodak recommends processing at 75F/24C to keep times manageable.

Microdol-X equivalents

Ilford Perceptol is formulated to be used at the same dilutions and times as Microdol-X. It has some working properties in common with Microdol-X, is marketed as an equivalent, and appears to be chemically close to Microdol.[8]

Finally, D-23 plus 7.5 grams sodium bisulfite has been incorrectly published as being equivalent to Microdol-X.[9]

FX 5

Crawley published FX 5 as a Microdol-X equivalent. Instead of sodium chloride, Crawley uses additional sulfite to obtain a greater fine grain effect. "In FX 5 an attempt has been made to retain the maximum definition that is compatible with true fine grain." Speed loss is one stop compared to D-76.

The future of super-fine grain

FX 5 was the last super-fine grain developer to be formulated based on the D-23/D-25 technology of the 1940s. Crawley does not appear to have thought this line of developers could be exploited further. It might be possible to tweak FX 5 to work better with a given film by making fractional modifications to the proportions. But for those interested in modern super-fine grain developers, we think that experimentation with PPD derivatives would be more rewarding. We suspect they might prove particularly valuable with tabular grain films. Ammonia derivatives are tricky to work with because though highly solvent, they do not necessarily result in finer grain. We also believe that sodium chloride has not been sufficiently researched as a super-fine grain enhancer.

Experiment: Make up FX 2 as directed in Appendix 2. For solution B, use 150 grams of Kodalk per liter of water instead of potassium carbonate. You will not need Solution C. Make a working solution consisting of 75 ml A, 75 ml B, and water to make 1 liter. Add 30 to 60 grams of sodium chloride. This is a possible starting point for a compromise developer with very fine grain *plus* enhanced adjacency effects. The results might be comparable to those obtained with ripened PPD.

Experiment: It is interesting to note that the two commercial super-fine grain developers still available, Microdol-X and Perceptol, do not use Phenidone. Adding 30 grams of sodium chloride to PQ or Phenidone-ascorbate formulations might be a worthwhile avenue to pursue.

Ultimately, the cat that keeps on chasing the super-fine grain mouse is dichroic fog: DK-20 worked well with the films of the 1930s, but produced dichroic fog on the films of the 1940s, hence D-25. D-25 caused dichroic fog on the films of the 1950s, hence Microdol. Microdol caused dichroic fog on the films of the 1960s, hence Microdol-X. Since then, we've had a truce. Things haven't gotten worse, but they haven't gotten better. Super-fine grain myths remain tenancious: some distinguished photographic textbooks written in the 1980s still recommend DK-20, a developer which has not been usable for fifty years. We'll need clear eyes and meticulous testing to bring the practice of super-fine grain development into the 21st century.

FX 5	
Water at 125F/52C	750 ml
Metol	5 g
Sodium sulfite anhydrous	125 g
Borax	3 g
Boric acid	1.5 g
Potassium bromide	0.5 g
Water to make 1 Liter	
Develop undiluted 10-15 minutes	

NOTES

1. Disclosure to Anchell from Falcon Safety Products.

2. Crawley 60/61.

3. R.W. Henn & J.I. Crabtree, "An Elon-Sulfite Developer and an Elon-Sulfite-Bisulfite Fine-Grain Developer", *J.PSA* 10:727 (1944).

4. G.F. van Veelen & W. Peelaers, "Formation of Compact Silver in Metol Developers of Low Activity Containing Sodium Chloride", *Phot. Korr.* 103:107 (1967) .

5. Edgar Hyman, "Microdol", *35mm Photography*, 8 (1):10 (1965).

6. Kodak MSDS for Microdol.

7. This conventional wisdom is contradicted by Richard Henry's meticulous granularity and acutance tests in *Controls in Black and White Photography*. He found no significant difference in granularity or acutance ratings between Microdol-X used either full strength or at 1:3, with Tri-X and Pan-X. We cannot explain his findings. Dickerson and Zawadzki inform us that Henry's numbers run counter to what they have found over decades of research: almost without exception, dilution increases sharpness and speed. On balance, we must conclude there was an artefact in Henry's measurements.

8. Ilford Catalogue 12866, 10/1997.

9. Patrick Dignan, *150 Do-it-Yourself Black and White Photographic Formulas*, 1977, Dignan Photographic, Inc.

Chapter 8

TANNING DEVELOPERS

Pyro and pyrocatechin are mythical developing agents in the jargon of black and white photographers. Possibly because it is the oldest developing agent still in use, possibly because of the recent popularity of PMK, pyro is more widely known and used than pyrocatechin.

There are many reasons for the decline of pyro's popularity, not the least of which are its unreliability, toxicity, and tendency to oxidize rapidly. To a great extent PMK has changed that. It is the first carefully formulated pyro developer for modern films. Arguably, it is the first formula for pyro based on sound scientific research.

Properly formulated tanning developers, based on either pyro or pyrocatechin, produce gradation and sharpness effects no other developers can rival. If you want to get away from the generic look of D–76 or HC-110, try a tanning developer. Tanning also offers a potential chemical mechanism to improve the micro gradation of tabular grain films. Nevertheless, most tanning afficionados prefer conventional films.

Pyrocatechin, also known as catechol and catechin, has never been popular in the US. Yet it is a more reliable developing agent, with many of the strengths claimed for pyro, and without most of the weaknesses. But no important formulas based on pyrocatechin have been introduced in decades.

What is tanning?

Tanning is the hardening of the film's emulsion, rendering it insoluble and difficult to damage.[1] Tanning hardens in proportion to the amount of silver deposited during development. This causes the film to dry at different rates, according to the image density. The result is an adjacency effect unique to tanning developers which increases sharpness.

A secondary effect of tanning developers is staining of the image with a permanent dye that is created by the reaction products. Although staining goes hand-in-hand with tanning, it is a separate phenomenon.

There are two types of staining. One is *proportional* to the density of the silver image. It provides extra density and contrast *without increasing grain*. The second is a *general stain*, unrelated to the image, which has to be printed through as if it were fog. Not all films accept stain to the same degree. T-Max 100, Agfa 100, and Agfa 25 do not stain as heavily as others.[2]

Although many developing agents will stain and tan film, the two most important are pyrogallol (pyro) and pyrocatechin.

Printing with tanning developers

The yellow, yellow-green, or brown stain of a tanned negative has high printing contrast. A properly developed stained negative appears flatter than an unstained negative. According to Gordon Hutchings, the designer of PMK, a correctly developed pyro negative "will appear murky, low in contrast, have translucent highlights and in general, will seem unprintable."[2]

Because the color of the stain blocks blue light, to which enlarging papers are most sensitive, use the blue channel of a color densitometer for accurate readings.

Tanned negatives work with graded paper like ordinary negatives. The dye density blocks light as effectively as silver. But, with variable contrast papers, dye density acts like a color mask that reduces printing contrast proportionally. The effect is greatest in the highlights.

Negatives with a high stain density have a reduced Callier effect. This minimizes (though it does not eliminate) the contrast differences between point source, condenser, and cold light enlarger heads.

Before using a tanning developer

Test before using pyro or pyrocatechin developers with modern films. Unpredictable results can occur especially due to interactions between the developer and the hardening chemicals in the film.

For example, contemporary users of pyrocatechin and pyro sometimes notice a reticulation or mottling effect that cannot be eliminated by omitting the stop bath and substituting a water rinse. The effect is not seen with other low-salt, high-alkali developers such as Rodinal. The effect should disappear if distilled or deionized water is used for both development and in a water bath prior to fixing. If your water is exceptionally hard, use distilled/deionized water even in the fixer. Tap water can be used for washing after fixing.[3]

Sulfite inhibits stain. For maximum stain, keep sulfite in the formula to the practical minimum. Kodak D-7, a pyro-metol formula, uses 14 grams of sulfite in the working solution, and produces no visible stain. Kodak SD-1 uses a mere 1.4 grams and creates substantial stain.

Since desirable stain continues to form after the development process, sulfite should be minimal even in post-processing. The fixer should contain little or no sulfite, and bisulfite stop baths should not be used. Hypo clearing agents, which contain sulfites, should not be used.

The stain effect can also be neutralized by the acids in typical stop baths and fixers. To maximize stain and adjacency effects, use a plain running water rinse for one minute in place of a stop bath, followed by an alkaline fixer low in sulfite (chapter 12).

Unless otherwise specified, pyro should always be mixed and used between 65F/18C and 70F/21C.

Both pyro and pyrocatechin stain skin. They may also be, according to Hutchings, the **most toxic chemicals in the darkroom**. However, he goes on to add that "a few drops of the chemical on the skin during safe processing procedures is no cause for concern."[2] Always wear gloves and a dust mask when mixing the dry powders, and *always* wear gloves when immersing your hands in the liquid solution.

"With conventional developers, it is extremely difficult to render important atmospheric effects such as fog or mist convincingly in a print. Even prints from 8x10 negatives have a flat, slightly granular look. A stained pyro negative, because of the continuous tone effect of the stain, prints fog like a cool liquid– a seamless watercolor effect that baffles the senses, as real fog does."

— GORDON HUTCHINGS

THE BOOK OF PYRO

Pyro

Pyro is one of the most fickle developing agents. It tends to produce low speed, high fog, poor grain, and stained fingers. The working solutions are unstable, and even the stock solutions have to be carefully formulated to obtain any useful life. Nonetheless, the romance of pyro, photography's eldest developing agent, never seems to fade. Hardly a year passes without someone rediscovering an old pyro formula or inventing a new one.

Due to its unique tanning and staining action, pyro can provide acutance and gradation effects that no other developer can, except pyrocatechin. Its ability to separate nearly adjacent tones, particularly in the highlights, is legendary. To counteract speed loss and increase stability, pyro is often combined with metol in modern developers. This combination does not decrease pyro's desirable properties.

Pyro oxidizes quickly in all alkalis. For this reason stock solutions are often designed so the A part containing the pyro is acid. The alkali and sulfite are contained in the B, and sometimes a C, solution. The working solution is mixed immediately before use.

All stock solutions of tanning developers lose some potency immediately after mixing. PMK—perhaps the most stable of all pyro formulas—is claimed to stabilize after a few days and to be reliable after many years of storage. But for formulas like ABC, maximum film speed is achieved when it is freshly mixed.

Note: Virtually all tanning developer formulas are given as stock solutions. It is possible to gain approximately a half stop of speed and eliminate some of the inconsistency problems in old formulas such as ABC by mixing the formulas fresh each time as working solutions. There are two drawbacks to using fresh working solutions each time: (1) your exposure to chemicals is increased; (2) because the quantities are so small, you must use an exceptionally accurate scale (see Appendix II).

Tray development with pyro

The *Book of Pyro* contains not less than 12 pages of detailed suggestions for optimizing tray processing with pyro. This illustrates how difficult it can be to juggle all the demands a staining pyro developer makes in order to achieve even development with maximum image stain while avoiding random aerial oxidation stains which can ruin pyro negatives. It is essential to keep the negatives submerged as much as possible. We use a simple method we have found reliable with all pyro developers including ABC and PMK: to minimize the possibility of aerial staining, develop no more than eight 4x5 negatives in an 8x10-inch tray with one liter or more, of developer. Move the bottom negative only once every fifteen seconds, achieving a full cycle of eight negatives once every two minutes, as recommended in chapter 4 under tray processing. In between, keep the film agitated by gently rocking the tray. This method is contrary to the recommendations given by Hutchings in the *Book of Pyro*. Try both and decide which you prefer. **Always wear protective gloves when tray developing with pyro.**

"After years of printing conventional negatives we grow accustomed, perhaps unconsciously, to what can and cannot be successfully photographed and printed. Pyro will free the photographer to think and see in new ways. Its great sensitivity to minute differences in light values will capture subtle values and details not possible with conventional developers."

—Gordon Hutchings

PMK	
Metol	0.1 g
Sodium sulfite anydrous	0.2 g
Pyrogallol	1 g
Sodium metaborate	6 g
Water to make 1 liter	

See Appendix I for stock solutions and the Developing Time Chart for times.

Tank agitation with pyro

Pyro developers require more agitation in tanks than usual. Hutchings has specific advice which we can do no better than to quote:

> A staining pyro developer has a tendency to streak and mottle negatives.

> Optimum development with pyro requires frequent and vigorous agitation cycles but with reduced agitation repetitions per cycle. The agitation for closed tanks should consist of two complete inversion movements every 15 seconds.... Invert the tank in a different direction each time and do not idly roll the tank around between cycles. The inverting movements should be sudden and vigorous and then static until the next cycle.

> A successful agitation method is to invert the tank with an abrupt twisting motion. This sudden movement momentarily traps the air in the lid of the inverted tank. The trapped air then rushes upwards through the metal reel with an effect similar to a nitrogen burst system.

> Although the cycle time of 15 seconds may seem short, it is important not to allow time for oxidation products to accumulate and begin flowing across the film surface. The cycle time may be altered to suit your needs, but should not exceed 20 seconds.

PMK

Little postwar research had been done on pyro, except in relation to the now antiquated but still unrivaled Technicolor process for cinema film. That changed when Gordon Hutchings introduced his PMK formula, which has created a strong pyro revival.[2] His *Book of Pyro* is essential reading for anyone interested in working with pyro.

PMK is the best pyro developer for modern films. Its designer is the only person to have reviewed nearly the entire published (and unpublished) literature before undertaking the task of devising an ideal pyro developer for modern films. Few modern film developers have been studied so meticulously and for so many years by their formulators as PMK. (Hutchings waited 11 years before publishing the formula).

In formulating PMK Hutchings had four main goals: batch-to-batch reliability, full emulsion speed, maximum image stain, and minimum general stain. PMK meets these goals without compromising the unique look for which pyro negatives have been prized for more than a century.

The PMK formula has several interesting qualities:

■ No restrainer. Virtually all previous pyro developers contain a restrainer to reduce fog. This is a bad idea, since most restrainers, especially benzotriazole, tend to impair sharpness.

■ Lower pH. Virtually all previous pyro developers relied on carbonate to produce a high pH and a rapid development time. This sometimes caused fog and, according to Hutchings, general stain rather than image-specific stain. PMK uses sodium metaborate (Kodalk) for a pH approximately one unit less than earlier pyro developers. The results are

reduced fog and graininess, enhanced stability, and enhanced image-specific stain.

■ The amount of developing agent is correct to maximize image-specific stain, minimize general stain, maintain the film's inherent granularity, and enhance sharpness through controlled exhaustion/adjacency effects. (PMK has approximately the same total weight of developing agent as FX 2—see chapter 6).

Using PMK

The stock solutions for PMK are given in Appendix 1. The standard dilution is 1 part A, 2 parts B, 100 parts water. Though many photographers regard this (or any other) dilution as written in stone, it is not, and Hutchings advises altering the dilutions as necessary to meet special circumstances. The recommended starting points for developing times are shown in the Developing Time Chart at the end of this book. PMK should be used immediately after mixing the working solution. Right after mixing, the solution should change color from grey green to pale amber. If this does not happen, the solutions may not have been correctly mixed, or may have become contaminated.

Temperature

Hutchings has given much study to temperature differences. His standard times are for 70F/21C. He states that with PMK, development time should be decreased by about 4% for each degree the temperature is raised. He goes so far as to recommend processing at 80°F, stating that because the film is in the developer for less time, there is less grain aggregation. As a starting point for 80°F, he advises developing for 70% of the time that he recommends at 70°F. Hutchings regards 85°F as a safe maximum cutoff point. We are not entirely convinced by this line of reasoning, and will always be more comfortable with a normal developing temperature, but would point out that because of pyro's tanning action, it is safe to process films at somewhat higher temperatures than usual. We would suggest that increasing the temperature of pyro developers increases the rate of oxidation and the chance for aerial staining to occur.

PMK and Jobo processors

Jobo processors have two problems when it comes to PMK: (a) the revolution rate is too high; and (b) the motor is too weak to rotate when the drum is filled to capacity with developer, as it should be with PMK. The result with a partially-filled drum is excessive oxidation of the developer, which can "bomb out" prematurely. There are three simple techniques for dealing with these deficiencies: (1) start with half the total volume of the tank, and after half the developing time has elapsed, empty the drum and replace with a fresh quantity of PMK working solution; (2) add 0.3 g/L of sodium sulfite (about a pinch) to each liter of PMK working solution; or, simplest of all, (3) use 30% more of stock solution A when making up the working solution. The first technique has become quite popular but is unnecessarily cumbersome. We recommend the third technique.

Pyro post processing

Directly after fixing, Hutchings advises a two-minute alkaline after bath to induce stain formation. This after bath can consist either of the used developer (which can be used for this purpose, but not to develop further films), or a 2% solution of sodium metaborate. Agitate every 30 seconds. We suspect this after bath is not necessary when the pyro negatives are fixed in an alkaline fixer, unless the wash water is acid.

The negatives are now ready to be washed. Hutchings advises a full 20-30 minute wash, to intensify the pyro stain still further. To conserve water, use the method recommended in chapter 12.

Hutchings gives instructions on rinsing after washing which some photographers may find overfussy. His justification is simple: "I hate spotting."

If the processing water (including the wash water) is unfiltered, films should receive a final rinse in distilled or deionized water before drying. Discard the rinse bath after use. Adding 4 ml of Kodak Photo-Flo per gallon helps drain the water off the film when it is hung up to dry.

For sheet film, pour the water rinse into a tray and insert only one sheet at a time. Swish your fingers lightly over the surface of the film. This is an effective method for dislodging minute particles adhering to the film surface. These particles are often too small to be readily seen in the negative, but they will dramatically appear in the enlarged print.

After rinsing, quickly slide the film sideways up and out of the water. This should be accomplished with a smooth sliding movement. This is the most effective method for removing the rinse water from the film surface. Hang the film up by one corner in a dust-free space to dry.

Unfiltered water should not be used for film processing. Smaller negatives are capable of producing excellent enlarged prints when processing has been optimum. However, unfiltered water is responsible for many difficulties with these negatives.

Classic pyro developers

Although we think of PMK as being the first pyro developer for modern films, that honor, as Hutchings points out in his book, belongs to John Wimberly's WD2D formula, which created quite a stir when it was published in 1977 (Appendix I). There are also several older pyro developers worth examining. Each imparts its own unique "look" to negatives. Although they do not have the reliability and high image-specific stain/low general stain characteristics of PMK, they have stood the test of time. The main feature of the pre-PMK pyro developers is the use of carbonate rather than metaborate.

Kodak D-1 (ABC Pyro)

The classic pyro formula, Kodak D-1, which goes back to the 19th

ABC PYRO WORKING SOLUTIONS

	1:1:1:7	1:1:1:11	1:1:1:14
Water at room temperature	750	750	750 ml
Sodium sulfite anhydrous	11.5	8.2	6.6 g
Pyro	6	4.3	3.5 g
Potassium bromide, 10%	10	7	6 g
Sodium carbonate monohydrate	9.0	6.5	5.2 g
Water to make 1 liter			

See Appendix I for stock solutions and the Edward Weston variation.

century, is certainly the oldest published developer formula still being used. It is known as "ABC" because it has three stock solutions. There are several minor ABC variations (Ansco 45 and Defender 1-D), and different opinions as to the best ratio of the three solutions.

ABC still works well with modern films though, in a break with tradition, we recommend using the 1:1:1:11 dilution for tray development with times between 6 to 10 minutes at 68F/20C, and the 1:1:1:14 dilution for tank development with times between 8 to 12 minutes at 68F/20C.

Kodak SD-1

In the 1930s Kodak designed SD-1 to provide maximum image-specific stain while minimizing general stain with the films of the day. Like PMK, SD-1 does not use a restrainer. The formula is published as a working solution. Post process as for PMK. According to Hutchings, this developer as published has low energy, resulting in a low EI, and a very flat characteristic curve (which might be useful for very long scale subjects). For modern films we suggest diluting 1:3 but doubling the carbonate—which brings SD-1 closer to Bürki's formula, below.

Bürki's pyro developer

This developer was first published in the 1950 *American Annual of Photography*. It appears to be the first formula, before the introduction of FX 1 in 1960, to have specified less than 1 g/L of total developing agent.

Since the amounts of sulfite and pyro are so low, a very large amount of carbonate is required. The lack of restrainer is notable in a pyro developer of this vintage. It produces a high degree of stain, high sharpness, and moderate speed. We suggest adding 0.1 g/L of metol to help stabilize this formula, and halving the carbonate for thin emulsion films. Of all the pre-PMK formulas, this is the one most likely to work well with modern films. Post process as for PMK. It is essential not to use an acid stop bath with a developer that contains so much carbonate.

KODAK SD-1

Water (68F/20C)	750 ml
Sodium sulfite anhydrous	1.4 g
Pyrogallol	2.8 g
Sodium carbonate monohydrate	6.2 g
Water to make 1 liter	
Develop 5 to 10 minutes at 68F/20C	

BÜRKI'S PYRO DEVELOPER

Pyrogallol	0.75 g
Sodium sulfite anhydrous	0.75 g
Sodium carbonate monohydrate	24 g
Water to make 1 liter	
Develop 6 to 7 minutes at 68F/20C.	

PYROCATECHIN (CATECHOL)

Pyrocatechin (also called catechol, pyrocatechol and catechin) stains and tans as well as pyro. It is generally considered to be more stable and

reliable. It has been used in a few commercial developers such as Neofin Blue and even, for a brief period, in HC-110. As a developing agent pyrocatechin has been more widely used in Germany than the US.

Unfortunately, no one has yet done the research necessary to find a pyrocatechin developer that rivals PMK with modern films. This does not mean one could not be formulated.

The Windisch developer

This formula is listed in some BJ Annuals as a high acutance developer with the baffling title "Windisch Pyrocatechin Developer (USA)", although Windisch was a German who first published the formula in German.

The current reputation of pyrocatechin in the US is almost entirely based on the famous compensating formula published by Hans Windisch in the 1930s. This developer was championed by Ansel Adams in various editions of *The Negative*,[4] but was never printed even approximately correctly in this book until the last printing of the last edition.

The Windisch developer has been claimed over the years to have an extraordinary compensating action, suitable for

WINDISCH COMPENSATING DEVELOPER

	DIL. A	DIL. B
Sodium sulfite anhydrous	0.3	0.5 g
Pyrocatechin	2	3.2 g
Sodium hydroxide, 10% solution	15	10 ml
Water to make 1 liter		

Develop 12–15 minutes at 68F/20C

Windisch published two dilutions for this developer. We prefer dilution A; Ansel Adams preferred dilution B. See Appendix I for the stock solutions.

photography of very wide range subjects, such as a bare bulb filament. It is worth noting that, despite these claims, this developer has never been taken seriously in the technical literature, and is not mentioned in Levy's[5] or Shepp and Kammerer's[6] surveys of low contrast developers.

There are several reasons for this. First of all, pyrocatechin, closely related to hydroquinone, is known to be a high contrast developer. Second, it is a tanning developer—the density-increasing stain increases contrast further. Therefore, on the face of it, pyrocatechin is a high contrast developer, and has been specified for this purpose in formularies by Agfa, a company which knows a thing or two about developers.

On the other hand, it appears that, with the correct formulation, even a high contrast developing agent can be made to perform as an effective low contrast developer (chapter 3).

We believe that the Windisch developer is too alkaline for modern films, tending to create unnecessary fog; we also suspect that a high degree of fogging may be responsible for its reputation as a low contrast developer to begin with. Maxim Muir has recently published a variant which uses carbonate instead of hydroxide, which drastically changes the working properties of this developer (Appendix I). We have long believed that carbonate is the most rational alkali to use with pyrocatechin and modern films. A developer formula should not have to depend on fog to create low contrast.

Ideal post-processing for pyrocatechin is the same as for pyro: a one minute running water stop, followed by an alkaline fixer.

The Photographers Formulary Modified Windisch formula reverses the proportions of sulfite and pyrocatechin in dilution A. It produces a low contrast, high definition developer with very heavy stain and some fog. Negatives look very dense, but are printable without excessive grain. **Caution: read Appendix III before using sodium hydroxide.**

TD experimental pyrocatechin formulas

The experimental formulas below, which are disclosed for non-commercial use only, may be useful starting points for those who wish to find an ideal modern pyrocatechin developing formula. According to traditional research, pyrocatechin, like pyrogallol, should not be used with borate alkalis, a finding which may need reinvestigation. It is believed to be subadditive with metol, and is seldom used in combination with any other agent.

TD-101 is a normal to low contrast high definition developer. TD-102 produces high contrast without excessive grain because much of the highlight density comes from stain, not silver density. TD-103 is designed for very low contrast and can be used with document films.

Reducing the sulfite in any of these formulas to a half or even a quarter of the amounts specified will increase the tanning and sharpness, but may also decrease speed.

All of these formulas have the grain structure typical of carbonate high definition developers. This could be moderated by adding one gram of sodium bicarbonate for every two grams of sodium carbonate. However, the lower alkalinity will result in much longer development times and may necessitate adding more pyrocatechin to compensate.

These experimental formulas can easily be made up into stock solutions. To make stock solution A, simply multiply the amounts of sodium sulfite and pyrocatechin by 10 and add to one liter of water. Working solution will be 100 ml to a liter of water. To make stock solution B, make up a 10% sodium carbonate solution: 100 grams of sodium carbonate to a liter of water. Use 10 ml for every gram of sodium carbonate you want in the working solution. For instance, to get 14 grams of sodium carbonate per liter of working solution, use 140 ml. These stock solutions should keep for at least six months but, as with all stock solutions, should be used as quickly as possible. The keeping qualities of the stock solutions can be improved by using sodium bisulfite instead of sodium sulfite. This will create a small amount of bicarbonate buffer when the two stock solutions are combined to make the working solution.

As with all developers containing pyrogallol or pyrocatechin, use distilled or deionized water for the stock and working solutions to avoid mottling. Post process as for pyro developers.

TD EXPERIMENTAL PYROCATECHIN FORMULAS

	TD-101	TD-102	TD-103
Sodium sulfite anhydrous	4	1	1
Pyrocatechin	0.5	2	0.25
Sodium carbonate anhydrous	14	10	15–20
Distilled water to make 1 liter. All weights in grams.			
Develop for 10–15 minutes at 68F/28C			

NOTES

1. L.F.A. Mason, *Photographic Processing Chemistry*, Focal Press, Boston & London, 1974.

2. Hutchings. Our thanks to the author for permission to quote from *The Book of Pyro*.

3. Grant Haist has speculated both to BT and Gordon Hutchings that the relatively open molecular structure of both pyro and pyrocatechin allows these chemicals to react readily with water impurities—much more than other common developing agents do. This theory is supported by the observations of BT and Hutchings that the use of distilled or deionized water with either pyro or pyrocatechin seems to eliminate the problem.

4. Adams, *The Negative*.

5. Marilyn Levy, "Wide Latitude Photography", *Phot. Sci. and Eng.*, 11: 46 (1967).

6. A. Shepp and W. Kammerer, "Increased Detectivity by Low Gamma Processing", *Phot. Sci. and Eng.*, 14: 363 (1970).

Chapter 9

SPECIAL DEVELOPERS

This chapter covers several developer types that do not readily fit into our other categories: two-bath, water bath, high and low contrast, and ascorbic acid developers.

TWO-BATH DEVELOPERS

Two-bath developers give excellent results with almost all films at a fixed time and temperature. It is almost impossible to overdevelop with two-baths, and it takes an effort to underdevelop. They are ideal for photographers who want quality negatives but are not interested in obsessing about developers.

Although Zone-style control is not possible with two-baths, this is not a real limitation with thin emulsion films.

In two-bath developers the A bath contains the developing agent *with no alkali,* so that minimal development takes place. The film is immersed in this solution only to absorb the developing agent.

The B bath contains the alkali activator. In the B bath the developer is quickly exhausted in the highlights, making overdevelopment difficult. This also improves shadow contrast and increases definition. Agitation may be continuous without impairing image quality, ensuring even development with no streaking, mottling, or air bubbles. Two-baths are thus a tenable choice for JOBO rotary processors. However, as noted in chapter 4, it is exceedingly important to break up the directional flow during agitation, particularly during continuous agitation.

Two-baths can be used for virtually all films except document films. Since time is fixed, development is automatic, resulting in:

- normal emulsion speed, or slightly higher
- good acutance with moderately fine grain
- long scale gradation, with some highlight compensation, allowing high contrast scenes to be photographed without special adjustments
- good economy

Storage and capacity of two-baths

The stock solutions of most two-baths will keep for 6 months in tightly sealed bottles. Solution A can be used for up to 20 films. The inexpensive, replaceable Solution B should only be used for 10 rolls of film. After 10 rolls, discard and make a fresh solution. Unlike re-used or replenished single bath developers, there is almost no compromise in quality when the two-bath is reused.

Low contrast scenes

Although two-bath developers are not ideal for very low contrast scenes, moderately low contrast scenes can be printed on a high grade of paper. In any case, extended development, which was routine in the early days of the Zone System, fails with modern films. Today, expansion (i.e. high contrast) is best obtained by using a special high contrast developer (see below).

D-23 two-bath developers

Many two-bath developers use a Solution A similar to D-23, along with a plain alkaline Solution B. A potential problem with plain alkali B baths is that they contain no preservative to prevent staining or streaking, and no salt to prevent film swelling, which should be avoided whenever possible. Adding 50 g/L of sulfite will solve both problems. However, if you want to use less sulfite to improve acutance, add only 5 to 10 g/L of sulfite plus 40 g/L of sodium sul*fate* to decrease swelling.

The table below lists some of the D-23-type two-baths, and our own versions, TD-200, and TD-201, which is particularly recommended for tabular films.

Note: In the Dalzell modification of the Stoeckler developer, sulfite has been reduced to 75 grams to increase sharpness. In this developer do not add additional sulfite to the second bath.

Experiment: To increase the fine grain effect of the two-baths below, add about 30 g/L of sodium chloride (common salt, but use a laboratory grade) to either the A or B solution—or both. The result would be something like a two-bath version of Microdol, which would eliminate the need for sodium sulfate in the second bath. The two-bath formulation and relatively short developing time might solve some of the problems encountered with Microdol-X over the years.

Directions for all two-baths

Do not presoak. Temperature may be between 65F/18C to 75F/24C.
1. Pour Solution A into the tank.
2. Agitate continuously for 3 minutes.
3. Pour Solution A back into its storage container.
Note: Do not rinse between solution A and B. This would wash out the

D-23 TWO-BATHS:	STOECKLER	DALZELL	ADAMS	LEITZ	TD-200	TD-201
Solution A (quantities in grams)						
Metol	5	5	5	5	3	5
Sodium sulfite anhydrous	100	75	100	100	100	100
Water to make 1 liter						
Solution B						
Borax	10	10	–	–	–	2
Sodium metaborate	–	–	10	–	–	5
Sodium carbonate anhydrous	–	–	–	15	10	–
Sodium bicarbonate	–	–	–	–	3	–
Sodium sulfite anhydrous	–	–	–	–	6	6
Sodium sulfate	–	–	–	–	40	40
Water to make 1 liter						

developing agent.

5. Pour Solution B into the tank.

6. Agitate continuously for 3 minutes.

8. Pour Solution B back into its storage container.

9. Stop or rinse, fix, and wash the film.[1]

Divided D-76

The problems of swelling and preservation in the second bath were recognized as early as 1933 by Russell in his two SD developers (below). A modern developer where this problem was solved (quite by accident) is David Vestal's version of divided D-76. He could not remember whether the sulfite should go in the A or the B bath, so he split it evenly between them.

Many other two-bath versions of D-76 have been published, but we think Vestal's is the best. We suggest omitting the hydroquinone, boosting the metol to 3 grams and the borax to 5 grams. Directions are the same for other two-baths except that Vestal recommends 5 minutes in each bath instead of the usual 3, for most films.

A popular variant by R.J. Starks is usually called Farber's split D-76 after the writer who made it popular. The reason we prefer Vestal's formula is that the alkali in Farber's formula is too high, requiring the addition of bromide to solution A. The point of D-76 is that it has been carefully balanced so as not to require bromide. This formula could be improved by halving the amount of borax and omitting the bromide. An article on this developer by Neil Lipson was published in *Darkroom and Creative Camera Techniques*, Nov/Dec 1988.

Kodak SD-4 and SD-5

H.D. Russell introduced two excellent formulas in the 1930s that never received the attention they deserved, Kodak SD-4 and SD-5. The sugar in these formulas was added to suppress development in the A Bath.

Two modern variations, TD-144 and 145, are an attempt to provide subtle improvements in image quality. TD-145 produces slightly higher sharpness, with slightly coarser grain than TD-144. However, the practical differences between the two developers are small.

VESTAL'S DIVIDED D-76

Solution A

Metol	2 g
Sodium sulfite anhydrous	50 g
Hydroquinone	5 g
Water to make 1 liter	

Solution B

Borax	2 g
Sodium sulfite anhydrous	50 g
Water to make 1 liter	

FARBER'S SPLIT D-76

Solution A

Metol	2 g
Sodium sulfite anhydrous	100 g
Hydroquinone	5 g
Potassium bromide	1 g
Water to make 1 liter	

Solution B

Borax	60 g
Water to make 1 liter	

Develop 3 minutes in Bath A followed by 2-4 minutes in bath B.

	SD-5	TD-145	SD-4	TD-144
Solution A (quantities in grams)				
Metol	7	5	5	5
Sodium sulfite	10	10	100	100
Hydroquinone	–	–	2	–
Sodium bisulfite	2	6	5	5
Granulated sugar	100	100	100	100
Solution B				
Sodium carbonate	10	14	14	10.0
Sodium sulfite	25	100	100	10
Sodium sulfate	–	–	–	40
Potassium. iodide	–	0.01	0.01	0.01
Potassium bromide	–	–	0.5	–
Water to make 1 liter	–	–	–	–

Water bath developers

Water bath development is a cousin to two-bath development. Generally, film is immersed in the developer for two or three minutes, then in plain water and left motionless for two or three minutes. These steps are usually repeated several times. Ansel Adams used a water bath for his famous 1936 picture *Moonrise Over Hernandez*, but later repudiated the technique for contemporary films because it causes streaking.[1]

Nevertheless, it is possible that the streaking problem could be cured, just as it was for two-bath developers, by using a 3% sodium sulfite solution instead of plain water for the "water" bath. There will be somewhat less compensation as a result, but this is of minor importance, considering that streaking ruins the negatives completely. It is important to transfer the film between the developer and water solutions as quickly as possible to avoid aerial fog. A glycin developer might work well for this process, perhaps double-strength FX 2.

Although we have suggested a way to make water bath development work with modern films, we agree, on balance, with Adams, that it is no longer a viable technique.

As a final note, we recommend a running water bath for 1 minute in place of an acid stop bath. This is in effect a very mild form of water bath development. It does not cause streaking, because the time in the water bath is short, and because the developer/water bath cycle is not repeated.

LOW AND HIGH CONTRAST DEVELOPERS

Low and high contrast development was a cornerstone of photographic technique from the 1930s to the 1960s. It was particularly important to Zone System photographers who often recorded high contrast landscape scenes. But with today's films, low and high contrast development is hard to achieve, and Zone System photographers now rely more on multiple grades of paper than they did in the past.

Until the late 1970s, most quality photographic papers only came in two or three grades, and variable contrast papers were not highly thought of by experienced printers (with the sole exception of DuPont Varigam, which was discontinued in the early 1970s.)

Low and high contrast development lives on in the maxim "Expose for the shadows, develop for the highlights." This does not work as well as it used to, because with modern films, you cannot change the way highlights develop without changing the way shadows develop.

Depending on how flexible both the film and the developer are, you can usually change contrast by at least a "zone" (one stop) in either direction, by changing development time. Diluting the developer with more water for lower contrast, or with less water for higher contrast, is also effective. While changing development time will change contrast, it will also change speed.

What constitutes a low or high contrast developer?

The first component to consider is the developing agent. All developers oxidize (exhaust or decompose) as they are used. As they do, reaction (oxidation) products are formed. These oxidation products are not

neutral in effect. They can either accelerate or decelerate development. This has a marked effect on contrast, because the effect is *not* just one of faster or slower development.

Oxidation products are formed most in areas where there is much exposed silver—the highlights, and less in areas where there is little exposed silver—the shadows. If the oxidation products *accelerate* development, contrast will be *increased,* because the rate of development in the highlight areas will be increased, while the rate of development in the shadows remains normal. But if the oxidation products *decelerate* development, contrast will be *decreased,* because the rate of development in the highlights is decreased, while development in the shadows again remains normal.

The oxidation products of metol, Phenidone, and the PPD family decelerate the rate of development. The oxidation products of most other developers accelerate the rate of development. The situation can get complicated when you combine developing agents.

Formulating low contrast developers

The first thing to do when formulating a low contrast developer is to select one of the agents whose reaction products decelerate development. The next is to formulate the developer so that a controlled amount of oxidation takes place during development. There are three ways of doing this:
- lowering the concentration of the developing agent
- lowering the concentration of the preservative
- a combination of both approaches

To achieve a dramatic effect, use a specially formulated low contrast developer. A good starting point for those interested in experimenting with low contrast developers would be our modification of T/O XDR-4 in chapter 11.

Agitation technique for low contrast developers is critical. Agitate little, so exhaustion products around the highlights will have a chance to accumulate. We recommend ten seconds every two or three minutes, after continuously agitating for the first minute (chapter 4). Ideally, developing time should be at least 12 minutes. Minimal agitation is not appropriate for development times under 8 minutes.

Formulating high contrast developers

Formulating high contrast developers is similar to formulating low contrast developers, except that you choose a developing agent where the reaction products accelerate development. An ideal developer would be hydroquinone in a low sulfite formulation. Such developers are used in many industrial applications for high contrast images. However, in a full tonal scale photograph, there are other variables to maintain: sharpness, fine grain, and speed.

One of the best tricks for increasing contrast through development is to use a carefully formulated, fog-free staining developer. Staining should be proportional to density: The greater the density, the more the stain. Such developers often increase contrast dramatically, without increasing silver density or apparent graininess. A suitable agent is

pyrocatechin. The TD-102 formula in Chapter 8 is a good starting point.

With modern films, developers such as full strength DK-50 or D-61a produce fairly high contrast by the time development has gone on long enough to reach normal film speed. Even D-72 or Dektol could be used for extreme expansion. But the problems with all these suggestions include low speed, low acutance, and coarse grain.

Ascorbic acid

Photographic research on L-ascorbic acid (vitamin C) has been ongoing since 1935 when Mauer and Zapf identified it as a developing agent. Since that time, numerous articles have appeared in photographic publications and ascorbic acid formulas have been used in the motion picture industry. Research heated up in the 1990s, and dozens of patents have recently been granted for ascorbic acid developers.[2] With the introduction of Kodak XTOL in 1996, still photographers became universally aware of ascorbic acid's potential as a low toxicity developing agent.

Ascorbic acid and its derivatives appear to be useful replacements for hydroquinone in developers where hydroquinone is used as the secondary agent, usually in combination with metol or Phenidone. However, our concept of what usually constitutes a primary and what a secondary agent in a formula may be in need of refining. Silvia Zawadzki, the formulator of XTOL, believes that the ascorbic acid derivative in that developer is, in fact, the primary agent. Most valuable is Zawadzki's observation that the ascorbate can provide a half stop speed increase over hydroquinone in similar formulations.

Ascorbic acid has been characterized as both a weak and a strong developing agent. It has been said to have a tendency to high contrast, and to require high alkalinity to be active on its own. Moderate alkalinity is apparently sufficient when it is used as a secondary agent. It is superadditive with Phenidone and metol, and is currently being used as a more environmentally friendly replacement for hydroquinone in some new formulas. However, some developers, for example Ilford Ilfosol-S, use sodium ascorbate in addition to hydroquinone. There is no environmental or health benefit with this approach: ascorbates are simply being used to enhance the photographic properties of conventional chemicals.

It has been thought that, because ascorbic acid is an antioxidant, it could partially replace sulfite as a preservative. As a practical matter, this does not seem to be the case. Even formulations with large amounts of sulfite are difficult to preserve.

Based on present information, ascorbic acid cannot be used as the sole developing agent unless fairly high contrast (approximating D-72) is desired. Bearing this out, the only developer we know of which claims to use ascorbic acid derivatives as the sole developing agent is Agfa Neutol Plus, a print developer.

Probably the best source for information on ascorbic acid is the full text of US Patent 5,756,271 (1998) (see Sources for how to get copies). This patent thoroughly discloses the technology behind Kodak's new XTOL developer, discussed in more detail in chapter 5.

Kodak D-96A is an ascorbic acid formula widely used in the movie

industry. Though Kodak has never promoted it for still photography, it should work equally well with all black and white films. Times should be shorter than for D-76. (To use borax decahydrate in this formula, substitute 5 grams for the 3.8 grams of pentahydrate.)

Many formulas which include ascorbic acid or a derivative have been published. Paul Lewis's Mytol is a formula similar to XTOL (chapter 5) but uses readily available chemicals.[3] It is recommended full strength or 1:2.

Ascorbic acid in the future

Progress in photographic chemistry has always been slow: it has taken chemists 50 years to begin to become comfortable with Phenidone and its derivatives. Knowledge and use of ascorbates is still in its infancy. Unfortunately, this coincides with a time when not only is developer research on hold but major photography companies are actually destroying earlier research. Yet there is a need for more research. Certainly not from the photographic point of view: we have enough to play with there. But from the point of view of human and environmental health, we need better and safer chemicals.

Photographic chemicals, when handled with reasonable precautions, do not, in the view of some manufacturers (such as the Paterson Group), appear to pose a material health hazard greater than many common household cleaning solutions or cosmetic products such as hair dyes. Yet there is a continual desire by educators, who wish, for example, to teach black and white processing to children, for chemistry that is entirely safe. This desire is complicated by our imperfect and constantly evolving knowledge of toxicity. Phenidone and its derivatives are an example: it was thought, until recently, that the oral toxicity of the Phenidones was very low. Recently, however, animal data suggest that Phenidone may be more dangerous than hitherto supposed—when ingested. It is not yet known whether these data are applicable to humans. Even vitamin C is coming into question. Dr. Linus Pauling's well-publicized avocacy of massive dosages of vitamin C on a daily basis may not be as safe as has been supposed for two decades (see Appendix III). Nevertheless, ascorbates are the safest developing agents both for humans and the environment yet discovered.

KODAK D-96A

Distilled water	750 ml
Calgon	1 g
Sodium bromide	0.35 g
Sodium sulfite anhydrous	15 g
L-Ascorbic acid	2 g
Metol	1.5 g
Borax pentahydrate	3.8 g
Sodium sulfite	60 g
Water to make 1 liter	

MYTOL

Distilled water (80F/27C)	750 ml
Sodium sulfite anhydrous	60 g
Sodium metaborate (Kodalk)	4 g
Sodium ascorbate	12 g
Phenidone	0.15 g
Sodium metabisulfite	3 g
Water to make 1 liter	
At 1:2; 8–13 minutes at 68F/20C	

NOTES

1. Adams, *The Negative*. Adams includes two additional techniques for obtaining yet more compensation from two-bath developers which interested readers can consult, but we are reluctant to recommend them.

2. The best sources for information on ascorbic acid are US patents—the full text, not the abstracts (see Sources). A fundamental patent is 2,688,549. Other important patents include:
5,766,830 (1998), 5,766,832 (1998), 5,756,271 (1998), 5,702,875 (1997), 5,648,205 (1997), 5,578,433 (1996), 5,503,965 (1996), 5,503,966 (1996), 5,384,233 (1995), 5,278,035 (1994), 5,264,323 (1993), 5,236,816 (1993), 5,217,842 (1993), 5,196,298 (1993), 5,098,819 (1992), 4,038,080 (1977), 3,942,985 (1976), 3,938,997 (1976), 3,658,527 (1972), 3,649,280 (1972).

3. Paul Lewis, "Don't Forget Your Vitamin C," Maxim Monochrome, Volume II, No. 2, March/April 1997.

Chapter 10

INCREASING FILM SPEED

True speed increase versus pushing

A film's speed rating indicates its ability to record shadow detail. A *true speed increase* therefore means that the film can record shadows with less exposure. It is almost impossible to achieve more than a one stop true speed increase over a manufacturer's ISO rating, in spite of claims by countless products. The simple reason is that film manufacturers use every technique possible to increase the speed of modern films. There is not much more that can be done! There are, however, three effective methods for increasing speed with modern films:

- hypersensitization before exposure
- latensification after exposure
- special developer techniques or additives

Pushing film means underexposing and overdeveloping. Overdevelopment produces greater density in the midtones and highlights, but little increase in the grossly underexposed shadows. The result of pushing film is:

- a maximum 2/3 stop increase in shadow density
- a 1 to 4 stop increase in midtone and highlight density
- vastly increased grain and contrast

There are two reasons to push film: (1) hand held practicalities and (2) aesthetics. Pushing lets you make tenable exposures in low light situations. For example, if your meter reads f/2.8 at 1/8 of a second for a normal exposure, you may have to underexpose by two stops to make a hand held exposure at f/2.8 at 1/30 of a second.

Overdeveloping results in printable midtones. Highlight detail will be blocked but can be brought out through printing techniques. The increased grain and contrast of overdeveloped negatives can result in prints with high graphic impact, an effect that makes pushing a viable aesthetic choice.

Pushing was disastrous with the first tabular grain films, which simply blocked up completely with overdevelopment. The latest films from Kodak and Ilford seem more flexible. Moderate overdevelopment *in a dilute developer* (XTOL 1:3 or FX 37 1:5) seems to work well.

Films for pushing

Until the advent of P3200, the fastest *high quality* film which could be successfully pushed was Tri-X. No version of Agfa 400 or HP5 has ever

responded as well to pushing techniques. This does not mean they cannot be pushed. It just means they cannot be pushed as far. Available light photographers push Tri-X in undiluted D-76 up to EI 3200 with varying degrees of success. While T-Max P3200 has reduced the *need* for pushing, it cannot replace the unique appearance of prints from pushed Tri-X negatives.

Developers for push processing

There are many phenidone-based developers which increase speed by 60%, including XTOL, T-Max, FX 15, FX 37, FG7, Acufine, and Microphen. Traditionally, careful researchers have found that this speed increase is *only* evident when negatives are developed to normal contrast. Paradoxically, these developers do not *push* underexposed film as effectively as undiluted MQ-based D-76, which is considered by most to be the best developer for pushing. However, as of the late 1990s, the picture has begun to change. Geoffrey Crawley in England and Silvia Zawadzki in the US have both come to the same conclusion: with modern films, especially tabular grain films, best pushability comes from newly formulated developers such as XTOL (chapter 5) or FX 37 (chapter 6) when used at greater than normal dilutions.

When push processing, an old rule is to extend development by 40%-50% over normal for a one stop increase; for a two stop speed increase, extend development by 100%. (We think 25% and 50%, respectively, are better guides.) Using the new recommendations, the general guide is: dilute the developer with twice the amount of water you would use for normal development, then increase time by 50-100% for a two-stop push. For instance, if "normal" is undiluted, dilute 1:1 or more for pushing. If "normal" for that developer is 1:3, dilute 1:5 or 1:6 for pushing. As always when diluting, use more solution for each roll of film (chapter 4).

Hypersensitization and latensification

Photographers and scientists have long sought techniques to increase film sensitivity before development. There are two major categories:

Hypersensitization. The film is treated *before* exposure to increase its sensitivity.

Latensification The film is treated *after* exposure but before development. The aim here is not to increase the film's *sensitivity*, but to increase the *developability* of the least exposed grains, which would not develop with normal processing.

These techniques were more popular prior to the 1960s, when films were slower. However, they are still useful for "available darkness" photography. Their main advantage over push processing is that they produce image quality which closely approaches the results of normal processing.

Note: Hypersensitization and latensification work best with slower films. Results are often negligible with inherently fast films, which are treated by the manufacturer to obtain every nuance of speed. These techniques also exhibit the greatest effect with long exposures (more than one second).

Increasing speed *before* exposure: hypersensitization

The traditional methods for hypersensitization do not appear to work well with modern films.[1] The one successful method employed today is hydrogen gas hypersensitzation, often called "gas-hypering" or just "hypering", first published by Everhart in 1981.[2]

Gas-hypering has been dramatically successful with Kodak 2415 (Tech Pan) and other contemporary monochrome and color films. Before exposure, the film is soaked in a forming gas mixture of 92% nitrogen and 8% hydrogen for several hours. The hypersensitization effect can last for years if the film is properly stored (earlier hypersensitization techniques only worked for a few hours). Astronomers, working with exposures which may run into the hours, report reliable and dramatic speed increases as well as reduced reciprocity failure with long exposures. For example, with gas-hypered film a night sky photograph that would formerly take four hours can now be made in 30 minutes or less. With conventional exposures, shorter than one second, the maximum speed increase you can expect is one stop which, while of benefit, is not as significant.

There is at least one vendor which currently sells hypered film and does custom hypering. It also provides information and materials for do-it-yourself hypering.[3]

Increasing speed *after* exposure: latensification[4]

The best method of latensification requires no chemistry, just a darkroom safelight. The safelight should have a broad area of coverage. A 7.5 or 10 watt bulb with a dark green No. 3 safelight filter is required.

After exposure, the film is taken to the darkroom, unwound, and taped to a wall ten feet away from the safelight. The film emulsion should face the safelight. The film is exposed to the safelight for between 15 and 40 minutes. Expect a one stop speed increase from Tri-X. Slower films may yield as much as a two stop increase. It is not known how well tabular grain films work with green light latensification.

Note: This recommendation is only for panchromatic films. We do not know how well it works for extended red, ortho, or infrared films.

With both hypering and green light latensification some fog rise and loss of contrast is inevitable. Even so it is best to use normal developing times and print on a higher grade of paper if necessary.

Increasing speed *during* exposure: concurrent photon amplification

Concurrent Photon Amplification requires a specially modified camera fitted with small LEDs in front of the film plane.[5] This is the most effective method for increasing film speed for exposures shorter than one second, with no loss of image quality.

Increasing speed *after development:* hydrogen peroxide

Unlike hypering and latensification, sensitizing with hydrogen peroxide takes place *after development, before fixing*. The technique is to "steam" the film in pressurized hydrogen peroxide fumes just after development.

According to Bob Schwalberg, the best normal developing time for Tri-X (EI 400) in D-76 1:1 is 8 to 10 minutes at 68F/20C. To push one stop (EI 800) he recommended undiluted D-76 for 9 to 10 minutes. For pushing two stops (EI 1600) he recommended at least 12 minutes and found development beyond 15 minutes useless. These recommendations contradict Kodak's. A recent Dataguide recommends 9 minutes for normal time processing of Tri-X in D-76. In Schwalberg's system that amounts to a one–stop push. Schwalberg's thirty year dispute with Kodak over development times is legendary. According to Schwalberg, Kodak's longstanding policy is to build a generous safety factor into development times to prevent accidental underdevelopment. (Many people within Kodak we respect deny this.)

This technique can measurably increase shadow detail in film that has been "pushed" two to three stops with D-76 or XTOL. It works well with conventional films, but not with tabular grain films. The results are grainy but have a unique quality that often complements low light photography aesthetics.

1. Place either two 35mm reels or one 120 mm reel, as a spacer, and eight ounces of over-the-counter 3% hydrogen peroxide in a *metal* tank of at least 1 liter. With the lid on, place the tank in a water bath of 105F/40C to 110F/43C. Bring the peroxide to this temperature.

2. Develop the film by push processing with D-76, FX 37 or XTOL.

3. After development rinse the film with plain water at the temperature of the developer. *Do not use acid stop bath at any time during this process.*

4. In total darkness transfer the film to the tank holding the peroxide and the spacer reels. Never allow the peroxide to touch the film. Place the lid on firmly—the tank must be airtight so pressure can build up. Leave the film to "steam" for ten minutes, maintaining a water bath temperature of 105F/40C. During this period, it is safe to turn on the lights. Once every minute the tank should be gently swirled (not inverted!) for ten seconds, being careful not to splash the peroxide onto the film.

5. At the end of 10 minutes, turn the lights off. Carefully remove the lid. Transfer the film to a dry tank (metal or plastic). Cap the lid tightly. Let stand for 5 minutes.

6. Rinse the film in plain water at the original processing temperature by filling and emptying the tank at least five times. Fix and wash as usual.

Increasing speed through developer additives

Various proprietary additives have been marketed over the years. They usually contain development accelerators such as hydrazine or ethanolamines, and a highly active developing agent, such as Phenidone, that is likely to increase the activity of developers that do not already contain Phenidone. Two of the most popular are Formulary EXCEL and Brandess/Kalt Crone-C. There is not, in the entire photographic literature, a single well-documented study showing that *any* developer additives actually increase speed. However, under some circumstances, these products do appear to accelerate the *rate* of development, which accounts for the initial impression that they are increasing speed.

NOTES

1. Haist, Clerc, and Jacobson.

2. E. Everhart, *Sky and Telescope*, 1981.

3. A vendor for gas-hypered films is Lumicon (see Sources).

4. Haist.

5. Bob Schwalberg, *Popular Photography*, June 1976.

Also see Mitsuo Kawasaki and Yoshiaki Oku, "Characterization of High-efficiency Hypersensitization of AgBr Emulsion by Gold(ı) Thiocyanate Solution", *J. Photogr. Sci.*, Vol. 43, No. 4, pp.122–130, 1995.

Chapter 11

DOCUMENT FILMS

35mm and 120 roll film users have been known to seek ways to rival large format quality. One of the best is to use high contrast document films. Document films are slow, ultra sharp, ultra fine grain, ultra-high contrast emulsions. Yet when processed in special low contrast developers, they can produce negatives that have almost normal gradation with amazingly fine grain and high sharpness. They can rival the grain and sharpness of large format films, even though they can never possess the microtonal subtleties which keep large format popular. Nevertheless, truly spectacular results can be achieved with document films at enlargements of 20X or more.

Document films can be used to photograph low contrast subjects quite successfully. But scenes of normal (7 stops) or higher contrast will show impaired highlight rendition. Even so, with the right developer, it is possible successfully to record a 12-stop range.

Since the contrast range of document films is limited, exposure is critical. Traditional Zone System methods for determining film speed should *not* be used. With the Zone System, the first usable density is usually taken to be 0.1 above base+fog. In fact, the *minimum printable density* is usually about one exposure stop *below* this point. With document films processed in developers which produce high toe contrast the first printable density can be as low as 0.03 above base+fog.[1]

At the time of writing, three document films are available: Kodak Technical Pan (Tech Pan), an extended red panchromatic film, in 35mm, 120, and 4x5, and Agfa Ortho and Cachet Macophot ORT25, in 35mm and 120, both orthochromatic films. All have a nominal ISO around 25.

Low contrast developers for document films

Although the chemical mechanism of low contrast developers is not well understood, they have been around since the 1960s. The first developer to be widely used for this purpose was the famous POTA formula of Marilyn Levy, published in 1967.[2] (POTA stands for Photo-Optics Technical Area at the Fort Monmouth military installation where Levy worked.)

Developing time for Tech Pan is about 15 minutes with 10 seconds agitation each minute, and about 6 minutes with continuous agitation in a tray for sheet films. Times for Agfa Ortho and ORT25 should be

QUICK GUIDE RECOMMENDATIONS

■ Use XTOL 1:5, POTA, the related Kodak Technidol-LC, or Formulary TD-3, with Tech Pan, Agfa Ortho, or Macophot ORT25.

■ POTA-type developers produce exceptionally even density growth over their useful range but have an abrupt shoulder after eight stops (zones). No further highlight detail is available above that point. Developers based on Beutler technology such as TD-3 have choppier density growth but a much gentler shoulder with an overall printing range as high as 10 stops.

similar. POTA may be used with regular films when extremely low contrast is desired.

Superficially, this developer resembles D-23, with the metol replaced by 20% of its weight of Phenidone and the sulfite reduced by 70%. However, its results are quite different, and cannot be duplicated by any known metol formulation. The pH of POTA mixed with distilled water is about 8.7. The pH of the sulfite solution alone is about 9.8, which indicates the importance of sulfite in POTA as an alkali.

POTA	
Sodium sulfite anhydrous	30 g
Phenidone	1.5 g
Water to make 1 liter	

POTA problems and modifications

POTA is distinguished by the fact that it is in a state of exhaustion from the moment it is prepared, because straight Phenidone is not well preserved in sulfite. This can be seen by observing the typical orange color of the POTA solution. If hydroquinone were added, the orange discoloration would disappear. Because the oxidation products of Phenidone in POTA retard development less development will take place in areas of high density, where more developer is being used, and more oxidation products are being created. This is what makes POTA such a low contrast developer.

Interestingly, these oxidation products do not obviously stain the film. Unfortunately, considerable *streaking* can result. The streaking may be due to oxidation, but it has been theorized that it may also relate to a physical development effect that may take place with POTA.[3] The streaking problem most obviously affects large areas of uniform density, such as cloudless skies. It is an intermittent problem.

Marilyn Levy noticed these problems in 1967. They were not considered critical as the large aerial films for which POTA was originally intended were commonly given continuous brush agitation, which minimized the effect. However, brush agitation is not practical with 35mm film, and exceedingly tiresome with sheet film. In any event document films should have intermittent agitation to produce the desired contrast and definition characteristics.

One way to minimize the problems associated with Phenidone oxidation is to modify the formula. A simple way to minimize oxidation with only a small rise in contrast is suggested in Levy's earlier paper on Phenidone-pyrogallol developers.[4] If a small amount, about 0.25 grams, of either hydroquinone or pyrogallol, is added to the solution, the result is good preservation of both agents, with a surprisingly small rise in contrast compared to plain POTA.

There are two other factors to consider. The first is that Phenidone is hard to dissolve at the pH of POTA. With another developing agent present there is no reason to use 1.5 g/L; 0.5 g/L would be a good trial amount.

The second is high fog, a problem with Phenidone and pyro developers. It is desirable to have a low fog level if this can be achieved without spoiling other characteristics of the developer.

Levy did not employ antifoggants in POTA because they would have reduced speed and increased contrast. They could also have other unpredictable effects on image quality. However, one of the problems with fog is that its growth is never even or predictable, which can cause subtle degradation in image quality.

Part of the fogging problem found with POTA may be due to the level of sulfite. In POTA sulfite is the main alkali. Reducing sulfite will also reduce the pH, which is the best way to reduce fog. Early work at Kodak by Crabtree indicated that a low level of sulfite (such as 10 g/L liter) had a minimum tendency to fog. Although it is unwise to generalize from this kind of early experimental information, 10 g/L would be an appropriate level of sulfite for trial.

There is another good reason for lowering sulfite when a document film is used. Sulfite at *any* level has a solvent action which initiates solution physical development. The finer grained the film, the more pronounced this action. Document films are exceedingly fine grained. Sulfite should be reduced to a minimum on the assumption that doing so will improve image quality.

The formula to the right is a trial modification in which we try to optimize POTA for Technical Pan. Because sulfite has been reduced, the pH of the developer may not be quite as high. But developing times should be shorter than the 15 minutes generally used with POTA and variants such as Technidol, because of the superadditive activity of the combined developing agents.

This formula contains much less of the difficult-to-dissolve Phenidone. It will also be more stable, and cheaper. Raising the pH with a small amount of bicarbonate or borax will enable you to fine-tune the results. Yet another possibility to obtain higher overall image quality is to add metol, a trick Crawley finds useful with Phenidone developers. A half gram of metol could be added to the Modified POTA formula above, or could replace the pyro or hydroquinone.

POTA modifications with glycin

As stated, the problem with adding a second agent to POTA is that the better it stabilizes the Phenidone solution, and therefore theoretically prevents streaking, the more it raises contrast. Probably the most stabilization with the least rise in contrast will be obtained with glycin. Because of its resistance to oxidation, glycin permits adding the lowest practical amount of sulfite. These trial formulas can be used as starting points.

Another possible addition to these formulas is a small amount of potassium iodide as an antifoggant, and possibly as a speed accelerator (0.001-0.01 g/L). Isopropyl alcohol could also be added (50 ml per liter). This will increase speed slightly, and preserve the solutions better when stored. For more compensation, use a small amount of a stronger alkali such as metaborate or carbonate to replace the bicarbonate.

MODIFIED POTA	
Hot water (150F/65C)	
Sodium sulfite anhydrous	10 g
Phenidone	0.5 g
Pyrogallol or Hydroquinone	0.25 g
Cold Water to make 1 liter	

Add borax or bicarbonate as desired to control time, contrast, and speed. Hot water helps the Phenidone to dissolve, but the solution should then be cooled to working temperature as soon as possible. Develop Tech Pan for 11 minutes.

	TDLC-101	TDLC-102
Sodium sulfite anhydrous	4	4 g
Phenidone	0.1	0.25 g
Glycin	0.5	0.25 g
Sodium bicarbonate	20	5 g
Water to make 1 liter		
Develop Tech Pan for 15 minutes.		

The Delagi POTA modification

Other problems with POTA formulas are slow speed and, according to R. E. Delagi, a metallurgist, poor edge sharpness. A modification by Delagi published in an article by Bob Schwalberg in Popular Photography in 1982, was said to increase sharpness and acutance dramatically. This is an overoptimistic claim which reflects the inherent variability of POTA formulas, as well as batch-to-batch variations in Tech Pan that are due to its complex manufacturing process.[5] In the original publication a 2% BZT solution was given in error; it should have read 0.2%, as published here. Borax has been added to boost activity presumably lost through the BZT addition. Kodalk (sodium metaborate) boosts activity (and contrast) even more. Formulators normally use potassium bromide rather than an organic antifoggant in low to medium pH Phenidone developers. BZT has little antifoggant effect at these pH levels. It is still better to avoid using an antifoggant if possible. Usually the best way is to lower the alkalinity.

DELAGI-8	
Sodium sulfite	25 g
Phenidone	1.4 g
Borax (decahydrate) or Kodalk	2 g
Benzotriazole, 0.2%	15 ml
Water to make 1 liter	

Other low contrast developers

Stepping away from the abyss of Phenidone and all its problems, Shepp and Kammerer at Polaroid formulated Developer T/O XDR-4, using the MQ combination.[6]

Again, like POTA, this is a simple and ingenious formulation. However, we see no reason to use the uncommon potassium salts. In our variant of this formula, TDLC-103, we use sodium salts. TDLC-103 is more likely to give good results with document films, and as an extreme low contrast developer for today's normal contrast films.

T/O XDR-4	
Metol	1 g
Potassium sulfite	25 g
Hydroquinone	1 g
Potassium bicarbonate	10 g
Water to make 1 liter	

TDLC-103	
Metol	1 g
Sodium sulfite anhydrous	5 g
Sodium bicarbonate	10 g
Water to make 1 liter	

There is no need for hydroquinone in either formula, as it is not active at this pH. Contrast with this formula and T/O XDR-4 is somewhat higher than POTA, but still much lower than D-23. Most importantly, the Phenidone streaking problem is eliminated.

Actually, most developing agents can be used for document films, if the amount of the agent is low enough. Formulas with metol, metol-glycin, or pyrocatechin can be prepared with carbonate as the alkali. Such developers are similar to the traditional high acutance compensating formulas, except that the amount of the developing agents is approximately half, and the carbonate is proportionately higher.

The technique is to keep the total amount of developing agent between 0.15 and 0.3 grams per liter of solution. This assumes rather high carbonate alkalinity. With this in mind, either FX 2 or PMK could be used with one-half to one-third their standard A solution and twice

their standard B solution.

The table on the next page shows suggestions for low contrast developers based on metol and pyrocatechin. The pyrocatechin developer is very sharp, has good speed and gradation, and a tanning effect. Develop for 10 to 15 minutes, depending on the film and desired effect. Agitation is an important factor with all such developers. Minimal agitation— 10 or 15 seconds every 3 minutes—helps to increase the speed by suppressing highlight development, without affecting shadow development (see Chapter 4).

As with all carbonate developers, use a buffered stop bath of pH 4.5-5.5, or a 5% sodium sulfate solution, or a plain water rinse for one minute. Follow with an ammonium thiosulfate fixer.

The speed of these dilute high alkali developers can be expected to be as much as twice that of POTA, while still maintaining low fog levels. With Tech Pan this amounts to a working speed around EI 50.

Variants of some commercial developers have been used to achieve low contrast. One is FX 14 (Acutol) at 1:20, another is Microdol-X at 1:10. Even D-76 has been successfully used full strength, but the developing time of one minute or less is too difficult to practice reliably, and there is undoubtedly speed loss with this procedure. XTOL 1:5 for 12.5 minutes at 70F/21C, is recommended by Kodak. We suggest trying XTOL at 1:10 and adding 1g/L of sodium metaborate to keep developing times reasonable. This will produce an increase in speed.

All of these variants will produce noticeably different gradation characteristics. Different developers will give infinitely more variety of response than "normal" developers give with "normal" films. This extraordinary measure of tonal control makes experimenting with document film developers a fascinating experience.

LOW CONTRAST DEVELOPERS	
Metol or Pyrocatechin	0.15-0.30 g
Sodium sulfite anhydrous	1-5 g
Sodium bisulfite	0-2 g
Sodium carbonate anhydrous	10-15 g
Distilled water to make 1 liter	

Reducing the sulfite to a half or even a quarter of a gram will increase the tanning and hardening effects as well as sharpness and contrast.

Low contrast developers based on PPD derivatives

Grant Haist has suggested that it should be possible to formulate low contrast developers valuable for both document films and tabular grain films by adapting techniques used for developing color negative films. We hope this suggestion will be addressed by researchers in the future.

Commercial low contrast developers for document films

Commercial low contrast developers for document films show a depressing lack of sophistication and performance. Though research chemists at the major photographic laboratories have the skill to produce novel formulations with greatly improved performance, low contrast developers for document films are neither a research nor a marketing priority. The various iterations of the Technidol developers from Kodak are a case in point. All are still based on the relatively primitive POTA technology, and share its faults.

One commercial developer which alleviates the streaking problem is Formulary TD-3.[7] This developer has a different characteristic curve from POTA derivatives, with a short toe, exceptionally marked shadow and middle-tone contrast, and a long shoulder which gives a pearly appearance to high tone values.

TD-3 produces speed approximately double that of POTA types while significantly lowering granularity.[5] However, it can be more difficult to print with than POTA. The best overall results are obtained when contrast is high enough to require grade 1 paper with a condenser enlarger or grade 2 paper with a diffused light source.

The original commercial document developer was H&W Control, but this seems no longer to be available. Finally, Tetenal has for years made a well-known developer called Neofin doku. It is available at the time of writing only in Europe.

Low contrast developers with normal films

All the developers mentioned can be used with normal films when it is necessary to photograph scenes of tremendous light range (over 10 stops). It is crucial to test individual developers beforehand since it is impossible to predict exactly how each will behave with a given film.

A perspective on document films and fine negatives

Some photographers expect to obtain the quality of 8x10 sheet film with 35mm or 120 document films. The reality is that no matter what developer is used, document films will never have either the micro or the macro contrast range of 8x10 Tri-X. Unless this is understood results with document films will be disappointing. Exposure must be determined much more carefully and bracketing of important exposures is highly recommended where possible (a stop either way should be adequate). Furthermore, it cannot be overemphasized that due to the low green sensitivity of Tech Pan, scenes with green foliage will always be underexposed unless a green filter is used.

In addition, Zone System photographers must realize that planned overexposure, which is essentially built into the Zone System, is not possible with document films unless the subject has a low contrast range. Speed for Tech Pan, Agfa Ortho and ORT25 must be determined either by experience, or, if a scientific basis is desired, by the fractional gradient point Jones method or the fixed point gradient method of Nelson and Simmonds.[1] Both methods allow speed to be accurately determined at any gradient.

OTHER CONCERNS WITH DOCUMENT FILMS

Camera and lenses

An attraction of using document films is that they can be enlarged 20–40x and still maintain excellent sharpness. 20X enlargement from a 35mm negative is equivalent to a 20x30–inch print. 40X enlargement would be equal to a 40x60–inch print, almost 4x5 feet! To accomplish this while maintaining excellent sharpness requires much care.

Magnifications of this size require excellent lenses, clean and in good condition. Lens faults you were unaware of will become obvious with 20x enlargements.

It is important to avoid camera motion. Hand-held exposures should be made in good light or with flash. For maximum sharpness use a tripod and cable release at any speed below 1/125. If possible, pre-

release the mirror at least 10 seconds before exposure.

Use the lens's sharpest aperture, usually 2–4 stops down from wide open. Depth-of-field indicators on lenses should be regarded as optimistic if you plan big enlargements. If you use very small apertures to obtain great depth of field, you will notice a falloff in lens sharpness. That falloff is often masked by the grain of conventional and tabular films, but not with document films.

All filters impair lens definition to some extent. If used with document films, filters should be of the highest quality, and in perfect condition. Only filters made of optical glass, such as B+W's, should be used.

Finally, document films are more sensitive to static electricity marks than other films. Handle film slowly and carefully, especially when rewinding.

Enlarging document films

Just as it is important to avoid camera shake in the field, it is important to avoid vibration during enlargement, especially during the long print exposure times which are often required for big enlargements. Moving around the darkroom while the print is being exposed may lead to unsharp prints.

It is essential that your enlarger be in perfect alignment. Even professional enlargers, such as the Omega D5, fall out of alignment. Misalignment becomes more obvious when very large enlargements are made.

Negative carriers should have an adjustable masking device to reduce flare.

Some document films have polyester bases with a particular tendency to curl. To minimize film curl with all films, dry the film with weights and store flat.

Tiny micro-abrasions can be caused by excessive handling. They may not be noticeable with normal enlargements, but can become evident when the negatives are enlarged 20 or 40x.

Enlarging lenses

Almost all enlarging lenses for 35mm film are optimized for maximum sharpness at 10x magnification (just as most camera lenses, except macro lenses, are optimized for maximum sharpness at infinity or a middle distance). However, with Technical Pan, there is always the desire to make 20x and greater blowups. With 40x to 100x blowups, a top quality camera lens—such as the Leitz 50mm Summicron—mounted on the enlarger may give better results than many enlarging lenses. An exception is the Schneider 45mm Apo-Componon which can be used to 30x.

There is also a series of Schneider G-Componon lenses designed for 20x and greater magnifications (a similar range is available from Rodenstock). For general use, a 28 or 35mm enlarging lens can be used if only a small part of the negative is being used. Care should be taken to center the part of the negative being enlarged. Unfortunately, most of these lenses are optimized for 10x. Exceptions are the 28mm Schneider

These recommendations also apply to conventional films when extreme enlargements are planned.

Componon and Rodenstock Rodagon which are optimized for 20X.

Use all lenses at their optimum aperture—usually 2 to 3 stops down from their largest opening. For critical corner-to-corner sharpness, a glass carrier should be used, although this creates other problems. When using a glassless carrier the lens may have to be stopped down to f/11 to obtain corner to corner sharpness. This is not the ideal aperture for a good 50mm lens.

Technical Pan and astro photography

Tech Pan is often used by astronomers and photographers interested in capturing nighttime scenes. For very long exposures, the speed of Tech Pan can be increased up to 10X by *gas hypering* (see Chapter 10).

NOTES

1. For a technical explanation of this point, see L.A. Jones and M.E. Russell, "Minimum Useful Gradient as a Criterion of Photographic Speed, *Phot. J.*, 75:657 (1935); L.A. Jones "The Evaluation of Negative Film Speeds in Terms of Print Quality, *J. Franklin Inst.*, 227:297, 497 (1939); L.A. Jones, "Photographic Film Speeds as Evaluated in Terms of Print Quality, *British J. Phot.*, 87: 191 (1940); and C.N. Nelson and J.L. Simonds 'Simple Methods for Approximating the Fractional Gradient Speeds of Photographic Materials', *Journal of the American Optical Society*, 46: 324 (May 1956). These classic articles form the cornerstone for all speed determination methods right down to the present. Though crystal clear, they have been radically distorted by most subsequent commentators claiming expertise in sensitometry. One exception is Stephen Benskin, 'The New ISO Standard', *Darkroom & Creative Camera Techniques*, Sep/ Oct 1995.

2. Marilyn Levy, "Wide Latitude Photography", *Phot. Sci. and Eng.*, 11: 46 (1967).

3. T.H. James & M. Levy to BT, 1982.

4. Marilyn Levy, "Superadditivity of Phenidone/Pyrogallol Developers", *Phot. J.*, 105: 303 (1965)

5. Henry. Sylvia Zawadzki has found that the original POTA formula is sharper than any of the variants based on it (SZ to BT, 1998).

6. A. Shepp and W. Kammerer, "Increased Detectivity by Low Gamma Processing", Phot. Sci. and Eng., 14: 363 (1970).

7. R. Bender, *Darkroom Photography*, May/June 1984.

See also:
A. Shepp, W. Kammerer, and R. Shuman, "Extended Dynamic Range Processing", Technical Operations, Inc., AFCRL-67-0633, Air Force Cambridge Research Laboratory, Bedford, Mass., November 1967.
R. M. Shaffer and D. M. Dutton, "Wide Latitude Processing of Tri-X Ortho Oscillographic Film", EG&G Report 1183-1465, Tech Report No. L-9, 15 January 1970.

Chapter 12

AFTER DEVELOPMENT PROCESSES

Stop baths: acid versus water

The function of an acid stop bath is to stop development as completely and quickly as possible. This is most desirable with development times under 10 minutes since a relatively small error can make a significant difference in negative quality. One advantage of long developing times is that the error must be much greater to have any visible effect.

Although there are advantages to acid stop baths, there are major disadvantages:

1. pH variations occur when a film is moved from an alkaline developer into an acid stop bath. This can generate enough molecular heat to cause the grains of the film to clump together.

2. Acid stop baths can cause pinholes and reticulation with developers that contain carbonate.

3. Acid stop baths cause excessive swelling of the gelatin which leads to a loss in image integrity.

Using a neutral water stop bath in place of an acidic stop bath creates a different set of circumstances. When film is placed in water, the developer does not immediately cease to work; it is merely diluted. Since the developer is very dilute in the water stop, it will rapidly exhaust in the highlights, but continue to develop in the shadows for a few moments. At the same time, sharpness-enhancing adjacency effects will occur.

Using water stop baths

Using this "slow stop" water bath system will result in slightly shorter developing times. Our recommended system for tank development is:

1. Pour the developer out of the tank and drain for ten seconds.

2. Immediately refill the tank with water. Agitate for ten seconds, then pour out the water.

3. Repeat the sequence for one minute or five cycles, then pour the fixer into the tank.

With tray development of sheet film we recommend a running water tray setup, such as the Paterson High Speed Print Washer. Wash the film for one full minute. Drain for ten seconds before moving it to the fixer.

Composition of acid stop baths

Most commercial and published formulas for stop baths are based on acetic acid (the acid in common vinegar). The working solution is usually between 1% and 2% in water. The only other ingredient sometimes added is a pH indicator dye for "indicator" stop baths.

Objections to this typical bath are its odor, low buffering capacity, excessively low pH when first used, and inability to stop development in under 10 seconds. Even so, acetic acid stop baths are still preferable to those based on bisulfites and most other acids.

The pH of a fresh acetic acid stop bath is 2.9. The pH of an ideal stop bath is 4.5. The ideal stop bath is an approximately 10% buffered solution consisting of 120 ml of 28% acetic acid plus 80 grams of sodium acetate in a liter of water. Capacity: at least 40 times 80^2 inches.

In this bath the pH is raised and the *total acidity* is increased. As a result, this bath will stop development more quickly than a conventional stop bath (3 seconds as opposed to 30 seconds), prevent pinholes and reticulation, and have maximum compatibility with acid fixing baths. (Think of pH as measuring strength, and total acidity as measuring stamina.)

Odorless stop baths

There is no reason to suffer the unpleasant and unhealthy odors of conventional stop and fixing baths. An excellent stop bath can be made with 3% to 5% boric acid in water. Unlike most other acids, boric acid does not interfere with the metal hardeners used in acid hardening fixers, making it the ideal odorless stop bath. To make, add 50 grams of boric acid to one liter of warm water. Boric acid does not go into solution easily. Use a grade intended for photographic use. The solution should become clear after 24 hours. If it does not, add more water until it does. Capacity is about 20 times 80^2 inches.

pH indicators for stop baths

The ideal pH range of a stop bath is between 4 and 5, with pH 5 about the safest maximum. If you do not have a pH meter, a narrow range indicator strip is the most convenient way to check pH (see Sources). Indicator paper can be unreliable, but so can an uncalibrated pH meter. If you use a meter, calibrate it often with reference solutions.

The most commonly used indicator dye is bromocresol purple. It is yellow at pH 5.2 or below, and purple at pH 6.8 or above. Bromocresol green is preferable. It is yellow at pH 4 or below, green at just above pH 4, and blue at pH 5 or above. The bath is still good when green, but should be discarded very soon after it turns blue.

Stop baths and tanning developers

More developers form colored oxidation products—brownish stains—than is commonly realized, because acid baths (conventional stop or fix) remove these stains. Thus where this type of stain is desired, such as when using a pyro or catechol tanning developer, it is desirable to keep the film processing alkaline or at least neutral from start to finish.

This fact has often been overlooked, which has led to some of the

disappointments experienced by those attempting to use pyro developers. A water bath, in place of an acid stop, should be used with all tanning developers.

Using acid stop baths

To use an acid stop bath, drain the film for 10 seconds after development and move to the stop bath as quickly as possible. Agitate continuously for 30 seconds, drain for 10 seconds, and then move the film to the fixing bath.

FIXERS: SODIUM VERSUS AMMONIUM THIOSULFATE

With the gutting of the Kodak Research Laboratory in the 1980s practically all major research into the nature of the fixing process has come to a halt. At the time of the purge, preliminary findings were that sodium thiosulfate fixers were not adequate for modern films and papers. Some Kodak researchers went so far as to suggest that thiosulfate should be replaced by more stable chemicals, but layoffs ended further investigation.

The most current research indicates that sodium thiosulfate, the photographer's standby for most of the 20th century, cannot adequately fix modern films or papers.[1] This appears to be due to the increased use of iodide in contemporary films and papers. If an acid fixer is to be used, use only acid "rapid" fixers based on ammonium thiosulfate.

ATF-1

	Working Solution	Stock Solution
Water	700 ml	–
Ammonium thiosulfate, 57-60%	185 ml	740 ml
Sodium sulfite anhydrous	12 g	48 g
Acetic acid glacial	9 ml	36 ml
Boric acid	7.5 g	30 g

Water to make 1 liter. To use the stock solution dilute 1:4.

OPTIONAL HARDENER

Aluminum chloride, hexahydrate	50 grams
Water to make 100 ml.	

If desired, add 25 ml of the hardener solution to 1 liter of fixer working solution.

Acid fixers

Several acid rapid fixers, all more or less the same, are readily available. The one we are able to recommend is Kodak Rapid Fixer. The optional hardener which comes with most fixers is no longer necessary except with processing temperatures over 80F/27C (see Appendix I).

Very few formulas for acid ammonium thiosulfate fixers have been published. It is simpler and usually more economical to buy them ready made. The best published formula is Alnutt's ATF-1.[2]

Before using an acid fixer, films should be either immersed in a fresh acid stop bath with continuous agitation for 60 seconds, or rinsed in running water for 60 seconds. Fix for *three times* the clearing time (usually a minimum of three minutes). After fixing, rinse the film in fresh water for one to two minutes, agitate continuously in a fresh hypo clearing bath for one minute and wash for 10 minutes.

Hypo clearing agent

Hypo clearing agent is *only* necessary when an acid fixer is used. After fixing, wash film in running water for one minute, then place in hypo clearing agent for one minute with continuous agitation. Wash the film in running water for an additional 5 to 10 minutes.

HYPO CLEARING AGENT

Water at 125F/52C	750 ml
Sodium sulfite anhydrous	200 g
Sodium bisulfite	15 g
Cold water to make 1 liter	

Dilute 1:10 to make working solution.

TF-3 ALKALINE FILM FIXER	
Ammonium thiosulfate, 57-60%	800 ml
Sodium sulfite anhydrous	50 g
Sodium metaborate	20 g
Water to make 1 liter	
Working solution: Dilute 1:4 with water	

Alkaline fixers

Although it is more convenient to use acid fixers simply because they are readily available, film processing should ideally take place in high salt solutions at or near the pH of the developer.

There are several advantages to using an alkaline fixer:

1. Alkaline fixers do not dissolve image-bearing silver. Therefore, there is less danger of over fixing.

2. Alkaline fixers allow shorter washing times. Removal of hypo is faster than when an ordinary fixer plus a hypo clearing agent is used. Film fixed in an alkaline fixer does not require hypo clearing agent: hypo is down to archival levels after a minute of washing. But film should be washed a total of at least three minutes to ensure all developer residue is removed.

3. Keeping the entire system either neutral or alkaline, from alkaline developer, neutral water stop, alkaline fixer, neutral final wash (without HCA), will improve the permanence of all films and papers because the thiosulfate does not mordant to the silver image or base.

4. Alkaline fixers have greater capacity than acid fixers.

5. Alkaline fixers are easier to formulate and more stable as thiosulfates are more stable in an alkaline solution.

6. Alkaline fixers can be formulated to have very low odor.

Although alkaline fixers have been used for years in research labs, the only commercially available alkaline fixer is Formulary TF-4. For those who wish to mix their own we are disclosing, for non-commercial use only, the formula for TF-3. TF-3 has higher alkalinity than TF-4, which means it has a faint ammonia odor. That makes it less suitable than TF-4 for film or print fixing in open trays. Because of its alkalinity and low sulfite content, TF-3 is particularly recommended for PMK and other staining/tanning developers.

To use TF-3 or TF-4 immediately follow development with a sixty-second running water wash or a minimum of five full changes of water. Fix the film for three times the clearing time—usually 3 to 5 minutes. A hypo clearing agent is not required.

Experiment: To obtain maximum image stain with PMK, reduce the sulfite in TF-3 or eliminate it altogether. If you do this, the life of the working solution cannot be guaranteed beyond one day, but you will achieve the maximum imagewise staining of which PMK is capable.

Acid stop baths and alkaline fixers; alkaline stop baths

It is possible to use acid stop baths with alkaline fixers when you need to stop development on the dot and in order to suppress edge effects—for instance in scientific photography and astronomy. Simply rinse the film in running water for 30 seconds *after* the stop bath but before the fixer. This will keep acid from being carried over into the fixer. Alkaline stop baths are still experimental. See Appendix I for suggestions.

Determining fixing times and capacity

Ideally, *fixer should be tested before each use.* From a practical standpoint, testing every third time should be adequate. Keep in mind that *clearing times are different for every film.* You should determine

clearing time for the kind of film you are using.

With the lights on, place at least half of a film strip (or the 35mm leader) in fresh fixer. With gentle agitation observe how long it takes the film to become completely transparent, or clear. This is the clearing time. Multiply the clearing time by three for your total fixing time.

As the fixer is used the clearing time will increase. Test whenever convenient. When the clearing time doubles from the fresh test, discard the fixer. In any event, never use any fixer for more than 20 8x10 square inches of film per liter or 80 8x10 square inches of film per gallon.

The working solution of a fixer should never be kept for more than two months—two weeks if the ambient temperature is over 85F/29C. Stock solutions of commercial ammonium fixers should not be kept for more than a year. When storage for more than a month is contemplated use a container filled to the top and tightly capped.

Discard any fixer the moment it turns yellowish. This is a sign of sulfur precipitation. This is yet another reason not to use a conventional indicator stop bath. The indicator dye may be carried over into the fixer, disguising sulfur precipitation.

Problems with potassium salts

Potassium salts can cause trouble during fixing because, if they enter the fixer, they can partially convert the ammonium or sodium thiosulfate to potassium thiosulfate. Potassium thiosulfate is inactive compared to the ammonium or sodium salts. Thus developers or stop baths high in potassium salts can appreciably lengthen the clearing time. This problem will not arise as long as the following precautions are observed:

1. Never use a stop bath based on potassium metabisulfite or another potassium salt.

2. If using a water stop, make sure the film is well rinsed, at least 60 seconds with running water, or five complete changes, before placing it in the fixer.

WASHING

When possible film should be washed in a running water bath. Films fixed with an acid fixer followed by a one minute hypo clearing bath should be washed for 10 to 20 minutes. Film fixed in an alkaline fixer does not need a hypo clearing bath and only needs to be washed for 5 to 10 minutes. In fact, research has indicated that films processed in alkaline fixers may be archivally washed in as little as two minutes, but we prefer to err on the conservative side.

When water is in short supply an alternate water saving method can be used with film in spiral tanks. A non-hardening fixer must be used and the washing temperature kept below 77F/25C.

1. Process the film in a spiral tank and fix in the normal manner.

2. After fixing, fill the tank with water at the same temperature as the processing solutions, and invert it 5 times. Let the tank sit for 5 minutes.

3. Drain the water and refill. Invert the tank 10 times. Let the tank sit for 5 minutes.

4. Drain and refill for the third time; invert the tank 20 times. Let

Before World War II German companies formulated many stop baths using potassium salts. The reason was simple: potassium was less expensive than sodium and Germany was in an economic slump (as was much of the rest of the world). When subsequent research revealed the problems associated with using potassium in stop baths, its use was discontinued. However, potassium-based stop baths and fixers can still be found in many old formula books, and should be avoided.

the tank sit 5 minutes. Drain the water.

5. A final rinse of water to which a few drops of wetting agent have been added will aid rapid and uniform drying.

This method is particularly effective when used with an alkaline fixer.

Note: This method has been published elsewhere without the five minute waiting time between steps. This is incorrect.

Washing tabular grain films

Without special sensitizing dyes, all films would only be sensitive to blue light. Because tabular grains have a large surface area, they require more sensitizing dye, and this in turn needs more time to wash out. The dye is hard to wash out, and manufacturers have had conflicting advice as to whether the dye actually needs to be washed out or not. Our present understanding is that the dye is not readable as density by any current printing papers, and should therefore have no photographic effect. Nor does there appear, at present, to be any archival concern. However, even if these beliefs are borne out by time, it is both psychologically and visually unpleasant for photographers to have this residual dye left in tabular grain films.

For a time, extended fixing, which is manifestly an improper processing procedure, was recommended as a cure. In addition, many fixers have claimed to be able to remove the dye, but we have not seen any that actually do. What we have found is that three intermittent soaks in standing water will remove the dye: After fixing, rinse films for a minute in running water. If an acid fixer was used, place the films in hypo clearing agent for a minute with continuous agitation. If an alkaline fixer was used, no hypo clearing agent is required. Now fill the tank or wash chamber and leave the film to stand in fresh water. After 3 to 5 minutes change the water completely. Allow the film to stand for another 3 to 5 minutes. Repeat a third time for complete removal of the dye. If the film was processed in an acid fixer, wash for an additional ten minutes in running water. If the film was processed in an alkaline fixer, wash only for one additional minute in running water.

Wetting agents

A wetting agent allows water to run off the film quickly and easily, preventing water spots. To use a wetting agent, soak the washed film in a solution of *distilled* water and wetting agent. We recommend Edwal LFN, Kodak Photo-Flo, or Tetenal Mirasol 2000. (Mirasol is the only photographic wetting agent with antibacterial and antifungal properties.) Agitate for 30 seconds. It is essential to mix the wetting agent working solution carefully: this is a case where less does good but more does harm. We recommend using half or less the amount the manufacturer recommends. Just one ml per liter seems to work well.

After hanging, remove excess water from the film's surface. A *one-sided* soft rubber squeegee, dipped in wetting agent (working solution) and held at a slight angle so the blade runs behind, works very well. Wipe each side of the film only once. This method works equally well with sheet film.

Roger Davidson insisted that the best film squeegee money could buy was the windshield wiper off of a pre-1970 VW van. He was adamant that the van had to be pre-1970. I have used the same 1969 VW van windshield wiper since 1974.

—ANCHELL

Never wipe film with a sponge or use any tool that squeezes the film on both sides. Even an apparently non-abrasive sponge might make micro-scratches in the negative which, though invisible to the naked eye, could degrade image quality. This is especially true with document films.

DRYING

Hang film in a dust-free place with weights attached to the bottom of roll and 35mm film. Whenever possible use a drying cabinet. Even if film appears to be dry wait several hours before printing or filing it in archival pages. We recommend avoiding plastic storage pages that do not allow atmospheric moisture to escape.

With the exception of a dust-free, temperature controlled drying cabinet, avoid quick drying. Many chemical techniques have been proposed,[3] but all of them are likely to cause irreparable damage to negatives. Tetenal has a product which dries film in 2–5 minutes called Drysonal, available only in Europe. We have not evaluated this product, but are concerned by cautions such as "Flecks may appear after drying if the film has not been wiped evenly and not all of the Drysonal has been caught."

If you absolutely must dry film in a hurry, the safest method is to blow gentle heat over the film, at less than 100F/38C. In an emergency you can use a blow dryer at its lowest heat setting. Hold the dryer at least three feet away. It is slower, but safer, to use a fan without heat. Dust spots are bound to result.

PROCESSING FOR PERMANENCE

K.B. Hendriks writes that "Recent studies have shown that toner treatments should be considered mandatory for contemporary films and paper if permanent photographic images that are resistant to chemical changes are to be obtained."[4]

Even so, the jury is still out on the need for post processing of properly washed negatives. Indeed, there are some indications that if film is processed correctly in the conventional manner, the limiting factor in its life is the film base, not the silver image. Nevertheless, there appears to be no harm in toning for permanence and perhaps, if Hendriks is ultimately proved right, a great deal of benefit.

There are three commercially available products for protecting negatives from environmental pollutants. I*n all cases, the films must be completely fixed and washed before the permance processing is begun.*

Agfa Sistan is a stabilizer originally intended to protect RC prints. It is claimed to work equally well with fiber base prints and negatives to protect the silver in the image. It has no toning effect on film or paper.

Dilute 25 ml of Sistan with 975 ml of water to make a working solution. After washing, immerse the film for one minute with agitation. As Sistan contains a mild wetting agent, no further treatment is required before the film is hung to dry. If desired, a solution of LFN or Photo-Flo may be used after the Sistan treatment, but not before or with. This is the easiest and fastest method of treating film for permanence.

NOTES

1. Haist; see also W.E. Lee et al., "New Procedures for Processing and Storage of Kodak Spectroscopic Plates", *Journal of Imaging Technology*, Vol. 10, no. 1, Feb. 1984.

2. Donald B. Alnutt, "Some Characteristics of Ammonium Thiosulfate Fixing Baths", *J. SMPE*, 41 300 (1943).

3. C.I. and R.E. Jacobson, *Developing*, 18th edition revised, Focal Press, 1978.

4. *Focal Encyclopedia*, page 380.

Kodak Selenium Toner can be used immediately after washing, or the film can be rewet after it has dried. The wet film should be toned for three minutes in a 1:29 solution at 68F/20C, with frequent agitation. Wash film for 20 to 30 minutes after toning as selenium toner contains thiosulfate. Immerse for one minute in working solution wetting agent and then hang to dry.

Kodak Brown Toner is claimed to perform similarly to selenium toner. After fixing and washing, use a 1:32 solution for one minute with frequent agitation. As with selenium, the process can be performed on dry film as long as it is thoroughly rewetted first. After toning, rinse the film in working solution hypo clearing agent for 1 to 2 minutes. Wash in running water for 2 minutes. Treat the film with wetting agent for one minute and hang up to dry.

Post-treatment with gold toner has been strongly recommend by Kodak in the past, particularly for microfilm, but the less expensive toners now recommended seem to do a better job. Tetenal offers a proprietary gold toner for stabilizing black and white films.

Caution: The benefits of the post treatment processes in this section are still uncertain. There is also one identifiable area of downside, which is that most toning processes require the use of potentially dangerous chemicals, such as sodium selenite. Many photographers would prefer to avoid this additional exposure to chemicals. Given the present state of knowledge, there is reason to believe that properly fixed and washed negatives will be archivally stable for at least the life of the film base. Those who do not wish to use these post treatment processes may take comfort in the fact that they are not placing their negatives at risk.

Caring for the negative

Even a small amount of fixer spilled and not wiped up may become chemical dust. Once airborne it can deposit on materials at random. Even trace amounts of fixer on your hands or clothes, and subsequently transferred to a negative, can undo all your efforts towards permanent processing. There is no point in processing films for permanence if the next minute they are stained by hypo-laden hands.

When making prints it is often necessary to change negatives in the enlarger. Unless hands are thoroughly washed in soap and water, and dried on an uncontaminated towel, the negative may take up hypo from hands that are apparently dry and clean. Even if prints are handled with tongs or gloves, splashes may still occur.

The darkroom, measuring room, and drying room should be thoroughly aired and vacuumed as often as possible. Hands should be washed with soap and water and thoroughly dried before handling a negative.

The issue is simple: Do you want your work to last?

Appendix 1

REFERENCE FORMULAS

Where given below, the developing times come from a variety of sources and should only be used as approximate starting points. Mostly they are given for medium speed films. You will usually have to develop a third less for slow films, and a third more for fast films, but there are no hard and fast rules. All amounts are in grams, unless otherwise specified, and all are to make 1 liter. All development times are 68F/20C unless otherwise noted. Sodium sulfite and sodium carbonate are always anhydrous unless noted.

Agfa/Ansco film developers

	14	17	17A	17M
Metol	4.5	1.5	2.2	1.5 g
Sodium sulfite	85	80	80	80 g
Hydroquinone	–	3	4.5	3 g
Borax	–	3	18	– g
Sodium metaborate	–	–	–	3 g
Sodium carbonate monohydrate	1.2	–	–	– g
Potassium bromide	0.5	0.5	–	0.5 g
Water to make 1 liter				

 Agfa 14 is somewhat related to D-76, but the carbonate results in coarser grain, and necessitates bromide restraint. The Agfa 17 family is similar to D-76, but somewhat less solvent: results should be coarser grain and higher sharpness. 17A is the replenisher for 17; 17M is the metaborate version.

Ilford film developers

Historically, most published Ilford film developers have been either generic or Kodak knockoffs. Innovation only set in after Ilford perfected the manufacturing process for Phenidone in 1951. ID-68 is the most representative formula of this era. Another published developer of this era has no number, but is known to have been designed by Axford and Kendall, Ilford's principal chemists. It was assumed by Dignan, among others, to correspond to Microphen. That it was intended for professional use is indicated by the target pH indications which, as Grant Haist has remarked, should be specified for every developer. However, the pH specifications to two decimal places are a fussy absurdity: few

ID-68	
Sodium sulfite	85 g
Hydroquinone	5 g
Borax	7 g
Boric acid	2 g
Phenidone	0.13 g
Potassium bromide	1 g
Water to make one liter	

pH meter are capable of reliably measuring to two decimal places. There are two replenishers for this developer; one is for the topping up system; the second is for the bleed system.

ILFORD REPLENISHING DEVELOPER

		TOPPING UP	BLEED
Sodium sulfite	100	100	100
Hydroquinone	5	8	6.25
Borax	3	9	4
Boric acid	3.5	1	2.5
Potassium bromide	1	–	–
Phenidone	0.2	0.24	0.22
pH	8.95	9.28	9.09

Water to make 1 liter; all other quantities in grams.

Virtually all PQ developers provide a 30-60% speed increase over D-76 when the film is developed to normal contrast. However, sharpness and photographically acceptable gradation are very hard to obtain. The published and proprietary developers in Crawley's FX series were the first Phenidone developers designed specifically for the perfectionist photographer.

Once Kodak eventually made up its mind to use Phenidone, it produced innovative developers such as HC-110 (chapter 6) and XTOL (chapter 5). It is worth noting again that Phenidone developers with a shelf life greater than one year are almost impossible to prepare, especially if they must be packaged in polyethylene plastic rather than glass. Derivatives of Phenidone have proved more stable, but shelf life remains a concern. It is for this reason that XTOL is sold as a two-package powder.

As to replenishing systems: where volume is so high that a replenishing system is required, we suggest Kodak XTOL, based on the evidence available at this time.

Kodak Developer Formulas

DK-20 is given for historical reasons only. It represents an interesting attempt by Kodak in the 1930s to achieve super-fine grain without employing phenylenediamine. It continues to be cited in contemporary publications for its historical interest, but cannot actually be used on contemporary films with satisfactory results. Sharpness will be poor and dichroic fog likely. For those determined to try DK-20 with modern films, we suggest reducing the thiocyanate by 50% and adding 0.25 grams of polyvinylpyrrolidone as suggested in the prototype for HC-110 noted in chapter 6.

DK-20 was the first in Kodak's long line of developers based on D-76 which attempted to provide finer grain than D-76. It was replaced by D-25 in the 1940s, Microdol in the 1950s, and Microdol-X in the 1960s. See chapter 7 for more information on these developers. Other related developers include FX 5 and Perceptol. Kodak's most recent developer,

KODAK DK-20

Metol	5 g
Sodium sulfite	100 g
Sodium metaborate	2 g
Sodium thiocyanate	1 g
Potassium bromide	0.5 g
Water to make 1 liter	

XTOL (chapter 5), has finer grain and greater sharpness than D-76, but is not a continuation of this line of thought.

D-61A appears to be the first buffered MQ developer not to rely on borates. For old films the directions were: for tray use take 1 part of the stock solution to 1 part of water. Develop for about 7 minutes at 65F/18C. For tank use take 1 part of the stock solution and 3 parts of water. Develop for 10 minutes at 68F/20C.

D-76 variations—MQ fine grain developers

The most interesting variations on D-76 are the ones discussed in the chapter on solvent developers. However, a significant formula not mentioned there is Kodak D-89, which contains no hydroquinone, and pointed the way for future development of D-76 type developers.[1]

This formula was stated to be similar to D-76. It was intended for development of motion picture films by inspection when sampling of strips could not be done. Directions for the films of the 1930s were to develop for one minute in total darkness, then inspect with a two cell flashlight fitted with a 3.8 volt bulb and a Series 3 dark green filter. Two thicknesses of medium weight paper should be placed between the filter glasses to reduce the light further. The desensitizing action of the bath is said to decrease with age, whether it is used or not. (Crawley notes that the action of pure Pinacryptol Yellow solutions may increase with age—this may not happen when it is combined with a developer.) As noted in chapter 5, an improved form of D-76 can be prepared by increasing the metol or borax slightly, and omitting the hydroquinone. In D-89, where metol is 3 g/L, some loss of energy is probably due to the desensitizer. The effects of these desensitizing chemicals on modern films, particularly tabular grain types, is not known.

Of the conventional D-76 variants, only the Adox formula, with somewhat less sulfite and the addition of bromide, was of interest to Crawley, who studied these formulas carefully. When a variation has the difference of 98 g of sulfite instead of 100, or 4 g hydroquinone instead of 5 g, this is absolutely insignificant—in the former case, the difference of two percent is well within allowable measuring error; in the latter, since the hydroquinone is not active at the target pH, it makes no difference at all. In a PQ developer, where the interaction between the two developing agents is more complex, a 20% difference in the weight of the hydroquinone would have greater effect, even at a pH lower than 9.

Pyrogallol formulas

The most famous of all pyro formulas is Kodak D-1, affectionately referred to as ABC for its three solutions. The formula is discussed, and the working solutions are given, in chapter 8. Here we give the stock solutions and briefly discuss the famous Edward Weston dilution.

The Edward Weston dilution

The standard dilutions are 1:1:1:7 and 1:1:1:11. Weston's dilution is quite different: 3:1:1:30. Weston believed this dilution resulted in a better tonal scale with less risk of aerial oxidation. Weston was of course using

KODAK D-61A	
Metol	3 g
Sodium sulfite	90 g
Sodium bisulfite	2 g
Hydroquinone	6 g
Sodium carbonate mono	14 g
Potassium bromide	2 g
Cold water to make 1 liter	

KODAK D-89	
Metol	3 g
Sodium sulfite	100 g
Borax	5 g
Pinacryptol Green 1:500	5 ml
Water to make 1 liter	

ABC PYRO STOCK	
Solution A	
Sodium bisulfite	9.8 g
Pyrogallol	60 g
Potassium bromide	1.1 g
Distilled water to make 1 liter	
Solution B	
Sodium sufite anhydrous	105 g
Distilled water to make 1 liter	
Solution C	
Sodium carbonate mono	90 g
Distilled water to make 1 liter	

BÜRKI PYRO STOCK	
Solution A	
Pyrogallol	15 g
Sodium sulfite anhydrous	15 g
Water to make	250 ml
Solution B	
Sodium carbonate mono	100 g
Water to make	4 liters
To make 1 liter of working solution, add 50 ml of Solution A to 950 ml of Solution B.	
Develop 6 to 7 minutes at 68F/20C.	

films that have little relation to the working characteristics of today's films. Other dilutions might be found which work better with contemporary films.

Pyro-metol formulas

Pyro-metol is generally considered to be more useful than pyrogallol alone. The metol compensates for pyro's loss of speed, without spoiling the qualities for which pyro is prized. The table contains three formulas: BJ Pyro-metol, Wimberly WD2D in its latest incarnation (which no longer contains benzotriazole), and PMK. PMK stock solutions have, according to their formulator, exceptional shelf life. "Partially filled and stoppered bottles will last 10 years or more After a week or two, the color of stock solution A will turn a pale yellow color. This is the equilibrium point and no further change will occur." This makes them amongst the most useful of all photographic stock solutions.

One of the oldest pyro-metol formulas is the venerable British Journal of Photography formula. With old films, it produced a greenish-brown stain. By today's standards, there is too much metol, and the bromide is probably unnecessary. The weakest dilution given for this formula was 1:1:6. To be usable with modern films, 1:1:20 would be a more realistic starting point. (The original formula calls for potassium metabisulfite rather than sodium bisulfite. The substitution should not have any observable effect.)

	BJ	WD2D	PMK	
Solution A				
Distilled water	750	750	750	ml
Metol	8	3	10	g
Sodium bisulfite	20	10	20	g
Pyrogallol	9	30	100	g
Water to make	1	1	1	liter
Solution B				
Distilled water	750 ml	750 ml	1400	ml
Sodium metaborate	–	–	600	g
Sodium carbonate mono.	65	44	–	g
Water to make	1	1	2	liters

Directions for mixing PMK

These directions are quoted directly from *The Book of Pyro*.
Caution: Hutchings advises extreme caution when mixing any developer containing either pyrogallol or pyrocatechin. It is particularly important to avoid contact with the skin, eyes, and lungs. Since pyrogallol is crystalline, dust is not a major problem, but gloves should be worn when handling the dry chemical and when tray developing. See Appendix III for further safety recommendations. See *The Book of Pyro* for further safety recommendations specific to pyrogallol.

Stock Solution A

1. It is best to use distilled or deionized water for stock solution A, but

high quality filtered tap water can be used. Mix the solution with water at room temperature. Maximum solution purity and stability is obtained at this temperature.

2. Weigh out the sodium bisulfite first. From this quantity, take a small finger pinch of it and add it to the water for the A solution. Set the rest of the weighed sodium bisulfite aside.

3. Add the metol to the A solution and stir until it is *dissolved completely.*

4. Add the remaining sodium bisulfite and stir until dissolved.

5. Weight out the pyrogallol and add it to the stock solution *outside or under a ventilating hood.* See *Toxicity* in the *Appendix* [of the *Book of Pyro*] before handling.

Stock Solution B

1. Distilled or deionized water must be used for solution B. It is highly concentrated and a considerable quantity of the sodium metaborate may eventually precipitate if the water is not pure.

2. Dissolve the sodium metaborate in room temperature water. Best solution purity and stability will result at this temperature. It may be difficult to dissolve completely at this temperature, but any residual amount will dissolve by itself over a 24-hour period. The small amount of residual chemical will not affect the solution activity even if it is to be used immediately. The chemical will dissolve much more readily if the water is above 100°F, although upon cooling, a cystal precipitate may form.

Be sure to label all solution bottles. The shelf life of the stock solutions is exceptional. Partially filled and stoppered bottles will last 10 years or more. Clear glass is fine for PMK, if solution A is kept out of strong light.

After a week or two, the color of stock solution A will turn a pale yellow color. This is the equilibrium point and no further change will occur. (The PMK solutions can be used immediately after mixing.)

Working solutions of PMK

1 part A + 2 parts B + 100 parts water

Example: 10 ml A + 20 ml B + 1000 ml of water make approximately one liter of working solution (1030 ml). Measure the quantity of water and add the A and B stock solutions. It does not matter which is added first. *Note:* When the PMK working solution is mixed together, it will immediately proceed through color changes from grey-green to pale amber. This is an important visual check of solution activity. If there is no color change, something is wrong! Recheck stock solutions for correct formulation and the working solution for correct dilution.

Pyrocatechin formulas

In the Jacobson developer, the grade of potassium carbonate is not specified, but it can be assumed to be anhydrous. Better results will be obtained with the crystalline grade.

There is probably not a well-known developer that has been misprinted as frequently as the Windisch Pyrocatechin developer. It has been printed in dozens of books printed with substantial errors. This is the definitive formula with the definitive dilutions—we think.

JACOBSON PYROCATECHIN

Stock Solution A	
Sodium sulfite	40 g
Pyrocatechin	20 g
Water to make 1 liter	
Stock Solution B	
Potassium carbonate	120 g
Water to make 1 liter	
Working solution: 1 part A, 1 part B to 8 parts of water.	

WINDISCH PYROCATECHIN COMPENSATING

tock Solution A

Water (room temperature)	750 ml
Sodium sulfite	12.5 g
Pyrocatechin	80 g
Water to make l liter	

Stock Solution B

Cold water	750 ml
Sodium hydroxide	100 g
Water to make l liter	

There are two basic dilutions for the Windisch developer. The first, which we prefer, calls for 25 ml A plus 15 ml B plus water to make one liter. The second, preferred by Ansel Adams, calls for 40 ml A plus 10 ml B. Development times should be 9 to 12 minutes with modern films.

Caution: do not use pyrogallol, pyrocatechin, or sodium hydroxide without reading Appendix III on Safety thoroughly and taking the precautions advised.

Maxim Muir has been active in reworking some of the old pyrocatechin formulas. For his developer, Muir advises presoaking the film for 2 to 5 minutes in either plain water or water with Edwal LFN added per directions. We do not recommend presoaking or the use of wetting agents during development.

As can be seen, the stock solution is almost identical to the Windisch formula, except that 20 g of metabisulfite replaces Windisch's 12 g of sulfite. What is more significant is Muir's recommended dilution, which results in a more moderate developer. The working solution comes out to:

Pyrocatechin 0.8 g Sodium metabisulfite 0.2g Sodium hydroxide 0.5 g

MUIR PYROCATECHIN COMPENSATING

Solution A

Water (125F/52C)	500 ml
Sodium metabisulfite	20
Pyrocatechin	80
Cold water to make one liter	

Solution B

Sodium hydroxide	100
Cold water to make one liter	

Working solution: 10 ml A, 5 ml B to 1 liter of water; develop 6 to 8 minutes at 70F/21C for slow films

This is a very dilute developer, certainly capable of heavy tanning and staining.

For low contrast, Muir recommends an alternate solution B: instead of 10% sodium hydroxide, 10% sodium carbonate anhydrous. Muir believes this will allow N-2 and N-3 contractions with the following working solution: 10 parts A, 40 parts B, to a liter of water; 8 minutes at 70F/21C with slow films. Muir notes that N-2 and N-3 development result in "inevitable" film speed loss and midtone compression. While we agree that highly dilute developers compress midtones, if the developer is correctly balanced, there should not be a speed loss, but a speed gain. **We strongly recommend making the stock and working solutions of all pyrogallol and pyrocatechin developers with distilled water.**

Glycin developers

Glycin developers were among the first real high definition developers, especially when used as so-called stand developers: with developing times of about an hour and no agitation (chapter 4). The most famous photographer to use this kind of developer was Atget. A typical developer of the early 20th century is Hübl Paste, a highly concentrated suspension with excellent keeping properties. Indeed, this may be the most highly concentrated of all developer formulas. The potassium carbonate should be crystalline.

HÜBL PASTE

Hot water (130F/54C)	500 ml
Sodium sulfite	165 g
Glycin	135 g

Mix well, and add gradually:

Potassium carbonate cryst.	625 g
Water to make 1 Liter	

Shake well before use. The normal dilution suggested for turn of the century films was 1:12. As a guide for modern films, Paul Lewis suggests 1:35, developing Agfa APX 100 for 11 minutes. With all pure glycin developers, a speed loss of about one stop can be expected.

The classic modern developer using glycin is FX 2 (chapter 6). FX 2 is undoubtedly the best glycin developer yet formulated. Chapter 11 contains some suggestions for low contrast Phenidone-glycin developers for document films. But what about glycin and tabular grain films?

Could this agent be advantageous? For those willing to experiment, we propose TD-107 as a starting point. For more sharpness but coarser grain, replace the metaborate with 1 gram of sodium carbonate anhydrous.

TD-107	
Metol	1 g
Sodium sulfite	25 g
Glycin	1 g
Sodium bisulfite	1 g
Sodium metaborate	1 g
Water to make 1 liter	

MCM 100

This formula originally required Meritol, a developing agent that was the reaction product of an an equimolar admixture of p-phenylenediamine and pyrocatechin. After Meritol was no longer available, the formula was revised to provide the same functional results with the two chemicals split up. We publish the formula because, unlike most PPD formulas, it can work with some modern films, due to its high alkalinity and the high energy of pyrocatechin, which accounts for most of the development. This formula illustrates how useful phosphate alkalis can be. MCM 100 is said to offer normal emulsion speed. On older films developed in MCM 100, the emulsion side of the film had the appearance of being so highly polished that it was difficult to distinguish from the base side.

Presoak the film in water or a 5% solution of sodium sulfite for 2 to 3 minutes to remove the anti-halation coating which may restrain development. Use a running water stop bath with this developer and fix in an alkaline fixer. It is essential not to use an acid hardening fixer with any developer containing any form of sodium phosphate.

MCM 100	
Water (125 F/52 C)	750 ml
Sodium sulfite	88 g
p-Phenylenediamine	7 g
Pyrocatechin	9 g
Borax	2.3 g
Trisodium phosphate, cryst.	6.9 g
Potassium bromide, 10%	2 ml
Cold water to make 1 liter	
Do not use the monohydrate of trisodium phosphate.	

Traditional Rodinal

There have been hundreds of unauthorized publications of the "original" Rodinal formula. All of the most authentic ones consist of 100 grams of p-aminophenol hydrchloride and 300 grams of potassium metabisulfite in a liter of water. To this is added a 50% solution of sodium hydroxide, drop by drop, until only a few crystals of precipitate are visible. All classic Rodinal formulas *must have* a crystal or two of precipitate at the bottom of the container. If they do not, the developer will not work well and the concentrate will not keep. The best instructions for making this formula were given to us by Dr. Elie Shneour, as follows:

Caution: When making up the 50% solution of sodium hydroxide heat is generated. The solution must be cooled before adding to the developer. Add a small amount of sodium hydroxide to the water, let dissolve, check heat, then add a little more. Never add water to the sodium hydroxide. Only add hydroxide to the water. **Use gloves and protective eye goggles, and carefully read the additional information in Appendix III regarding sodium hydroxide.**

Note: Although it is sometimes considered acceptable to substitute sodium metabisulfite for potassium metabisulfite, the substitution is not successful in this formula.

Allow Solution A to cool. A precipitate of p-aminophenol hydrochloride will form. Place Solution A in an iced water bath and, with continuous mixing, slowly add 280 ml of Solution B. Then very slowly add additional Solution B until a sudden darkening in color takes place. Finally, add, drop-by-drop, Solution B until only a few crystals remain.

TRADITIONAL RODINAL	
Solution A	
Water (125 F/52 C)	750 ml
p-Aminophenol hydrochloride	100 g
Potassium metabisulfite	300 g
Cold water to make 1 liter	
Solution B	
Cold water	300 ml
Sodium hydroxide	200 g
Cold water to make	400 ml

The developer will, in time, turn dark brown. The stock solution will last for several years. Some Rodinal experts believe that Rodinal-type formulas should be used within a few weeks for optimum and consistent results. Others believe that it improves with age. Although its characteristics do change with age, the change is not dramatic, and the developer remains viable for an astonishingly long time.

This formula can be used at dilutions ranging from 1:25 to 1:200. The most frequently used in continuous tone photography are 1:50, 1:75 and 1:100. Developing times published for Agfa Rodinal in the Developing Time Chart at the end of this book can be used as a starting point.

Windisch Film Developers

WINDISCH METOL-SULFITE	
Metol	2.5 g
Sodium sulfite	25 g
Water to make 1 Liter	

The Windisch metol-sulfite formula is identical to D-23 except that metol is exactly at one-third and and sulfite exactly one-fourth. Functionally, then, it is simply D-23 1:3. Some photographers have been reporting promising results with tabular grain films. Developing times will be on the long side, certainly over ten minutes. Although state-of-the-art tabular grain developers such as XTOL and FX 37 are likely to give more satisfactory overall results, we believe this formula (or D-23 1:3) should be investigated further. Certainly, it seems clear that tabular grain films work best with a developer that contains less than 35 g/L of sulfite per liter of working solution, as this one does.

Windisch's more famous developer, the pyrocatechin formula, is listed in this appendix under the section on pyrocatechin developers and is also discussed in chapter 8. Windisch's other famous formula was a super-fine grain developer based on *o*-phenylenediamine. It can be found in *The Darkroom Cookbook*.

Monobath Formulas

In a monobath, development and fixation both take place in the same solution. For those who wish to experiment, here are two formulas. To use either formula, gitate continuously for the first thirty seconds, then every 10 seconds every 30 seconds thereafter. At 75°F the film should be fully developed in less than three minutes, and will develop no further. However, due to the relatively low concentration of hypo, fixing usually takes from 4 to 7 minutes. If you remove the film from the solution prematurely it will have a milky-white appearance. Don't panic. Simply place the film back in the solution, continue agitating as you would for normal fixation, and the fixing process will continue.

Phenidone is often difficult to dissolve except in highly alkaline solutions. With these formulas, using sodium hydroxide as the alkali, start with water at room temperature and dissolve the sulfite. Do not use water over 75°F, as the hydroxide may heat up and spatter. After the addition of the Phenidone, add a pinch of hydroquinone followed by the sodium hydroxide. The Phenidone will dissolve completely; the small amount of hydroquinone will help prevent oxidation of the phenidone. Then add the remainder of the hydroquinone and other chemicals in the order given. **Read the cautions regarding sodium hydroxide in Appendix III. Wear gloves and protective eye goggles.**

G.W. CRAWLEY (BJ ANNUAL, 1974)

Water at room temperature	750 ml
Sodium sulfite	50 g
Phenidone	1 g
Hydroquinone	12 g
Sodium thiosulfate	70 - 125 g
Sodium hydroxide	10 g
Water to make	1 liter

KODAK RESEARCH LAB (PHOTO. SC. ENG. 5, 198 (1961)

Water at room temperature	750 ml
Sodium sulfite	50 g
Phenidone	4 g
Hydroquinone	12 g
Sodium thiosulfate	110 g
Sodium hydroxide	4 g
Water to make 1 liter	

Of these two formulas, we prefer the BJ version by Crawley. They are very similar, but note that the Kodak formula calls for 4 grams of Phenidone, which is very hard to dissolve, as opposed to the 1 gram in Crawley's formula, which uses more sodium hydroxide to compensate. In Crawley's formula, the precise amount of thiosulfate is left open. This is an underlying principle of all monobath formulas. The precise amount of thiosulfate required depends on how quickly the particular film being used fixes. Slower, finer grained films have a faster clearing time, and therefore need less thiosulfate. Faster films, especially tabular grain films, will need the maximum amount of thiosulfate.

Washing time after monobath processing is exceedingly rapid because the solution is alkaline. No more than five minutes is needed for a wash to archival standards. However, as sodium thiosulfate is no longer recommended for fixing films, it is hard to recommend the use of these traditional monobath formulas unconditionally. We have seen no formulas published for ammonium thiosulfate monobaths. Development would have to be exceedingly rapid.

ACID STOP BATHS

Chapter 12 makes clear that the authors strongly favor all-alkaline film processing without acid stop baths. Nonetheless, the chapter contains our two best suggestions for using acid stop baths today: a buffered acetic acid stop bath and an odorless boric acid stop bath. Other odorless acids can be used, such as citric acid, but most must not be used when an acid hardening fixer (which we also do not recommend) is to follow the stop bath. The only two commonly available acids which are entirely compatible with acid hardening fixers are acetic acid and boric acid. The historical literature on stop baths does not contain any information more valuable than to use the traditional 2% acetic acid stop bath. This should, of course, for safety's sake, be made up from 28% acetic acid, not from glacial acetic acid. Potassium metabisulfite

stop baths should be avoided at any price: there is the danger of some of the potassium salts being carried over into the fixer, and creating salts of potassium thiosulfate, which will ruin the process of fixation.

ALKALINE STOP BATHS

Alkaline stop baths have not yet gone beyond the experimental stage. The approach that has been taken is to use a high concentration of an antifoggant, such as 5–10% potassium bromide, 0.5–1% benzotriazole, or 0.05–0.1% 1-phenyl-5-mercaptotetrazole. Sodium sulfite should be added as a preservative to help prevent swelling and oxidation staining. Between 2 and 5% is a suitable amount. An alkali buffering system may be used to keep pH within the desired range, which will probably be between 8.5 and 10. A combination of sodium metaborate and sodium bisulfite would be suitable for trial.

SODIUM THIOSULFATE FIXER FORMULAS

KODAK FIXERS

	F-5	F-6	F-10	F-24
Sodium thiosulfate pentahydrate	240	240	330	250 g
Sodium bisulfite	–	–	–	25 g
Sodium sulfite anhydrous	15	15	7.5	10 g
Boric acid crystalline	7.5	–	–	– g
Sodium metaborate (Kodalk)	–	15	30	– g
Acetic acid 28%	48	48	71.25	– ml
Potassium alum	15	15	22.5	– g
		Water to make 1 liter		

The table above lists the traditional Kodak sodium thiosulfate fixers. These are better formulated than any other competing published formulas. All of these formulas are rated to be able to fix about 20 to 25 rolls of 35mm, 36 exposure film (80 square inches). F-5 is the standard sodium thiosulfate-based formula. The commercial product known as Kodak Fixer is functionally identical. Most acid fixing formulas produce strong odors caused by sulphur dioxide emanating from the reaction of acid and sodium sulfite. In F-6 and F-10, odor is substantially reduced. The non-hardening formula, F-24, has been recommended for use with tanned negatives, such as those developed in pyro or catechol, as it is less acidic than the hardening formulas. However, it is still too acidic, and too high in sulfite, to be ideal for processing tanned negatives. *We have made clear that we do not believe sodium thiosulfate should be used to fix contemporary photographic materials (chapter 12).*

Alkaline sodium thiosulfate fixers

It is simple to construct an alkaline sodium thiosulfate fixer. One formula is TF-2. Although this fixer will wash out of negative and print materials more rapidly than any acid fixer, we only give this formula for users who are determined to use sodium rather than ammonium thiosulfate and who would like a formula superior to the traditional acid hypo fixers. It would, however, be appropriate to use for negative or

TF-2 ALKALINE FIXER

Water	750 ml
Sodium thiosulfate	250 g
Sodium sulfite anhydrous	15 g
Sodium metaborate	10 g
Water to make 1 liter	

print materials that contained little or no silver iodide, such as some hand-coated materials used in alternative processes. If sodium thiosulfate is used to fix contemporary print or negative materials, be sure to fix for *three times the clearing time*, rather than the traditional recommendation of twice the clearing time. This will alleviate, though it may not eliminate, concerns about the ability of sodium thiosulfate to fix iodide-containing materials adequately. As with all alkaline fixers, washing is very rapid and hypo clearing agent is not necessary. For films, a two-minute wash in running water should be archivally adequate. That time can be extended to five minutes for peace of mind, but will not bring residual thiosulfate levels appreciabily lower. Fiber-based prints should be washed for at least 30 minutes.

HARDENERS

For much of this century, formaldehyde hardeners have been recommended when hardening is necessary. However, researchers have known for decades that formaldehyde should not be allowed anywhere near a photographic material. The preferred hardeners are glutaraldehyde and succinaldehyde. Glutaraldehyde is the most readily available. It hardens best at a pH of about 10, near the pH of sodium metaborate.

A 25% solution of glutaraldehyde is the most readily available. TH-5 should not be kept for more than a week. This formula can be used as a prebath for 2 minutes, before development, when it is necessary to process at high temperatures. Glutaraldehyde can also be added to one-shot developers if desired—again, 30 ml of the 25% solution can be added to virtually any developer when extra hardening is needed.

Theoretically, glutaraldehyde could be used not just to harden films but to harden prints. However, as there is some tanning action, depending on the strength of the solution and how long the material is processed, there is also potential for some darkening of the material. We have experimentally used TH-5 on some papers for two minutes and have not found visible darkening of the whites. But we have not conducted aging tests and would not advise treating prints with aldehydes until more research is done.

High temperature processing

Acid hardeners have been recommended for use when processing temperatures above 80°F cannot be avoided. But they can only be used after the stop bath stage, yet hardening is needed at the developing stage too. This is yetanother reason to use glutaraldehyde before developing.

Acid hardeners

Acid hardeners such as chrome alum and potassium alum are no longer recommended in fixers because they must be used in acid solution and thus directly and indirectly cause longer washing times. However, where it is necessary to harden films or prints, potassium alum can be used after washing. An acid hardener can be made by mixing all of the ingredients of F-5 or F-6 except the sodium thiosulfate. Process the material for 3–5 minutes with intermittent agitation.

TH-5 HARDENER	
Water	750 ml
Glutaraldehyde 25%	30 ml
Sodium sulfite	20 g
Sodium metaborate	2 g
Water to make 1 liter	

NOTES

1.Crabree and Matthews, *Photographic Chemicals and Solutions*, American Photographic Publishing Co., Boston, 1939; Improvements in Laboratory Apparatus", C.E. Ives, A.J. Miller and J.I. Crabree, *J. Mot. Pict. Eng. 17*, 26 (1931).

Appendix 2

MIXING SOLUTIONS

When mixing solutions, especially those intended for storage, all operations should be slowly and gently carried out, so that no air is introduced into the solution. Concentrated liquid developers keep well until oxidation begins. Once oxidation begins, it proceeds very quickly.

All developers will oxidize when exposed to air. MQ and PQ developers containing high concentrations of sodium sulfite are slow to oxidize. High-energy developers containing caustic alkali, developers containing pyrogallol, amidol, and many others, oxidize rapidly, and should be used immediately after mixing the working solution.

Sequestering agents

Sequestering agents are used in virtually all commercial developers to deal with water quality problems in some areas. For mixing formulas from scratch, Calgon has in the past been widely recommended. Today, EDTA (ethylene-diamine-tetraacetic acid) is more often recommended, but manufacturers seem to prefer a more recent form, diethylene-triamine-pentaacetic acid, pentasodium salt (40%).

Crawley does not recommend the use of sequestering agents in most developers, particularly high definition developers. We recommend not using sequestering agents when possible. It is usually economically feasible to use distilled or deionized water for mixing stock and working solutions of developers, which obviates the need for sequestering agents. Sequestering agents are not photographically inactive under all circumstances. For instance, Gordon Hutchings reports that using greater than 0.05 g/L of EDTA in PMK working solution results in loss of desirable stain. Nevertheless, he recommends the use of this chemical to smooth out uneven development "when all attempts to vary agitation patterns still yield uneven development."

Mixing and scales

Most of the formulas in this book are available in kits with each chemical premeasured from Photographers Formulary and Artcraft. If, like many, you prefer to mix from scratch, you will need a good scale. There are many fine scales available for accurately weighing chemicals. The scale should have readability to at least 0.1 grams and contain a counter-balance system, or tare, to compensate for the weight of the measuring container or paper.

Scales are available in either mechanical or electronic models. An

inexpensive mechanical scale, the Pelouze R-47, is available through camera stores in either metric or US Customary (Avoirdupois). It is accurate enough for quantities to 100 grams and has a good counter-balance system.

The next step up in a mechanical balance is the Ohaus Triple Beam Balance. The model 750 will weigh up to 610 grams, which is more than enough for the small darkroom. The Ohaus is about the best mechanical balance for less than $100. However, its tare-system is poorly designed. For this reason the Ohaus 1600 Series Dial-O-Gram, though more expensive, is a better investment.

For about the same price as the Ohaus 1600 the electronic Acculab Model V-400 is an excellent choice. The Acculab takes up less counter space than any mechanical balance and, being electronic, is more accurate and easier to use. The capacity of the Acculab V-400 is 400 grams and it can be switched from grams to ounces.

If you will often be weighing small amounts of chemicals like Phenidone, you will need a scale with readability and accuracy to two or three decimal places. Going from 0.1 g readability to 0.001 g readability more than doubles the price of the scale. A suitable though expensive scale is Acculab's V-3mg.

A convenient method for weighing small amounts of chemicals is to place them on pre-cut pieces of paper. Write the name and weight of each chemical on the paper, and arrange the chemicals on the mixing bench in the order of use. In this way they can be checked before mixing to avoid errors. For amounts over 20 grams, use a small Dixie Cup instead. Polystyrene weighing dishes are very convenient. They can be washed and reused. They are available from chemical and laboratory suppliers.

Working with the chemicals

Dissolve each chemical thoroughly before adding the next. Stir gently, to reduce the introduction of air into the solution, and never shake to dissolve the ingredients. Use glass, enamel ware, hard rubber, or plastic containers to mix the solutions. Metals such as tin, copper, or galvanized iron will react with the ingredients of the developer to create fog and other unpredictable effects.

For most developers the sulfite should be dissolved first in order to retard the oxidation of the reducing agent when it is added. The exception is metol which does not dissolve in a *strong* solution of sulfite. Fortunately, metol oxidizes slowly so it is usually acceptable to dissolve the metol first then immediately add the sulfite. The recommended method is first to dissolve a pinch from the total sulfite, then follow with the metol, then the rest of the sulfite.

Unless otherwise recommended use water at about 125F/52C. There are several exceptions to this. The first is when mixing caustic soda: sodium or potassium hydroxide. Both produce considerable heat when added to water. They should always be dissolved separately in cold water and then slowly stirred into the rest of the developer. Intense heat is also generated by combining sulfuric acid and water. Always add the acid to the water, and never the reverse, or serious injury may result

from spattering. Add the acid slowly, or the sudden heat may break the container if it is glass. **See the precautions in Appendix III before using hydroxides or strong acids.**

Another exception is any developer which contains pyro or amidol. Hot water accelerates their already too rapid rate of oxidation.

Note: Although 125F/52C is the almost universal recommendation for mixing photographic solutions in the US, in the UK, temperatures of 75-80°F are more commonly used. The idea is that, though mixing may sometimes be more difficult, there is less likelihood of agent decomposition. For most formulas the lower temperature works well.

Unless called for, filtering is not necessary if the water is clean. Any ordinary sediment will be precipitated out if the solution is allowed to stand without agitation until cooled. If filtering is necessary it is usually sufficient to filter through absorbent cotton or fine cloth that has been washed to remove any sizing matter it might contain. Other good filter materials are Bounty Microwave towels and paper coffee filters. Filtering through tightly woven paper or fabric is a slow process and should be avoided as it exposes the solution to the air, causing avoidable oxidation.

Special considerations

A few chemicals sometimes require special treatment to make them easily dissolve in water.

1. Phenidone tends to cake when added to water. It can be crushed in the bottom of the solution by using the end of a clean screwdriver (preferably stainless steel, and don't use glass). Dissolving Phenidone in a little alcohol first often helps. We owe to Paul Lewis the insight that dissolving Phenidone at 150F/65C seems to elmininate most solubility problems. The solution should be cooled as soon as possible. Although weighing out small amounts of Phenidone is difficult, using a stock solution of this chemical is not advised, as no solvent is known in which Phenidone is stable, although many recommendations have been published.

In addition, Phenidone does not have a long shelf life in dry form. The chemical should not be used for film developers if it has been kept for more than six months, though it can work acceptably in print developers at that point.

2. Sodium carbonate which has clumped together while dry may form a hard crystal that is difficult to dissolve. The solution is to grind the carbonate powder with a mortar and pestle (or the end of a clean screwdriver) before adding it to the solution.

3. Boric acid is always hard to dissolve, even at concentrations less than 5%. Leaving the solution overnight will usually work.

Storing stock solutions

Aeration, or oxidation, is the primary cause of developer deterioration. Most developers prepared with water that has been boiled to remove the gases and allowed to settle, or with distilled or deionized water, will keep well for at least three months if stored in a filled and stoppered glass bottle. Many stock solutions will last much longer than this.

Rodinal and PMK are particularly noted for long life. Developers that contain Phenidone may be the most difficult to keep long, so the simplest thing to do, if you need to keep a stock solution for months or even years at a time, is not to use Phenidone.

Oxidation occurs in proportion to the amount of air in the container and is often apparent by a change of color of the developer. However, many developers can oxidize without a change of color. To keep stock solutions for many months, an old piece of advice is to dip the top of the container in melted paraffin to seal out air. Adding glass marbles to the bottle to keep out air is another old trick. When available glass should be used in preference to plastic containers.

For those interested in the state of the art, here it is: Tetenal, more than any other photographic company, has devoted considerable research to the problem of keeping concentrated solutions fresh. First, noting that it is no longer feasible to ship chemical solutions in glass containers, Tetenal recommends that if solutions are to be stored for long, they should be transferred to glass after opening. But there is still air in the container. Removing that air can, according to Tetenal, extend the life of solutions by 2 to 4 times. Tetenal's Protectan Spray appears to be a compressed gas heavier than air, probably simple nitrogen. It is sprayed onto the surface of the solution, driving away the air, and the bottle is sealed until the next use. Photographers who already have nitrogen on hand for nitrogen burst agitation systems may be able to improvise a similar system. At the time or writing, Protectan is only available in Europe.

AN EXAMPLE OF IDEAL MIXING PRACTICES

Although it is not necessary to mix all developers in the stringent manner recommended below by Crawley for FX 1 and FX 2, his instructions for mixing and storing make an excellent guide for those who wish exact control over the variables in the process. These methods may be used with other developers as desired.

These stock solutions were designed with considerable care, and if stored properly, may be kept six months without deterioration, particularly the very stable FX 2.

FX 1 STOCK SOLUTIONS

Stock Solution A

Metol	15 g
Sodium sulfite anhydrous	50 g
Potassium iodide, 0.001%	50 ml
Water to make 1 liter	

Stock Solution B

Sodium carbonate anhydrous	50 g
Water to make 1 liter	

Working Solution: 1 part A, 1 part B, and 8 parts of water. Stir gently for two minutes, and allow to stand for a minute more. Discard after use.

Mixing stock solution A

Boil the water (you will need just over 2 liters for both solutions) for three minutes, then cool to about 86F/30C. Place 500 ml of water in a container. Stir in a pinch of the sulfite. Then gently stir in the metol, until dissolved. Follow with the sulfite, and finally the potassium iodide solution. Add water to make 1 liter. Filter, through coffee filter paper, preferably one free of additives. Fifty ml of the water can be replaced with isopropyl alcohol to improve keeping qualities and avoid precipitation in extreme cold. Store in securely capped, filled, glass bottles.

The stock solution will keep for a year unopened, or until discoloration is evident. A faint yellowish tint can be ignored, but anything deeper means the solution must be discarded.

Mixing stock solution B

Pour 500 ml of water in a container, stir in the carbonate, and stir gently until dissolved. Stir in water to make 1 liter. Store as above. This solution should be stored in plastic if it is to be kept for more than a few weeks, as it might etch glass. It lasts indefinitely in completely full bottles. In partially full bottles it should be replaced after two months to maintain consistency.

Single Solution Concentrate: The chemicals in solutions A and B may be mixed together in a single solution to make 1 liter. Again, alcohol may be used. Discard when discolored. The working solution is prepared by adding 100 ml of stock to 900 ml of water. This solution is not as stable.

FX 2 STOCK SOLUTIONS

FX 2 STOCK SOLUTIONS	
Stock Solution A	
Metol	2.5 g
Sodium sulfite anhydrous	35 g
Glycin	7.5 g
Water to make 1 liter	
Stock Solution B	
Potassium carbonate crystals	75 g
Water to make 1 liter	
Stock Solution C	
Pinacryptol Yellow 1:2000	
Working Solution: 100 ml A, 100 ml B, 3.5 ml C; water to make 1 liter of working solution.	

Mixing stock solution A

Boil slightly over 1 liter of water for 3 minutes and cool to about 86F/30C. Use clean mixing and storage containers. Measure out 800 ml of water, and gently stir in a pinch of the sulfite. Next add the metol, then the rest of the sulfite, and finally the glycin, making sure that each chemical is fully dissolved before the next is added. Stir gently with a rod, trying not to aerate the solution. If the glycin fails to dissolve, either add a pinch of carbonate (from the 75 grams) or, preferably, add 50 ml

of isopropyl alcohol, which will improve keeping qualities and resistance to precipitation in the cold. Add water to make 1 liter.

Filter the solution, and pour into bottles filled to the top, and securely capped. The solution keeps for a year unopened. It is a clear golden tint when fresh, and should be discarded when it discolors to a deep yellow, or a shade noticeably darker.

It is not necessary to use distilled water, although this is always a good precaution. Even if distilled water is used, filtering is necessary. Use a good grade of sulfite, relatively free from impurities, as well as really fresh glycin, if this developer is to be kept for several months.

Mixing stock solution B

Boil slightly over 1 liter of water for 3 minutes and cool to about 86F/30C. Dissolve the carbonate in 800 ml of water. Add more water to make 1 liter. This solution maintains activity indefinitely in a full bottle. However, renew a half-used solution after two months to maintain consistency. As with the FX 1 carbonate solution, keep in plastic rather than glass if you plan to store for more than a few weeks. All other photographic solutions should be stored in glass.

Stock solution C

Preferably, obtain this as a prepared solution at 1:2000 dilution. If you must mix it, dissolve the Pinacryptol Yellow first in a little alcohol, then in distilled water to make a 1:2000 solution. It keeps indefinitely away from strong light. However, after two years, an increase in activity may occur, and it should be discarded.

Most other developers can be mixed using these guidelines.

Appendix 3

CHEMICAL SAFETY

The way we think about safety has evolved dramatically in recent decades. Safety guidelines are, rightfully, much more stringent than ever. Yet experienced chemists often wonder if we have not gone too far in the other direction? If metol were discovered today it would probably not be approved by any regulatory authority. Indeed, all developing agents used today, except ascorbic acid (vitamin C), are toxic by today's standards. Yet, to place the application of the word "toxicity" in some perspective, many of the developing agents considered the most toxic are present in such common cosmetic products as permanent hair dyes, and powerful alkalis such as sodium and ammonium hydroxide are used in many common household cleaning products.

Even vitamin C is under a cloud of doubt as of 1998. Multigram daily supplements of vitamin C have been widely recommended for over two decades. Yet researchers have recently found that ingesting as little as 500 mg per day can cause measurable genetic damage in humans in as little as six weeks. Large vitamin C supplements apparently have oxidant, as well as antioxidant, effects. The vitamin C naturally present in food is said not to have these oxidizing effects.[1]

In spite of all these dangers, a recent 31-year study of photographic processors (working with both black and white and color films and papers) exposed to photographic chemicals full-time, on a daily basis, over most of their working lives, shows that *photographic processors have a lower mortality rate* when compared either to the general population or to all hourly workers. Nor was there any evidence of any increase in any particular cause of death. Commenting on these data, the Encyclopedia of Occupational Health and Safety concludes that "Based on available epidemiological information, it does not appear that photographic processing presents an increased mortality risk, even at the higher concentrations of exposure likely to have been present in the 1950s and 1960s."[2]

Although we are now accustomed to thinking of most chemical substances, including vitamins, as potentially toxic, it appears, in the ordinary black and white darkroom, that if we exercise ordinary prudence with chemicals, including not eating them, we are unlikely to suffer ill effects. Based on the available literature, ordinary prudence appears to mean taking reasonable precautions against chemical exposure to the skin, the respiratory system, and the eyes.

General guide to chemical safety

The *Focal Encyclopedia of Photography,* 3rd edition, contains an article entitled "Chemical Safety" by Grant Haist.[3] We reprint this section, with Dr. Haist's permission, in its entirety as a guide:

> Safe handling of chemicals and solutions simply involves preventing any contact with human skin, eyes, or respiratory system or internal ingestion. Safety glasses or shields, an apron or laboratory jacket, and keeping the hands away from the face and mouth, will greatly minimize some of the potential dangers. Not smoking or eating candy or food in work areas will also help to eliminate possible mishaps. A workplace with adequate ventilation, or the use of a respirator, will limit the inhalation of air contaminated with dust, gases, vapors or fumes.
>
> Good laboratory and darkroom practices should be followed at all times. Label all bottles and containers, keep them closed except when in actual use, and store them in cool, dry areas away from direct sunlight (out of reach of children). Store liquid and processing solutions safely. Breaking a gallon glass bottle of glacial acetic acid is a major disaster. Always add acids and bases slowly and carefully to the surface of the water. Do *not* add water to strong acids and bases. Do not mix chemicals haphazardly, even during final disposal.
>
> Accidents, spills, and mistakes do happen during chemical handling and photographic processing. Clean up promptly all spilled chemicals and solutions. Do not wear sandals, opentoed, or canvas shoes as these provide little protection against spills or dropped containers. Clean gloves, aprons, and clothing or shoes that have become contaminated. Gloves, inside and out, should be clean to avoid chemical contamination of the skin, face, or mouth.
>
> Prompt removal of chemicals from the skin is essential. Wash thoroughly with plenty of water any part of the body that may have contacted chemicals. See a physician if any chemicals reach the eyes, as few substances are not irritating or painful. Chapping of the hands from the drying and cracking effects of alkali on the skin or breaks in the skin from cuts and bruises are major points of entry of poisons into the body. Acid types of hand cleaners are sometimes recommended for the removal of highly alkaline solutions, such as color developing solutions.
>
> Certain photographic chemicals and solutions require greater caution because they may cause allergy or contact dermatitis and skin sensitization of increased reactivity. Color developing agents and color developing solutions containing *para*-phenylenediamines, especially those of low water solubility, are primary causes of dermatitis. Black and white developers containing *para*-methylaminophenol (metol) or tanning developing agents, such as pyrogallol, also require care in handling. Gelatin hardening agents, particularly

formaldehyde, glutaraldehyde and chromium compounds, are potential sources of irritation. Certain chemicals that are relatively innocuous by themselves may react dangerously, even explosively, when combined with other chemicals. Other combinations of chemicals may emit poisonous gases, such as cyanide fumes or chlorine. Dangerous mixtures of chemicals are shown in the table.

Dangerous mixtures of chemicals[4]

DO NOT COMBINE	WITH
Acetic acid	chromic acid, nitric acid, peroxides, and permanganates
Ammonia	Halogens, calcium hypochlorite, or household bleach
Ammonium nitrate	Acids, chlorates, nitrates, combustible materials
Cyanides	All acids
Hydrogen peroxide	Most metals (particularly copper, chromium and iron) and their salts
Iodine	Ammonia
Nitric acid	Acetic, chromic or hydrocyanic acids, flammable substances
Oxalic acid	Silver
Potassium permanganate	Ethylene glycol, glycerol, benzaldehyde, and sulfuric acid
Sulfuric acid	Chlorates, perchlorates, and permanganates

Additional precautions

Keep all chemicals away from children and pets. If necessary, lock them up. Label and date all containers. Be sure storage bottles have a secure cap. Store chemicals in a cool, dry area away from direct sunlight.

Become familiar with all the inherent dangers associated with any chemicals being used. When acquiring chemicals, ask about proper handling and safety procedures.

Near the telephone, prominently display the telephone numbers for poison control, health information hot-lines (see **Other Sources** at the end of this chapter) and emergency treatment centers in your area.

Read and follow all instructions and safety recommendations provided by the manufacturer before using any chemical or chemical product. This includes mixing, handling, disposal, and storage. Request a Material Safety Data Sheet (MSDS) from the manufacturers of photo chemicals. Collect these in a loose leaf binder and keep it where someone can find it in an emergency. MSDS's and product label can be valuable sources of safety information.

Some chemicals, such as alcohol, are flammable. Keep them away from any source of heat or open flame to avoid a possible explosion or fire. Keep a fire extinguisher that can be used for both chemical and electrical fires in the work area.

If you are pregnant or have any pre-existing health problem, read all safety information carefully to determine if there are any additional precautions you should be aware of.

People have varying sensitivities to chemicals. If you have had allergic reactions to any chemicals, you should pay close attention to the effects that darkroom chemicals have on you, and you should be extra careful about following safety procedures.

Protecting your eyes

The most important factors in preventing accidental damage to the eyes are: wearing safety glasses with side shields or goggles or, at the very least, eyeglasses, and having in the darkroom a source of water that you can flush your eyes with that can be found even in the dark. If a chemical is accidentally splashed in the eyes, it must immediately be rinsed for at least 15 minutes in continuously running water, followed by immediate medical attention.[5]

Among other things Henry notes:

Speed is paramount and every laboratory sink should (must) have at least one cold water outlet with an attached soft rubber hose with an easily findable valve so that, groping in the dark, you can easily find it and flush your eyes or whatever with cold water. I cannot overemphasize that, of all the major body organs prone to occupational injury, the eye is the most vulnerable.

Henry notes the hazards connected with wearing contact lenses in the darkroom. Other safety experts now believe that contact lenses may exert a protective effect by preventing the chemical from touching the eyeball. Immediately flushing will take out the contact as well as the chemical.

All of the material we have been able to find on eye safety makes clear that the major hazards are from accidental splashing of strong acids, such as hydrochloric acid, or caustic alkalis, such as sodium and potassium hydroxide. To avoid these risks, simply do not use these chemicals in your photographic processing. See the section below entitled "Avoiding strong acids and alkalis in photographic processing."

Protecting your hands

We strongly suggest the use of neoprene gloves when mixing and using photographic chemistry of any kind. Wear neoprene or nitrile gloves such as Bluettes or Bench Mark, both made by MAPA, and a plastic apron. Latex gloves are not suitable. Just as important as wearing gloves is cleaning them after use. Wash thoroughly in mild soap and water, and hang up to dry until the next use.

Protecting your lungs

Safety authorities often recommend the use of dust masks, or respirators, when mixing photographic chemicals. Some of the chemicals used by photographers are fine powders which may be hazardous if inhaled. Henry states: Proper handling, however, can minimize the risk. Many chemicals, on the other hand, are crystalline, not fine powders.... Common sense tells you how to minimize dust problems. For example, in preparation of 1 quart of D-76 developer I fill up a container slightly larger than 1 quart with the prescribed 125F water, but short of the 1 quart mark placed on the container, cut off a corner of the D-76 packet and place the corner *below the water surface* and let the packet's contents fall into the water. Result—no dust. Remove empty packet and

carefully fold the top down to close the empty packet. Result—minimal or no dust. After the D-76 is brought into solution, water is added to a final volume of 1 quart and the solution mixed. Small amounts of powders can be weighed out or dissolved with a minimal or no dust problem if care is taken. For example, do not let the material on a spatula or plastic spoon empty on a weighing paper from any height greater than is absolutely necessary. This would definitely produce much more dust."

One recommended way of minimizing exposure to potentially hazardous dust or vapor is to have adequate ventilation in the darkroom. But in the real world, not every photographer has an adequately ventilated darkroom. In such a case, it is especially important to avoid using chemicals that emit gases or vapors. Avoiding acid fixers and stop baths is an excellent precaution. Keeping containers closed when not in use is another. In film development, avoiding the use of open trays by developing only in closed containers, will prevent the buildup of gases and vapors. If there is one thing more than another photographers should consider investing in, it is a well-engineered ventilation system for their darkrooms. The *Darkroom Cookbook* contains additional information on this subject.

Electricity in the darkroom

Avoid touching any electrical equipment with wet hands. Install shockproof outlets (ground fault interrupters) in your darkroom. Henry states: "*All* electrical equipment used in a darkroom should be properly grounded. If the wire cord has a 3-prong male connector, or has a UL (Underwriter's Laboratory) label on the equipment, you can assume proper grounding as long as the outlet receptacle will accept the 3-prong male plug. Similarly, if there is a 2-prong male connector with 1 prong larger than the other so that it can be placed in the female wall outlet only one way, you can assume proper grounding. If, however, there are only 2 prongs which are the same size, this signifies you have a problem and need to ground the equipment. Unless you are trained in such electrical problems, I can only advise you to have a qualified electrician do so for you."

Specific cautions for strong acids and alkalis

In addition to all other safety precautions, there are specific guidelines for handling strong acids and alkalis, particularly any hydroxide, and hydrochloric acid. Fortunately, it is possible to avoid completely the presence of strong, undiluted acids in the darkroom. It is harder, but not impossible, to avoid the hydroxides, which are useful alkalis. Hydroxides are used in Agfa Rodinal, photography's oldest continuously manufactured product, in the Windisch pyrocatechin developer, in Edwal 20, and in most monobath formulas.

Sodium hydroxide is a caustic alkali and possesses extremely corrosive properties. It can burn the skin, can cause blindness, and can be fatal if swallowed. The fact that sodium hydroxide is available in every supermarket as Drano is not an indication that this is a harmless chemical. The warning label on Drano makes clear that safe handling of

hydroxide requires care and caution. Wear some kind of protective eyewear, such as goggles, and gloves. Goggles are particularly important: you may not be able to feel a splash of sodium hydroxide on your eyes, and considerable damage to the tissues may be done before you are aware of it.

Mixing sodium hydroxide solutions
Begin with cold water and have ice handy in case the solution starts to boil. If it does, drop in the ice and leave the room until it cools! If any of the material falls or splashes on you or the counter top, wash it off immediately with water. If you detect a soapy feeling on your skin, sodium hydroxide is present.

The cardinal rule when mixing sodium hydroxide is to add the chemical to the water. **Never add water to the hydroxide**.

To begin, add a few pellets of sodium hydroxide to the cold water. Stir until dissolved. Monitor heat by touching the outside of the container. Keep on adding hydroxide slowly, a little at a time, allowing it to dissolve before adding any more.

Always wear safety goggles when handling sodium hydroxide. In the event of a splash, rinse with cold water for 15 minutes and seek medical help immediately.[5]

Mixing strong acids
The same precautions must be taken when mixing strong acids such as hydrochloric or sulfuric. The acid must be slowly poured into water, **never the other way around.** Always wear protective eye goggles.

In the event of a splash, rinse with cold water for 15 minutes and seek medical help immediately.[5]

Avoiding strong acids and alkalis in photographic processing
There is no need to be in contact with strong acids when developing films and prints. The only developer in this book that contains hydrochloric acid is Edwal 20. Simply avoid it, if you do not want to be in contact with strong acids. As we do not recommend the use of acid stop baths and fixers, it is easy to avoid their use. The only acid commonly recommended in this book is boric acid, which, at a pH of about 5, is one of the mildest of all acids, and is not commonly regarded as hazardous.[6] Sodium hydroxide is used in only four formulas in this book: Rodinal, the Windisch Pyrocatechin formula, and the two monobath formulas in Appendix I. These are easy chemicals to avoid. If you wish to use Rodinal, but would rather avoid the care necessary in mixing it, simply buy it prepackaged from Agfa. Even in this form, Rodinal requires careful handling, but the prepared solution should have a pH considerably lower than a sodium hydroxide solution. Even so, if you have decided not, in ordinary darkroom use, to use protective eyewear, then, at the very least, you should use protective eyewear when you develop with any developer containing a hydroxide.

Acetic acid is the acid in common vinegar, usually at a level of 4-5%. It is used in some of the acid fixers formulas given in this book, though none of them are recommended. It is also listed in the formulas for acid

stop baths, none of which we recommend. It is thus possible to avoid acetic acid in common photographic processing. If you choose to use acetic acid, do not use glacial acetic acid (99%). Instead, use the far more common 28% solution sold by photographic chemical suppliers.

Special cautions for pyrogallol and pyrocatechin

According to Gordon Hutchings, "Pyro may be the most toxic chemical used in the darkroom. The combination of toxicity and the ease of bodily absorption demands careful handling of the chemical. It is not a matter of individual sensitivity. I know of a few longtime pyro users who have not exercised normal precautions and are experiencing the debilitating effects of kidney dysfunction or other illness. It may take a lifetime for the damage to occur, but the effects are inevitable. Despite the danger, however, it is not difficult to avoid the harmful effects of pyro." Hutchings also notes that pyrocatechin should be used with the same precautions as pyrogallol.[7]

Hutchings then presents several pages of material on safety precautions which pyro and pyrocatechin users should read. It appears that the greatest danger with pyrogallol is in developing films in a tray with bare hands. Using gloves while tray developing is thus an essential precaution. Hutchings notes that "for most non-tray film processing, there is no need for gloves. A drop or two of the developer on the hands is relatively harmless. All tank, reel and nitrogen burst systems may be operated without gloves. Each photographer will have to decide what level of exposure is acceptable."

The additional level of risk that using staining developers entails can be avoided by simply not using them.

Disposal and safety

When working with any chemical, you assume the responsibility for its safe use and disposal. Follow any special instructions included with each chemical or process being used. Laws concerning disposal of chemicals vary widely. Contact the Hazardous Material (HazMat) Unit of your local fire department. They will explain in detail exactly what you can and cannot do in terms of disposal in your area.

Read MSDS sheets for disposal information. Do not mix any chemical with any other chemical unless you know it is safe to do so. Do not mix liquid and solid wastes together, as dangerous reactions might occur. Be sure to read and follow all safety recommendations that come with the chemicals.

Follow instructions for proper disposal of all chemicals. Wash yourself and any equipment that has come into contact with any chemicals. Launder darkroom towels after each session. Dispose of gloves and disposable masks to avoid future contamination. Keep your work space clean and uncontaminated.

Additional Information

On the World Wide Web

A highly detailed resource is http://www.orcbs.msu.edu. This is the web page of the Office of Radiation, Chemical & Biological Safety of Michigan State University (telephone 517-355-0153). This site has excellent links, including Oxford University's Physical and Theoretical Laboratory (http://physchem.ox.ac.uk/MSDS/).

Books

The presence of a book on the list below does not necessarily convey an endorsement by us.

Michael McCann, *Artist Beware*, New York: Watson-Guptill, 1979.

Susan Shaw, *Overexposure: Health Hazards in Photography*, San Francisco: The Friends of Photography, 1983.

Siegfried and Wolfgang Rempel, *Health Hazards for Photographers*, Lyons & Burford Publishers, 1992.

Judy Tell, *Making Darkrooms Saferooms* (1989). Available from National Press Photographers Association, 3200 Croqsdaile Drive, Suite 306, Durham, North Carolina 27705.

Richard Henry, *Controls in Black and White Photography*, Focal Press, Boston & London, 1986, 2nd edition. See Chapter 4, "Safety in the Darkroom".

Gordon Hutchings, *The Book of Pyro*, 3rd (revised) printing. Granite Bay, CA: Bitter Dog Press, 1992. Excellent guidelines on darkroom safety, especially with regard to pyrogallol.

Other Sources

Agfa, North America, 24-hour hot line, (800) 424-9300.
Ilford, North America, 24-hour hot line, (800) 842-9660.
Kodak, Australia/Asia/Western Pacific, 24-hour hot line, 03-350-1222 ext. 288.
Kodak, North/South America, 24-hour hot line, (716) 722-5151.
Kodak Ltd, United Kingdom/Europe/Africa, 24-hour hot line, 01-427-4380.
New Jersey Poison Control Center, 24-hour hot line, (800) 962-1253.
New York City Poison Control Center, 24-hour hot line, (212) POISONS (212-764-7667).

NOTES

1. *The New York Times*, April 9, 1998, p. A 19.

2. *Encyclopedia of Occupational Health and Safety*, 3rd (revised) edition, Geneva: International Labour Office, 1983, p. 85.10

3. Focal Encyclopedia.

4. Haist.

5. Henry.

6. Grant Haist, Chemical section in *Photo Lab Index*, 1990 edition, Morgan & Morgan, NY.

7. Hutchings.

BIBLIOGRAPHY

Out of print photographic books can often be obtained from the following booksellers:

A Photographer's Place, P.O. Box 274, Prince St. Station, New York, NY 10012; 212-966-2356. Ask for Harvey.

Photo-Eye, 376 Garcia St., Santa Fe, NM 87501; 505-988-5152.

Books

Adams, Ansel. *The Negative.* New York:New York Graphic Society, 1981.

Anchell, Steve. *The Darkroom Cookbook.* Newton, MA: Focal Press, 1994.

Arentz, Dick. *Platinum and Palladium Printing,* 3rd ed. Woburn, MA: Focal Press, 1999.

Clerc, L. *Photographic Theory in Practice.* London:Focal Press, 1971.

Crabtree, J. I. and G. E. Matthews. *Photographic Chemicals and Solutions.* Boston:American Photographic Publishing Co., 1939.

Dignan, Patrick D. *150 Do-It-Yourself Black and White Popular Photographic Formulas.* North Hollywood, CA:Dignan Photographic Inc., 1977.

Haist, Grant. *Monobath Manual.* New York:Morgan & Morgan, 1966.

Haist, Grant. *Modern Photographic Processing.* Volumes 1 and 2. New York: John Wiley & Sons, 1979.

Henry, Richard. *Controls in Black-and-White Photography.* 2nd ed. London and Boston: Focal Press, 1986.

Hutchings, Gordon. *The Book of Pyro,* 3rd ed. Granite Bay, CA: Bitter Dog Press, 1998. Can be ordered directly from the author, P.O. Box 2324, Granite Bay, CA 95746.

Jacobson, C.I. and R.E. Jacobson. *Developing.* 18th ed. London: Focal Press, 1976.

James, T.H. *The Theory of the Photographic Process,* 4th ed. New York: The Macmillan Company, 1977.

Mees, C.E.K. and T.H. James, *The Theory of the Photographic Process,* 3rd ed. New York: The Macmillan Company, 1966.

Mees, C.E.K. *The Theory of the Photographic Process.* New York: The Macmillan Company, 1942.

Mason, L.F.A. *Photographic Processing Chemistry.* 2nd ed. London: Focal Press, 1975.

Stroebel, Leslie, and Richard D. Zakia. *Focal Encyclopedia of Photography.* 3rd. ed. Boston: Focal Press, 1993.

Stroebel, Leslie, John Compton, Ira Current, and Richard Zakia. *Photographic Materials and Processes*. Boston: Focal Press, 1986.

Vestal, David. *The Craft of Photography*. New York: Harper and Row, 1975.

Vestal, David. *The Art of Black and White Enlarging*. New York: Harper and Row, 1984.

Wakefield, G. *Practical Sensitometry*. London: Fountain Press, 1970.

Wall, E.J., Franklin I. Jordan. *Photographic Facts and Formulas*. Revised and Enlarged by John S. Carroll. Garden City: AMPHOTO, 1975.

Woods, John C. *The Zone System Craft Book*. Dubuque, IA: Brown & Benchmark, 1993.

SOURCES

Photographic chemicals

Photographers' Formulary was the first mail-order supplier of chemicals for photographers, and introduced the concept of pre-measured kits for popular formulas. Formulary also has its own line of processing chemistry and itself manufactures several now rare photographic chemicals, including glycin. Artcraft sells bulk chemicals and kits for public domain formulas.

Artcraft Chemicals, P.O. Box 583, Schenectady, NY 12301; (800) 682-1730, (518) 355-8700. Call 5:30-7:30 p.m. EST and weekends only.

Photographers' Formulary, P.O. Box 950, Condon, MT 59806; (800) 922-5255 (406) 754-2891; e-mail formulary@montana.com; http://www.photoformulary.com.

Laboratory supply houses

Laboratory supply houses sell a wide variety of laboratory equipment. Some, like Tri-Ess and Antec, also stock a good range of photographic chemicals. Some chemicals may only be stocked in reagent grades, which are too expensive for photographic use. Many other laboratory supply houses, not listed here, only sell large quantities of chemicals and supplies.

Antec, 721 Bergman Avenue, Louisville,KY 40203; (502) 636-5176, Fax: (502) 635-2352; (800) 448-2954 e-mail kyantec@aol.com.

Bryant Laboratory, 1101 Fifth Street, Berkeley, CA 94710;
 (800) 367-3141, (510) 526-3141, e-mail: bry_lab@sirrus.com.

Tri-Ess Sciences , 1020 West Chestnut Street, Burbank, CA 91506; (818) 848-7838; 800-274-6910;
http://www.tri-sss.com; e-mail:science@tri-sss.com.

Film developers

Brandess-Kalt-Aetna (Ethol and Acufine film developers, Heico NH-5, Crone-C) 701 Corporate Woods Parkway, Vernon Hills, IL 60061; (847) 821-5429.

Luminos Photo Corp. (Paterson black and white film developers), P.O. Box 158, Yonkers, NY 10705, (800)-LUMINOS; www.luminos.com.

Falcon Safety Products (Edwal film developers and fixer), 25 Chubb Way, P.O. Box 1299, Sommerville, NJ 08876; (908) 707-4900.

Tetenal Photowerk GmbH & Co. Scuetzenwall 31-35, 22844 Noderstedt Germany. Tel 040-521 45-0; Fax 040-521 45 296. Some Tetenal products are distributed in the US by JOBO (see Darkroom equipment).

Film

Agfa, 100 Challenger Road, Ridgefield Park, NJ 07660-2199; (201) 440-2500. www.agfaphoto.com.

Bergger (BPF 200), Lotus View Camera, 5955 Palo Verde Drive, Rockford, IL 61114; (815) 282-9876, fax (815) 282-0902; viewcam@wwa.com; also http://www.lotusviewcamera.at/

Fuji, 555 Taxter Road, Elmsford, NY 10523; (800) 800-FUJI. www.fujifilm.co.jp.

Ilford, West 70 Century Road, Paramus, NJ 07653; (201) 265-6000. www.ilford.com.

Kodak, 343 State Street, Rochester, NY 14650; USA (800) 242-2424, Ext. 19; Canada (800) 465-6325. www.kodak.com/go/professional.

Konica USA (Konica Infrared), 440 Sylvan Avenue, Englewood Cliffs, NJ 07632; (201) 568-3100; Canada (416) 670-7722.

Macophot, Cachet Fine Art Paper Company, 3701 West Moore Avenue, Santa Ana, CA 92704; (714) 432-7070.

Hupersensitized film

Lumicon, 2111 Research Drive, Suites 4, 5, Livermore, CA 94550
Expert Information 1-510-447-9570
Toll-Free (Orders Only) 1-800-767-9576 Fax 1-510-447-9589
http://astronomy-mall.com/regular/products/lumicon/toc.htm

Uncommon film sizes

Film for Classics, P.O. Box 486 Honeoye Falls N.Y. 14472
(716) 624-4945; http://www.frontiernet.net/~joankay/.

Darkroom equipment

Charles Beseler Company (enlargers, easels), 1600 Lower Road, Linden, NJ 07036; (908) 862-7999.

Calumet (broad range of photographic equipment and chemicals), 890 Supreme Drive, Bensenville, IL 60106; (800) 225-8938.

CPM, Inc. (Delta 1 environmentally sensitive darkroom equipment), 10830 Sanden Drive, Dallas, TX 75238-1337; (214) 349-6886.

Darkroom Innovations (Darkroom equipment and supplies), P.O. Box 19450, Fountain Hills, AZ 85269-9450; (602) 767-7105; www.darkroom-innovations.com.

Doran Enterprises, Inc. (Premier darkroom accessories), 2779 S. 34th Street, Milwaukee, Wisconsin 53215; (414) 645-0109.

Freestyle Photo (Darkroom equipment and supplies; film), 5124 Sunset Boulevard, Los Angeles, CA 90027; (800)292-6137.

Hass Manufacturing (Intellifaucet water control monitors), 9 Tyler Street, P.O. Box 565, Troy, New York 12181-0565; (518) 274-3908.

JOBO Fototechnic (automatic film processors, including daylight development tanks for large format film, full line of darkroom products), P.O. Box 3721, Ann Arbor, Michigan 48106; (800) 664-0344; e-mail sales@jobo-usa.com.

Omega/Arkay (enlargers, easels, darkroom accessories, King Concept processors), P.O. Box 2078, 191 Shaeffer Avenue, Westminster, Maryland 21157; (800) 777-6634.

Paterson Darkroom Necessities (darkroom accessories), 21 Jet View Drive, Rochester, New York 14624-4996; (716) 328-7800. (Paterson black and white film developers are distributed in the US by Luminos—see film developers)

Redlight Enterprises (MetroLux enlarging timers), 1692 Roseland Drive, Concord, CA 94519; (510) 825-5999.

Rodenstock Precision Optics, Inc., (enlarging lenses), 4885 Colt Road, Rockford, Illinois 61109-2611 (815) 874-8300.

Samy's Camera (darkroom equipment and supplies), 200 S. La Brea Avenue, Los Angeles, CA 90036; (323) 938-2420, (800) 321-4726.

The Saunders Group (darkroom equipment), 21 Jet View Drive, Rochester, New York 14624-4996; (716) 328-7800.

Schneider Optics (B+W filters, enlarging lenses), 285 Oser Avenue, Hauppauge, New York 11788; (516) 761-5000.

Scales

Scales from these and other manufacturers are available from Formulary, Artcraft, and the laboratory supply houses.

AccuLab (digital electronic scales), 8 Pheasant Run, Newtown, PA 18940; (215) 579-3170; scales@acculab.com; http://www.acculab.com.

Pelouze Scale Company (Pelouze R-47 Photographic Balance Beam, and Postage Scales), 2120 Greenwood Street, Evanston, Illinois 60204; (708) 430-8330.

Morris Scales (Ohaus Scales), 1537 SE Morrison Street, Portland, Oregon 97214; (503) 232-5339.

Darkroom safety products

Karde Air Purifiers, 224 Pine Boulevard, Medford, New Jersey 08055; (800) 245-8802.

MAPA Consumer (Bluettes and Bench Mark neoprene safety gloves) 512 E. Tiffin Street, Willard, OH 44890.

Photographic Solutions (Photofinish cleaner, The Finishing Touch hand lotion), 7 Granston Way, Buzzards Bay, MA 02532; (508) 759-2322.

Information on the Internet

This list is intended only as a starting point.

Most US patents from 1971 to the present are accessible for free from IBM's Patent Server home page: http://www.patents.ibm.com/ibm.html

Jack's Photography & Chemistry Collection is an excellent resource: http://www.seanet.com/users/jwsmith/index.htm.

The French Professional Photographers' Web can be accessed at http://www.itisphoto.com—in French only.

Jon Mided's continuously updated and highly comprehensive development time chart is available at http://www.digitaltruth.com.

There are several excellent Internet newsgroups including rec.photo.darkroom, rec.photo.film+labs, and rec.photo.technique.art, and well-known forums on CompuServe.

Finally, updated information relating to this book will be available from time to time at Focal Press's website: http://www.bh.com.

FILM DEVELOPING TIME CHART

Relying on published times can often lead to disappointing results. For example, some current data sheets recommend different times for D-76 and ID-11, even though these two formulas are identical. Minor variations in manufacture cannot account for differences as high as 30%. This alone indicates the intrinsic untrustworthiness of published times. (ID-11 and D-76 should have identical developing times, whether they are mixed from scratch, from Ilford's commercial product, or from Kodak's commercial product.)

Many of the developers published in this book come with only the vaguest of recommendations. There are those who would maintain that this is the way it should be. To achieve the best results photographers should test one or more rolls of film to determine their personal development time. Yet knowing this, it is still useful to have a point of departure, whenever possible.

Unless otherwise noted these times assume 68°F/20°C, 35mm film, intermittent small tank agitation, and a diffusion-type enlarger. Develop 10%-20% less for a condenser head. For 120/220 and sheet film, many will prefer to increase times by 20–30%. For sheet film with continuous agitation, most times should be reduced by 20–30%.

Large format and 120 roll film negatives should usually be developed to print on grade 2 paper. 35mm negatives should usually be targeted for grade 3 paper. When in doubt it is better to have a slightly flat negative, and print it on a higher grade of paper.

For suggestions on agitation see chapter 4.

The following tables are mainly derived from film manufacturer's recommendations for developing film. The source for much of this information is Jon Mided's superb online developing chart, available at www.digitaltruth.com, printed here in book form with his gratefully acknowledged permission. We have, however, supplemented Jon's chart with additional information. We have retained Jon's use of the term ASA for EI, as it is mostly his chart.

The times for PMK are from *The Book of Pyro*. Temperature is 70F/21C and the times are calibrated for variable contrast paper with a 3400° Kelvin quartz printing lamp with an Ilford no. 2 filter. For cold light or graded paper, Hutchings advises approximately 20% less time. *The Book of Pyro* contains extensive tables for Zone-style plus and minus development with PMK.

If a developing time is not available, a rough starting guide is to pick a conventional film of the same speed.

AGFA

Agfapan APX 25

DEVELOPER	ASA	MIN
ACU-1 (1+10)	80	12 (21C)
Acufine	64	4.25 (21C)
Aculux (1+9)	32	7
Acutol (1+10)	40	6
Acutol (1+15)	40	9
Acutol (1+20)	40	12
Atomal	25	10
Atomal	50	17
D-76 (1+1)	25	11
D-76	25	7
Ethol Blue (1+30)	64	5 (21C)
Ethol TEC	64	15 (21C)
Ethol TEC	80	17.75 (21C)
Ethol UFG	40	4.75 (21C)
Ethol UFG	80	5.75 (21C)
FG7 (1+15)	25	7.25 (21C)
FG7 (1+15S)	25	6 (21C)
FG7 (1+3)	25	4.5 (21C)
Fotospeed FD10 (1+9)	—	4
Fotospeed FD10 (1+14)	—	10
FX-37 (1+3)	40	4
FX39 (1+9)	25	5
Gamma Plus (1+7)	25	5
Gamma Plus (1+12)	25	8
Gamma Plus (1+20)	25	10.5
HC110 (B)	25	6
Heico OS (1+10)	25	4.75
ID-11 (1+1)	25	10
Ilfosol S (1+9)	25	5
Ilfotec LC29 (1+29)	25	13
Microdol-X (1+3)	25	18
Microdol-X	25	12
Microphen (1+1)	25	7.5
Perceptol (1+1)	25	14
PMK (1+2+100)	25	11
Refinal	25	6
Refinal	50	10
Rodinal (1+25)	20	6
Rodinal (1+25)	25	7
Rodinal (1+50)	25	10
Rodinal (1+100)	25	14
Studional/RodinalSpecial	25	4
Studional/RodinalSpecial	50	7
TMax Dev (1+4)	25	6.5
TMax RS	25	5

DEVELOPER	ASA	MIN
Xtol	12	3.75
Xtol	25	4.75
Xtol	50	6.5
Xtol	100	10.25
Xtol (1+1)	12	5
Xtol (1+1)	25	6
Xtol (1+1)	50	8
Xtol (1+1)	100	10.5
Xtol (1+1)	200	14.5
Xtol (1+2)	12	7.75
Xtol (1+2)	25	9.25
Xtol (1+2)	50	11
Xtol (1+2)	100	14
Xtol (1+2)	200	17
Xtol (1+3)	12	10.25
Xtol (1+3)	25	11.75
Xtol (1+3)	50	14
Xtol (1+3)	100	17.5
Xtol (1+3)	200	21.5

Agfapan APX 100

DEVELOPER	ASA	MIN
ACU-1 (1+10)	320	12 (21C)
Acufine	160	5 (21C)
Aculux (1+9)	125	8
Acuspeed (1+7)	250	9
Acutol (1+10)	160	8
Acutol (1+15)	160	12
Acutol (1+20)	160	16
Atomal	100	9
Atomal	160	13
Atomal	200	14
D-76	100	8
D-76 (1+1)	100	12
Ethol Blue (1+30)	200	4.75 (21C)
Ethol TEC (1+15)	250	17.75 (21C)
Ethol TEC	160	13.25 (21C)
Ethol UFG	160	5 (21C)
FG7 (1+3)	80	4.25 (21C)
FG7 (1+15)	80	10 (21C)
FG7 (1+15S)	80	6.5 (21C)
Fotospeed FD10 (1+9)	—	5
Fotospeed FD10 (1+14)	—	11
FX-37 (1+3)	160	4
FX39 (1+9)	100	8
Gamma Plus (1+7)	100	5
Gamma Plus (1+12)	100	8
Gamma Plus (1+20)	100	10.5
HC110 (B)	100	7

DEVELOPER	ASA	MIN
Heico OS (1+10)	100	7
ID-11 (1+1)	100	11
Ilfosol S (1+9)	100	7.5
Ilfotec LC29 (1+29)	100	12
Microdol-X	100	13
Microdol-X (1+3)	100	20
Microphen (1+1)	100	10.5
Perceptol (1+1)	100	12
PMK (1+2+100)	100	13
Refinal	100	5
Refinal	125	6
Refinal	200	9
Rodinal (1+25)	100	8
Rodinal (1+25)	200	11
Rodinal (1+50)	125	17
Studional/Rodinal Special	125	4
Studional/Rodinal Special	200	6
TMax Dev (1+4)	100	6.5
TMax RS	100	5
TFX-2	160	17
Xtol	25/50	5.75
Xtol	100	6.75
Xtol	200	8.75
Xtol	400	11
Xtol	800	13
Xtol (1+1)	25/50	8
Xtol (1+1)	100	9.75
Xtol (1+1)	200	12
Xtol (1+1)	400	15.5
Xtol (1+1)	800	22
Xtol (1+2)	25/50	12
Xtol (1+2)	100	13.75
Xtol (1+2)	200	15.25
Xtol (1+2)	400	18.75
Xtol (1+2)	800	23
Xtol (1+3)	25/50	15.25
Xtol (1+3)	100	17.25
Xtol (1+3)	200	19.5
Xtol (1+3)	400	23
Xtol (1+3)	800	29

Agfapan 400

DEVELOPER	ASA	MIN
ACU-1 (1+5)	650	7.5 (21C)
Acufine	500	4 (21C)
Aculux (1+9)	500	9
Acuspeed (1+7)	1250	12
Acutol (1+10)	640	10
Acutol (1+15)	640	15
Acutol (1+20)	640	20
Atomal	400	10
Atomal	500	11
Atomal	800	13
Atomal	1600	16
Clayton F60 (1+9)	400	7.5
D-76	400	10
D-76 (1+1)	400	14
Ethol Blue (1+60)	400	12.5 (21C)
Ethol TEC (1+15)	1000	11 (21C)
Ethol UFG	1280	6 (21C)
FG7 (1+3)	200	6 (21C)
FG7 (1+15)	200	17 (21C)
FG7 (1+15S)	200	9 (21C)
Fotospeed FD10 (1+9)	—	7
Fotospeed FD10 (1+14)	—	12
FX-37 (1+3)	640	5
FX-39 (1+9)	640	11
Gamma Plus (1+7)	400	6
Gamma Plus (1+12)	400	9
Gamma Plus (1+20)	400	14.5
HC-110 (Dil.B)	400	6
Heico OS (1+10)	400	7.25
ID-11 (1+1)	400	11
Ilfosol S (1+9)	400	12
Ilfotec LC29 (1+29)	400	15
Microdol-X	400	13
Microdol-X (1+3)	400	22
Microphen (1+1)	400	11
Perceptol (1+1)	400	16
PMK (1+2+100)	400	16
Refinal	400	6
Refinal	800	16
Rodinal (1+25)	320	7
Rodinal (1+25)	400	8
Rodinal (1+50)	320	11
Studional/Rodinal Special	400	4.5
TFX-2	640	19
TMax Dev (1+4)	400	7
TMax RS	400	6
Xtol	100/200	6.5
Xtol	400	8
Xtol	800	9.75
Xtol	1600	12.25
Xtol	3200	14.5
Xtol (1+1)	100/200	10.5
Xtol (1+1)	400	12
Xtol (1+1)	800	14.5
Xtol (1+1)	1600	18
Xtol (1+1)	3200	21.5

Agfapan 400 (continued)

DEVELOPER	ASA	MIN
Xtol (1+2)	100/200	13.5
Xtol (1+2)	400	15.75
Xtol (1+2)	800	19
Xtol (1+2)	1600	23
Xtol (1+3)	100/200	16.5
Xtol (1+3)	400	19.25
Xtol (1+3)	800	22.5
Xtol (1+3)	1600	28.5

Agfa Ortho

DEVELOPER	ASA	MIN
Neutol NE	25	2-4
Refinal	25	10
Rodinal (1+10)	25	4

For suggestions on how to develop this film for continuous tones, see Chapter 11 and in this chart see the suggestions for Kodak Technical Pan.

ARISTA

Arista films are commonly assumed to be repackaged Ilford films. The published times are identical, so simply refer to the relevant Ilford chart for the dev you require.

Arista Pro 50 = Ilford Pan F+
Arista Pro 125 = Ilford FP4+
Arista Pro 400 = Ilford HP5+
Arista DMAX 400 = Ilford Delta 400

BERGGER

BPF200 (Tray)

DEVELOPER	ASA	MIN
D-23	200	6.5
D-23 (1+3)	200	18
D-76	200	9
D-76 (1+1)	200	13.5
DK-50	200	5.5
DK-50 (1+1)	200	8
Ethol UFG	200	8.25
HC-110 (Dil B)	200	6
PMK (1+2+100)	200	12
Rodinal (1+25)	200	6.5
Rodinal (1+50)	200	12

CACHET

ORT25 (see chapter 11)

DEVELOPER	ASA	MIN
Neutol (1+7)	—	3
Refinal	—	10
Rodinal (1+10)	—	5

UP100

DEVELOPER	ASA	MIN
Atomal	—	7
D-76	—	8
ID-11	—	8
Microphen	—	7

UP400

DEVELOPER	ASA	MIN
D-76	—	10
ID-11	—	10
Microphen	—	9
Perceptol	—	12
T-Max (1+4)	—	8

EFKE
Efke KB14

DEVELOPER	ASA	MIN
Aculux (1+9)	40	5.5
Acutol (1+10)	50	5
Acutol (1+15)	50	7.5
Acutol (1+20)	50	10
Ethol Blue (1+60)	40	4 (21C)
Ethol TEC (1+15)	100	7 (21C)
Ethol UFG	40	1.5 (21C)

Efke KB17

DEVELOPER	ASA	MIN
Aculux (1+9)	80	7
Acutol (1+10)	100	6
Acutol (1+15)	100	9
Acutol (1+20)	100	12
Ethol Blue (1+120)	64	9 (21C)
Ethol TEC (1+15)	160	7 (21C)
Ethol UFG	64	2 (21C)
Rodinal (1+50)	100	7

Efke KB21

DEVELOPER	ASA	MIN
Aculux (1+9)	160	9.5
Acuspeed (1+7)	400	10
Acutol (1+10)	200	9
Acutol (1+15)	200	13.5
Acutol (1+20)	200	18
Ethol Blue (1+60)	320	8 (21C)
Ethol TEC (1+15)	400	10 (21C)
Ethol UFG	200	3.5 (21C)
Rodinal (1+50)	200	14
Rodinal (1+50)	400	24

FUJI FILMS

Fuji Neopan 400

DEVELOPER	ASA	MIN
ACU-1 (1+5)	400	5.75
ACU-1 (1+10)	800	12.75 (21C)
Acufine	400	3.25
Acufine	800	4.5
Acufine	1600	7
Aculux (1+9)	500	12
Acuspeed (1+7)	1250	14
Acutol (1+10)	640	8.5
Acutol (1+15)	640	12.5
Acutol (1+20)	640	17
Clayton F60 (1+9)	400	6
D-76/ID-11	250	6.5
D-76/ID-11	400	7.5
D-76/ID-11	800	8.75
D-76/ID-11	1600	13.5
D-76/ID-11 (1+1)	400	9.5
D-76/ID-11 (1+1)	800	13
Ethol Blue (1+30)	800	7 (21C)
Ethol TEC (1+15)	500	14 (21C)
Ethol TEC (1+15)	1000	18 (21C)
Ethol UFG	640	5 (21C)
Ethol UFG	1000	5.5 (21C)
FG7 (1+3)	320	4.5 (21C)
FG7 (1+15)	320	11.5 (21C)
FG7 (1+15S)	320	7.75 (21C)
Fotospeed FD10 (1+9)	—	10
Fujidol	400	6.5
Fujidol	800	8.25
Fujidol	1600	12
FX39 (1+9)	400	10
FX-37 (1+3)	1+3	6

DEVELOPER	ASA	MIN
Fujidol (1+1)	400	9
HC110 (Dil.B)	400	5
HC110 (Dil.B)	800	7.25
HC110 (Dil.B)	1600	12
Heico OS (1+10)	400	5.75
ID-11	400	7
ID-11	800	8.5
ID-11	1600	12.5
Microdol-X	200	8.5
Microdol-X	400	10
Microphen	400	4.25
Microphen	800	5.75
Microphen	1600	8.5
Microphen	3200	16
Pandol	800	6
Pandol	1600	9
Pandol	3200	16
Rodinal (1+25)	400	6
Rodinal (1+50)	400	11
SPD	400	4.25
SPD	800	5.75
SPD	1600	9
SPD	3200	16
SPD (1+1)	400	7
TMax Dev (1+4)	400	6
TMax Dev (1+4)	800	7.5
TMax Dev (1+4)	1600	10
TMax RS	400	5.5
TMax RS	800	6.5
TMax RS	1600	9.5
Xtol	100/200	7.5
Xtol	400	8.25
Xtol	800	9.75
Xtol	1600	11.5
Xtol	3200	13.5
Xtol (1+1)	100/200	8.25
Xtol (1+1)	400	9.75
Xtol (1+1)	800	11.5
Xtol (1+1)	1600	13.5
Xtol (1+1)	3200	16.5
Xtol (1+2)	100/200	11
Xtol (1+2)	400	12.5
Xtol (1+2)	800	14.5
Xtol (1+2)	1600	17
Xtol (1+2)	3200	20.5
Xtol (1+3)	100/200	13.5
Xtol (1+3)	400	15.75
Xtol (1+3)	800	18.5
Xtol (1+3)	1600	22.5
Xtol (1+3)	3200	26

Fuji Neopan 1600

DEVELOPER	ASA	MIN
ACU-1 (1+5)	1600	5.75
ACU-1 (1+10)	2400	14.5 (21C)
Acufine	1600	4 (21C)
Aculux (1+9)	800	12
Aculux (1+9)	1600	15
Acuspeed (1+7)	2000	12
D-76	400	4
D-76	800	5
D-76	1600	7.5
D-76	3200	15
D-76 (1+1)	400	5.5
D-76 (1+1)	800	7
D-76 (1+1)	1600	9
D-76 (1+3)	800	11.5
D-76 (1+3)	1600	15.25
Ethol Blue (1+30)	2400	7.25 (21C)
Ethol TEC (1+15)	1600	24 (21C)
Ethol TEC (1+15)	2400	27 (21C)
Ethol UFG	1600	4 (21C)
Ethol UFG	2400	5 (21C)
FG7 (1+3)	1000	3.75 (21C)
FG7 (1+15)	1000	11 (21C)
FG7 (1+15S)	1000	6.5 (21C)
Fotospeed FD10 (1+9)	—	10
Fotospeed FD10 (1+14)	—	14
Fujidol	800	4.75
Fujidol	1600	6.5
Fujidol	3200	11
Fujidol (1+1)	400	4.75
Fujidol (1+1)	800	6
Fujidol (1+1)	1600	9
Fujidol (1+3)	400	8.25
Fujidol (1+3)	800	10.5
Fujidol (1+3)	1600	14
FX-37 (1+3)	1600	5
FX39 (1+9)	1600	5
Gamma Plus (1+7)	1600	4.5
Gamma Plus (1+12)	1600	6.5
Gamma Plus (1+20)	1600	10.5
HC-110 (Dil.B)	800	4.75
HC-110 (Dil.B)	1600	7
ID-11	800	4.5
ID-11	1600	6.5
Microdol-X	400	6.5
Microdol-X	800	8.25
Microdol-X	1600	10.5
Microfine	250	5

Microfine	400	6
Microfine	800	8
Microfine (1+1)	250	6
Microfine (1+1)	400	6.75
Microfine (1+1)	800	8.75
Microfine (1+3)	400	10
Microfine (1+3)	800	13
Microphen	1600	3.25
Microphen	3200	5.75
Pandol	1600	4
Pandol	3200	9
PMK (1+2+100)	1600	12
Rodinal (1+25)	1600	5
Rodinal (1+50)	1600	8
SPD	1600	4.25
SPD	3200	8
SPD (1+1)	1600	6.5
SPD (1+1)	3200	15
SPD (1+1)	800	4.5
SPD (1+3)	1600	12
SPD (1+3)	800	7.75
TMax Dev (1+4)	1600	4.5
TMax Dev (1+4)	3200	10
TMax RS	1600	5
TMax RS	3200	9.5
Xtol	200	4
Xtol	400	4.5
Xtol	800	5
Xtol	1600	5.75
Xtol	3200	6.5
Xtol	6400	7.25
Xtol (1+1)	200	5.5
Xtol (1+1)	400	6
Xtol (1+1)	800	6.75
Xtol (1+1)	1600	7.5
Xtol (1+1)	3200	8.5
Xtol (1+1)	6400	9.75
Xtol (1+2)	200	7
Xtol (1+2)	400	7.75
Xtol (1+2)	800	8.5
Xtol (1+2)	1600	10
Xtol (1+2)	3200	11.25
Xtol (1+2)	6400	13
Xtol (1+3)	200	9.25
Xtol (1+3)	400	10.25
Xtol (1+3)	800	11.5
Xtol (1+3)	1600	13
Xtol (1+3)	3200	14.75
Xtol (1+3)	6400	16.5

ILFORD FILMS

Ilford Pan F+

DEVELOPER	ASA	MIN
ACU-1 (1+10)	64	6.5 (21C)
Acufine	50	3.5
Acufine	80	5 (21C)
Aculux (1+9)	64	5.5
Acutol (1+10)	80	5
Acutol (1+15)	80	7.5
Acutol (1+20)	80	10
D-76	25-50	6.5
D-76 (1+1)	25-50	10.5
D-76 (1+3)	25-50	15.5
Ethol Blue (1+60)	80	4 (21C)
Ethol TEC (1+15)	64	6.5 (21C)
Ethol UFG	50	5 (21C)
FG7 (1+15)	50	9 (21C)
FG7 (1+15S)	50	6 (21C)
Fotospeed FD10 (1+14)	—	6
FX-37 (1+3)	80	4
FX39 (1+9)	50	4.5
Gamma Plus (1+12)	50	5
Gamma Plus (1+20)	50	8
HC-110 (Dil. B)	50	5.5
ID-11	25-50	6.5
ID-11 (1+1)	25-50	8.5
ID-11 (1+3)	25	14
ID-11 (1+3)	50	15
Ilfotec HC (1+31)	50	4
Ilfotec HC (1+47)	50	5.5
Ilfotec LC29 (1+19)	50	4
Ilfotec LC29 (1+29)	50	5.5
Ilfosol S (1+9)	50	4
Ilfosol S (1+14)	50	6
Microdol-X	25	12
Microdol-X	50	15
Microdol-X (1+3)	25	15
Microdol-X (1+3)	50	18
Microphen	25-50	4.5
Microphen	100	8
Microphen	200	12
Microphen (1+1)	25-50	6
Microphen (1+3)	25-50	11
Perceptol	25	9
Perceptol	50	14
Perceptol (1+1)	25	10.5
Perceptol (1+1)	50	15
Perceptol (1+3)	25	15
Perceptol (1+3)	50	17
PMK (1+2+100)	50	7.5
Refinal	50	5.5
Rodinal (1+25)	50	6
Rodinal (1+50)	50	11
TMax Dev (1+4)	50	4
TMax RS	50	4
Ultrafin (1+10)	50	4
Ultrafin (1+20)	50	8
Xtol	25	6
Xtol	50	7
Xtol	100	8
Xtol	200	9
Xtol	400	10
Xtol (1+1)	25	6.75
Xtol (1+1)	50	7.75
Xtol (1+1)	100	9.5
Xtol (1+1)	200	11.25
Xtol (1+1)	400	13
Xtol (1+2)	25	8.75
Xtol (1+2)	50	10
Xtol (1+2)	100	11.5
Xtol (1+2)	200	13.25
Xtol (1+2)	400	15.5
Xtol (1+3)	25	10.5
Xtol (1+3)	50	12
Xtol (1+3)	100	13.5
Xtol (1+3)	200	15.75
Xtol (1+3)	400	18.5

Ilford FP4+

DEVELOPER	ASA	MIN
ACU-1 (1+10)	100	9 (21C)
Acufine	320	5 (21C)
Acufine	400	10
Aculux (1+9)	160	6.5
Acuspeed (1+7)	400	7
Acutol (1+10)	200	6
Acutol (1+15)	200	9
Acutol (1+20)	200	12
Clayton F60 (1+9)	125	5.5
D-76	50	5
D-76	125	5.5
D-76	200	7
D-76 (1+1)	50	7.5
D-76 (1+1)	125	8.5
D-76 (1+1)	200	11
D-76 (1+3)	50	12
ID-76 (1+3)	125	14

Ilford FP4+ ((continued))

DEVELOPER	ASA	MIN
D-76 (1+3)	200	18
Ethol Blue (1+30)	200	6 (21C)
Ethol TEC (1+15)	200	14 (21C)
Ethol UFG	250	7.25 (21C)
FG7 (1+3)	80	3.5 (21C)
FG7 (1+15)	80	9 (21C)
FG7 (1+15S)	80	7 (21C)
Fotospeed FD10 (1+9)	—	6
Fotospeed FD10 (1+14_	—	9
FX-37 (1+3)	160	4.5
FX39 (1+9)	125	6
Gamma Plus (1+7)	125	5.5
Gamma Plus (1+12)	125	8
Gamma Plus (1+20)	125	12
HC-110 (Dil. A)	400	7
HC-110 (Dil. B)	125	5
HC-110 (Dil. B)	200	8
ID-11	50	5
ID-11	125	6
ID-11	200	8
ID-11 (1+1)	50	7
ID-11 (1+1)	125	8
ID-11 (1+1)	200	12
ID-11 (1+3)	50	15
ID-11 (1+3)	125	18
Ilfotec HC (1+15)	125	3
Ilfotec HC (1+15)	200	4
Ilfotec HC (1+15)	400	7
Ilfotec HC (1+31)	50	4.5
Ilfotec HC (1+31)	125	6
Ilfotec HC (1+31)	200	8.5
Ilfotec HC (1+47)	50	6
Ilfotec HC (1+47)	125	8
Ilfotec HC (1+47)	200	12
Ilfotec LC29 (1+9)	125	3
Ilfotec LC29 (1+9)	200	4
Ilfotec LC29 (1+19)	50	4.5
Ilfotec LC29 (1+19)	125	6
Ilfotec LC29 (1+19)	200	8.5
Ilfotec LC29 (1+29)	50	6
Ilfotec LC29 (1+29)	125	8
Ilfotec LC29 (1+29)	200	12
Ilfosol S (1+9)	50	3.5
Ilfosol S (1+9)	125	4
Ilfosol S (1+9)	200	5
Ilfosol S (1+14)	50	5
Ilfosol S (1+14)	125	6
Ilfosol S (1+14)	200	7.5
Microdol-X	50	7.5
Microdol-X	125	10.5
Microdol-X (1+3)	50	14
Microdol-X (1+3)	125	17
Microphen	125	5.5
Microphen	200	6.5
Microphen	400	11
Microphen (1+1)	125	7
Microphen (1+1)	200	9
Microphen (1+1)	400	16
Microphen (1+3)	125	10
Microphen (1+3)	200	13
Perceptol	50	7.5
Perceptol	125	9
Perceptol (1+1)	50	10.5
Perceptol (1+1)	125	14
Perceptol (1+3)	50	14
Perceptol (1+3)	125	18
PMK (1+2+100)	125	10
Rodinal (1+25)	125	6
Rodinal (1+25)	200	9
Rodinal (1+50)	125	8.5
Rodinal (1+50)	200	13
T-Max (1+4)	125	5.5
T-Max (1+4)	200	6.5
T-Max (1+4)	400	8
T-Max RS	125	5 (24C)
Xtol	125	8
Xtol	250	9
Xtol	32/64	6.5
Xtol	500	11
Xtol	1000	14
Xtol (1+1)	32/64	8.5
Xtol (1+1)	125	10
Xtol (1+1)	250	12
Xtol (1+1)	500	14.5
Xtol (1+1)	1000	17.5
Xtol (1+2)	32/64	10
Xtol (1+2)	125	11.5
Xtol (1+2)	250	13.75
Xtol (1+2)	500	17.25
Xtol (1+2)	1000	21
Xtol (1+3)	32/64	12.5
Xtol (1+3)	125	14.75
Xtol (1+3)	250	17
Xtol (1+3)	500	20
Xtol (1+3)	1000	23.5

Ilford HP5+

DEVELOPER	ASA	MIN
ACU-1 (1+10)	800	10 (21C)
Acufine	400	4.5
Acufine	640	6.5 (21C)
Acufine	800	6.5
Acufine	1600	9.5
Aculux (1+9)	500	9
Acuspeed (1+7)	1250	9
Acutol (1+10)	640	9
Acutol (1+15)	640	13.5
Acutol (1+20)	640	18
Clayton F60 (1+9)	400	7
D-76	400	7.5
D-76	800	9.5
D-76	1600	12.5
D-76 (1+1)	400	11
D-76 (1+1)	800	13
D-76 (1+3)	400	22
Ethol Blue (1+30)	1000	6.5 (21C)
Ethol TEC (1+15)	640	14.25 (21C)
Ethol TEC (1+15)	800	17.75 (21C)
Ethol UFG	500	4.5 (21C)
Ethol UFG	800	5.25 (21C)
FG7 (1+3)	320	4.5 (21C)
FG7 (1+15)	320	12.5 (21C)
FG7 (1+15S)	320	7.5 (21C)
Fotospeed FD10 (1+9)	—	7
Fotospeed FD10 (1+14)	—	11
FX-37 (1+3)	640	6.5
FX39 (1+9)	400	9
Gamma Plus (1+7)	400	6
Gamma Plus (1+12)	400	9
Gamma Plus (1+20)	400	11.5
HC-110 (Dil. A)	400	2.5
HC-110 (Dil. A)	800	3.75
HC-110 (Dil. A)	1600	5.5
HC-110 (Dil. A)	3200	9.5
HC-110 (Dil. B)	400	5
HC-110 (Dil. B)	800	7.5
HC-110 (Dil. B)	1600	11
Heico OS (1+10)	400	5.25
ID-11	400	7.5
ID-11	800	10.5
ID-11	1600	14
ID-11 (1+1)	400	13
ID-11 (1+1)	800	16.5
ID-11 (1+3)	400	20
Ilfotec HC (1+15)	400	3.5
Ilfotec HC (1+15)	800	5
Ilfotec HC (1+15)	1600	7.5
Ilfotec HC (1+15)	3200	12.5
Ilfotec HC (1+31)	400	6.5
Ilfotec HC (1+31)	800	9.5
Ilfotec HC (1+31)	1600	14
Ilfotec HC (1+47)	400	9
Ilfotec LC29 (1+9)	400	3.5
Ilfotec LC29 (1+9)	800	5
Ilfotec LC29 (1+9)	1600	7.5
Ilfotec LC29 (1+9)	3200	11
Ilfotec LC29 (1+19)	400	6.5
Ilfotec LC29 (1+19)	800	9.5
Ilfotec LC29 (1+19)	1600	14
Ilfotec LC29 (1+29)	400	9
Ilfosol S (1+9)	400	7
Ilfosol S (1+9)	800	8.5
Ilfosol S (1+9)	1600	14
Ilfosol S (1+14)	400	9.5
Ilfosol S (1+14)	800	14
Microdol-X	400	11
Microdol-X (1+3)	400	25
Microphen	500	6.5
Microphen	800	8
Microphen	1600	11
Microphen	3200	16
Microphen (1+1)	400	12
Microphen (1+1)	800	15
Microphen (1+3)	400	23
Perceptol	200/400	11
Perceptol (1+1)	400	15
Perceptol (1+3)	400	25
PMK (1+2+100)	400	12
Refinal	400	6
Refinal	800	8.5
Rodinal (1+25)	400	6
Rodinal (1+25)	800	8
Rodinal (1+25)	1600	12
Rodinal (1+50)	400	11
Rodinal (1+50)	800	16
Rodinal (1+50)	1600	24
TMax Dev (1+4)	400	6.5
TMax Dev (1+4)	800	8
TMax Dev (1+4)	1600	9.5
TMax Dev (1+4)	3200	11.5
TMax RS	400	6.5
TMax RS	800	5 (24C)
TMax RS	1600	7 (24C)
TMax RS	3200	10.5 (24C)
Ultrafin (1+10)	400	7.5

Ilford HP5+ (continued)

DEVELOPER	ASA	MIN
Ultrafin (1+10)	800	10
Ultrafin (1+20)	400	16
Xtol	100/200	7.5
Xtol	400	8.5
Xtol	800	10.5
Xtol	1600	13
Xtol	3200	17.5
Xtol (1+1)	100/200	10.25
Xtol (1+1)	400	12
Xtol (1+1)	800	14.25
Xtol (1+1)	1600	18
Xtol (1+1)	3200	22.5
Xtol (1+2)	100/200	12.75
Xtol (1+2)	400	15.5
Xtol (1+2)	800	18
Xtol (1+2)	1600	21
Xtol (1+3)	100/200	14.5
Xtol (1+3)	400	18
Xtol (1+3)	800	23
Xtol (1+3)	1600	27.5

Ilford Ortho+

DEVELOPER	ASA	MIN
D-76	—	8
D-76 (1+1)	—	10.5
Ilfotec HC-D (1+19)	—	6
Ilfotec HC (1+31)	—	6
ID-11	—	8
ID-11 (1+1)	—	10.5
ID-11 (1+3)	—	16
Microphen	—	9
Microphen (1+1)	—	11.5
Microphen (1+3)	—	13.5
Perceptol	—	13

Ilford Delta 100 Pro

DEVELOPER	ASA	MIN
ACU-1 (1+10)	100	8 (21C)
Acufine	200	5.5
Acutol (1+10)	100	8
D-76	50	7
D-76	100	9
D-76	200	11
D-76 (1+1)	50	9.5
D-76 (1+1)	100	12

DEVELOPER	ASA	MIN
D-76 (1+1)	200	14
D-76 (1+3)	50	14
D-76 (1+3)	100	22
Ethol Blue (1+30)	100	6 (21C)
Ethol TEC (1+15)	100	15 (21C)
Ethol UFG	100	5.5 (21C)
FG7 (1+3)	100	4 (21C)
FG7 (1+15)	100	10 (21C)
FG7 (1+15S)	100	7 (21C)
Fotospeed FD10 (1+9)	—	7
Fotospeed FD10 (1+14)	—	17
FX-37 (1+3)	160	7.5
FX39 (1+9)	100	7
Gamma Plus (1+7)	100	4
Gamma Plus (1+12)	100	6
Gamma Plus (1+20)	100	8.5
HC110 (Dil.B)	50	5
HC110 (Dil.B)	100	6
HC110 (Dil.B)	200	8
ID-11	50	7
ID-11	100	8.5
ID-11	200	10.5
ID-11 (1+1)	50	10
ID-11 (1+1)	100	11
ID-11 (1+1)	200	13
ID-11 (1+3)	50	15
ID-11 (1+3)	100	20
Ilfotec HC (1+31)	50	5
Ilfotec HC (1+31)	100	6
Ilfotec HC (1+31)	200	8
Ilfotec HC (1+47)	50	5.5
Ilfotec HC (1+47)	100	7.5
Ilfotec HC (1+47)	200	10
Ilfosol S (1+9)	100	6
Ilfosol S (1+14)	50	6.5
Ilfosol S (1+14)	100	20
Microdol-X	50	12
Microdol-X	100	15
Microdol-X (1+3)	50	16
Microdol-X (1+3)	100	22
Microphen	100	6.5
Microphen	200	8
Microphen	400	10
Microphen (1+1)	100	10
Microphen (1+1)	200	14
Microphen (1+3)	100	14
Microphen (1+3)	200	20
Perceptol	25	9
Perceptol	50	12
Perceptol	100	15

Perceptol (1+1)	50	13
Perceptol (1+1)	100	17
Perceptol (1+3)	50	16
Perceptol (1+3)	100	22
Refinal	100	5
Refinal	200	9
Rodinal (1+25)	50	7
Rodinal (1+25)	100	9
Rodinal (1+50)	50	10
Rodinal (1+50)	100	14
PMK (1+2+100)	—	11
SPD	100	5
SPD	200	8
SPD (1+1)	100	7
TG7 (1+3)	100	5.5 (21C)
TG7 (1+15)	100	8 (21C)
TG7 (1+15S)	100	6 (21C)
TMax Dev (1+4)	50	6
TMax Dev (1+4)	100	7
TMax Dev (1+4)	200	8
TMax RS	50	5 (24C)
TMax RS	100	6 (24C)
TMax RS	200	8 (24C)
Ultrafin (1+10)	100	6
Ultrafin (1+20)	100	8
Xtol	25/50	6.75
Xtol	100	8
Xtol	200	9.5
Xtol	400	11.5
Xtol	800	14.5
Xtol (1+1)	25/50	9
Xtol (1+1)	100	10.5
Xtol (1+1)	200	12
Xtol (1+1)	400	14
Xtol (1+1)	800	16.75
Xtol (1+2)	25/50	11
Xtol (1+2)	100	13
Xtol (1+2)	200	15
Xtol (1+2)	400	17.5
Xtol (1+2)	800	21.5
Xtol (1+3)	25/50	13.5
Xtol (1+3)	100	15.5
Xtol (1+3)	200	17.5
Xtol (1+3)	400	20.5
Xtol (1+3)	800	24.25

Ilford Delta 400 Pro

DEVELOPER	ASA	MIN
ACU-1 (1+5)	400	8.25 (21C)
Acufine	400	4.5
Acufine	400	6.5 (21C)
Acufine	800	5
Ethol Blue (1+30)	400	6.75 (21C)
Ethol TEC (1+15)	400	14 (21C)
Ethol UFG	400	6 (21C)
FG7 (1+3)	200	5 (21C)
FG7 (1+15)	200	11 (21C)
FG7 (1+15S)	200	8 (21C)
Fotospeed FD10 (1+9)	—	8
Fotospeed FD10 (1+14)	—	12
FX-37 (1+3)	640	8
FX39 (1+9)	400	10
Gamma Plus (1+7)	400	6
Gamma Plus (1+12)	400	8.5
Gamma Plus (1+20)	400	12
HC-110 (Dil.A)	800	5
HC-110 (Dil.A)	1600	8
HC-110 (Dil.B)	200	6
HC-110 (Dil.B)	400	7.5
HC-110 (Dil.B)	800	10
HC-110 (Dil.B)	1600	14
Heico OS (1+10)	400	5
ID-11/D-76	200	6
ID-11/D-76	400	7
ID-11/D-76	800	9
ID-11/D-76	1600	12.5
ID-11/D-76 (1+1)	200	9
ID-11/D-76 (1+1)	400	10.5
ID-11/D-76 (1+1)	800	12.5
ID-11/D-76 (1+3)	400	18
Ilfotec HC (1+15)	800	5
Ilfotec HC (1+15)	1600	8
Ilfotec HC (1+31)	200	6
Ilfotec HC (1+31)	400	7.5
Ilfotec HC (1+31)	800	10
Ilfotec HC (1+31)	1600	14
Ilfotec HC (1+47)	400	13
Ilfosol S (1+9)	200	7
Ilfosol S (1+9)	400	9
Ilfosol S (1+9)	800	13
Ilfosol S (1+14)	200	11.5
Ilfosol S (1+14)	400	14
Microdol-X	200	10
Microdol-X	400	13
Microdol-X (1+3)	400	22
Microphen	400	7
Microphen	800	9
Microphen	1600	12.5
Microphen (1+1)	400	10.5

Ilford Delta 400 Pro (continued)

DEVELOPER	ASA	MIN
Microphen (1+1)	800	13
Microphen (1+1)	1600	18
Microphen (1+3)	400	17
Perceptol	100	8.5
Perceptol	200	10
Perceptol	400	13
Perceptol (1+1)	200	14
Perceptol (1+1)	400	18
Perceptol (1+3)	400	22
Refinal	400	4
Refinal	800	6
Rodinal (1+25)	200	7
Rodinal (1+25)	400	9
Rodinal (1+25)	800	12.5
Rodinal (1+50)	200	12
Rodinal (1+50)	400	16.5
TG7 (1+3)	200	5.5 (21C)
TG7 (1+15)	200	8.5 (21C)
TG7 (1+15S)	200	6 (21C)
TMax Dev (1+4)	400	7.5
TMax Dev (1+4)	800	10
TMax Dev (1+4)	1600	14
TMax RS	800	6 (24C)
TMax RS	1600	8 (24C)
Ultrafin (1+10)	200	6.5
Ultrafin (1+10)	400	8
Ultrafin (1+20)	400	10
Xtol	100/200	6
Xtol	400	7
Xtol	800	8
Xtol	1600	10
Xtol	3200	12
Xtol (1+1)	100/200	9
Xtol (1+1)	400	10.5
Xtol (1+1)	800	12.25
Xtol (1+1)	1600	14.5
Xtol (1+1)	3200	17
Xtol (1+2)	100/200	12
Xtol (1+2)	400	14
Xtol (1+2)	800	16.25
Xtol (1+2)	1600	19.5
Xtol (1+2)	3200	23.5
Xtol (1+3)	100/200	14.5
Xtol (1+3)	400	16.5
Xtol (1+3)	800	19.5
Xtol (1+3)	1600	23

Ilford SFX 200

DEVELOPER	ASA	MIN
Aculux 2 (1+9)	—	11
Acutol (1+9)	—	9
D-76	200	10.5
D-76	400	12.5
D-76	800	16.5
D-76 (1+1)	400	14.5
FX-39	1+9	5.5
HC-110 (Dil. B)	200	9
HC-110 (Dil. B)	400	13
HC-110 (Dil. B)	800	19
ID11	200	10
ID11	400	14
ID11	800	18
ID11 (1+1)	200	17
Ilfotec HC (1+15)	200	5
Ilfotec HC (1+15)	400	7
Ilfotec HC (1+15)	800	10.5
Ilfotec HC (1+31)	200	9
Ilfotec HC (1+31)	400	13
Ilfotec HC (1+31)	800	19
Ilfotec LC29 (1+9)	200	5
Ilfotec LC29 (1+9)	400	7
Ilfotec LC29 (1+19)	200	9
Ilfotec LC29 (1+19)	400	13
Ilfotec LC29 (1+29)	200	9
Ilfosol S (1+9)	200	9.5
Ilfosol S (1+9)	400	11.5
Ilfosol S (1+9)	800	19
Ilfosol S (1+14)	200	13
Ilfosol S (1+14)	400	19
Microphen	200	8.5
Microphen	400	10.5
Microphen	800	14.5
Microphen (1+1)	200	15.5
Microphen (1+1)	400	19
Perceptol	200	14.5
Perceptol (1+1)	200	20
Refinal	200	8
Refinal	400	11.5
Rodinal (1+25)	200	6
Rodinal (1+50)	200	10
TMax (1+4)	200	8.5
TMax (1+4)	400	10.5
TMax (1+4)	800	12.5
TMax RS	200	6 (24C)
TMax RS	400	7 (24C)
TMax RS	800	9 (24C)

KODAK FILMS

Kodak Plus-X

DEVELOPER	ASA	MIN
ACU-1 (1+10)	250	9 (21C)
Acufine	250	4 (21C)
Aculux (1+9)	160	6
Acuspeed (1+7)	400	7.5
Acutol (1+10)	200	7
Acutol (1+15)	200	10.5
Acutol (1+20)	200	14
Clayton F60 (1+9)	125	5.5
D-76	125	5.5
D-76 (1+1)	125	7
Ethol Blue (1+30)	400	3 (21C)
Ethol Blue (1+60)	125	3.5 (21C)
Ethol TEC (1+15)	400	12 (21C)
Ethol UFG	125	3 (21C)
Ethol UFG	250	4 (21C)
FG7 (1+3)	80	3.25 (21C)
FG7 (1+15)	80	8 (21C)
FG7 (1+15S)	80	6 (21C)
Fotospeed FD10 (1+9)	—	7
Fotospeed FD10 (1+14)	—	10
FX-37 (1+3)	200	5.5
FX39 (1+9)	125	6
Gamma Plus (1+7)	125	4.5
Gamma Plus (1+12)	125	8
Gamma Plus (1+20)	125	11.5
HC-110 (Dil.B)	125	5
Heico OS (1+10)	125	5.75
ID-11	125	6
ID-11 (1+1)	125	8
ID-11 (1+3)	125	13
Microdol-X	125	7
Microdol-X (1+3)	125	9.5 (24C)
Microphen	200	6
Microphen	400	19.5
Microphen (1+1)	200	8.5
Microphen (1+3)	200	13.5
Neofin Red	125	9
Neofin Blue	125	6
Perceptol	64	8
Perceptol (1+1)	64	8.5
Perceptol (1+3)	64	12
PMK (1+2+100)	80	10
Rodinal (1+25)	125	6
Rodinal (1+50)	125	13
Rodinal (1+85)	200	12 (24C)

TMax RS	125/250	5.5
TMax RS	500	6.5 (24C)
Ultrafin (1+20)	125	8
Xtol	32/64	4.5
Xtol	125	5.25
Xtol	250	6.5
Xtol	500	8
Xtol	1000	10.25
Xtol (1+1)	32/64	6.5
Xtol (1+1)	125	7.5
Xtol (1+1)	250	8.75
Xtol (1+1)	500	11
Xtol (1+1)	1000	15.5
Xtol (1+2)	32/64	7.5
Xtol (1+2)	125	8.5
Xtol (1+2)	250	9.75
Xtol (1+2)	500	13
Xtol (1+2)	1000	16.5
Xtol (1+3)	32/64	9.5
Xtol (1+3)	125	10.5
Xtol (1+3)	250	12
Xtol (1+3)	500	15.5
Xtol (1+3)	1000	19.5

Kodak Verichrome Pan

DEVELOPER	ASA	MIN
ACU-1 (1+5)	250	11.25 (21C)
Acufine	250	5 (21C)
Aculux (1+9)	160	9
Acutol (1+10)	160	9
Acutol (1+15)	160	13.5
Acutol (1+20)	160	18
D-76	125	7
D-76 (1+1)	125	9
Ethol Blue (1+60)	200	5 (21C)
Ethol TEC (1+15)	320	8 (21C)
Ethol UFG	160	2.5 (21C)
Gamma Plus (1+12)	100	7.5
HC-110 (Dil.B)	125	4.25
Microdol-X	125	9
Microdol-X (1+3)	125	12
PMK	64	7*
Xtol	32/64	5
Xtol	125	6
Xtol	250	7
Xtol	500	8.5
Xtol	1000	11
Xtol (1+1)	32/64	6.75

Ilford Delta 400 Pro (continued)

DEVELOPER	ASA	MIN
Xtol (1+1)	125	7.5
Xtol (1+1)	250	8.75
Xtol (1+1)	500	10.75
Xtol (1+1)	1000	13.75
Xtol (1+2)	32/64	7.5
Xtol (1+2)	125	8.5
Xtol (1+2)	250	10.25
Xtol (1+2)	500	12.75
Xtol (1+2)	1000	16.25
Xtol (1+3)	32/64	9.25
Xtol (1+3)	125	10.25
Xtol (1+3)	250	11.75
Xtol (1+3)	500	14
Xtol (1+3)	1000	16.5

* Continuous agitation

Kodak Tri-X

DEVELOPER	ASA	MIN
ACU-1 (1+5)	1000	10 (21C)
Acufine	1000	5 (21C)
Aculux (1+9)	500	9
Acuspeed (1+7)	1250	9
Acutol (1+10)	640	9
Acutol (1+15)	640	13.5
Clayton F60 (1+9)	400	6
D-76	400	8
D-76	1600	13
D-76 (1+1)	400	10
Ethol Blue (1+60)	400	5.5 (21C)
Ethol Blue (1+30)	1600	5.25 (21C)
Ethol Blue (1+30)	2400	6.75 (21C)
Ethol TEC (1+15)	1000	12 (21C)
Ethol UFG	1280	5.25 (21C)
Ethol UFG	400	3 (21C)
FG7 (1+3)	320	5.25 (21C)
FG7 (1+15)	320	12 (21C)
FG7 (1+15S)	320	9 (21C)
FX39 (1+9)	400	8
Gamma Plus (1+7)	400	7.5
Gamma Plus (1+12)	400	9
Gamma Plus (1+20)	400	13.5
HC-110 (Dil.A)	400	3.75
HC-110 (Dil.B)	400	7.5
HC-110 (Dil.B)	1600	16
Heico OS (1+10)	400	5.75
ID-11	400	8

DEVELOPER	ASA	MIN
ID-11 (1+1)	400	11
Microdol-X	400	10
Microdol-X (1+3)	400	13 (24C)
Microphen	500	6
Microphen	1600	16
Microphen (1+1)	500	11
Microphen (1+1)	800	15
Microphen (1+1)	1600	16.5
Microphen (1+1)	3200	24
Microphen (1+3)	500	22
Neofin Red	400	9-12
Perceptol	320	10
Perceptol (1+1)	320	12
Perceptol (1+3)	320	15
Rodinal (1+100)	400	20
Rodinal (1+100)	800	17.5 (24C)
Rodinal (1+25)	400	7
Rodinal (1+50)	400	13-16
Rodinal (1+50)	800	16.5
Rodinal (1+50)	1600	18.5
Rodinal (1+60)	400	15
Rodinal (1+75)	400	17.5
TMax Dev (1+4)	400/800	6
TMax Dev (1+4)	1600	8.5
TMax Dev (1+4)	3200	11
TMax RS	400/800	5 (24C)
TMax RS	1600	8 (24C)
TMax RS	3200	11 (24C)
Ultrafin (1+10)	400	6-8
Xtol	100/200	5.5
Xtol	400	6.75
Xtol	800	7.75
Xtol	1600	9
Xtol	3200	10.5
Xtol (1+1)	100/200	8
Xtol (1+1)	400	8.75
Xtol (1+1)	800	10
Xtol (1+1)	1600	11.75
Xtol (1+1)	3200	13.5
Xtol (1+2)	100/200	8.75
Xtol (1+2)	400	10.5
Xtol (1+2)	800	12.5
Xtol (1+2)	1600	14.5
Xtol (1+2)	3200	17
Xtol (1+3)	100/200	10.75
Xtol (1+3)	400	12.5
Xtol (1+3)	800	14
Xtol (1+3)	1600	16.5
Xtol (1+3)	3200	20

Kodak TMAX 100

DEVELOPER	ASA	MIN
ACU-1 (1+10)	160	12 (21C)
Acufine	200	4.5 (21C)
Aculux (1+9)	100	9
Acuspeed (1+7)	250	10
Acutol (1+10)	125	8.5
Acutol (1+15)	125	13
Acutol (1+20)	125	17
Clayton F60 (1+9)	100	7
D-76/ID-11	100/200	9
D-76/ID-11	400	11
D-76/ID-11 (1+1)	100/200	12
Ethol Blue (1+30)	160	6.5 (21C)
Ethol TEC(1+15)	100	14.5 (21C)
Ethol TEC (1+15)	160	17 (21C)
Ethol UFG	100	6 (21C)
Ethol UFG	320	9.5 (21C)
FG7 (1+3)	64	4.75 (21C)
FG7 (1+15)	64	12 (21C)
FG7 (1+15S)	64	8 (21C)
FX39 (1+9)	100	8
Gamma Plus (1+7)	100	6
Gamma Plus (1+12)	100	9
Gamma Plus (1+20)	100	14
HC-110 (Dil.B)	100/200	7
HC-110 (Dil.B)	400	9.5
Heico OS (1+10)	100	5.5
Microdol-X	100/200	13.5
Microdol-X (1+3)	100/200	16 (24C)
Microphen (1+1)	100/200	11
Rodinal (1+25)	100/200	5.5
Rodinal (1+50)	100/200	12
TG7 (1+3)	50	4 (21C)
TG7 (1+15)	50	10 (21C)
TG7 (1+15S)	50	7 (21C)
TMax Dev (1+4)	100/200	6.5 (24C)
TMax Dev (1+4)	400	9 (24C)
TMax Dev (1+4)	800	10.5 (24C)
TMax RS	100/200	6 (24C)
TMax RS	400	9 (24C)
TMax RS	800	11.5 (24C)
Xtol	25/50	5.75
Xtol	100	6.75
Xtol	200	7.75
Xtol	400	9
Xtol	800	10.5
Xtol (1+1)	25/50	8
Xtol (1+1)	100	9.25
Xtol (1+1)	200	10.25
Xtol (1+1)	400	12.5
Xtol (1+1)	800	14.5
Xtol (1+2)	25/50	11.5
Xtol (1+2)	100	12.5
Xtol (1+2)	200	13.75
Xtol (1+2)	400	15.75
Xtol (1+2)	800	18
Xtol (1+3)	25/50	14.5
Xtol (1+3)	100	16
Xtol (1+3)	200	18.25
Xtol (1+3)	400	20.5
Xtol (1+3)	800	23

Kodak TMAX 400

DEVELOPER	ASA	MIN
ACU-1 (1+10)	1000	12 (21C)
Acufine	800	4.5 (21C)
Aculux (1+9)	400	12
Acuspeed (1+7)	1000	13
Acutol (1+10)	500	9.5
Acutol (1+15)	500	14
Acutol (1+20)	500	19
Clayton F60 (1+9)	400	7.5
D-76/ID-11	400/800	8
D-76/ID-11	1600	10.5
D-76/ID-11 (1+1)	400/800	12.5
Ethol Blue (1+30)	800	6.25 (21C)
Ethol TEC (1+15)	320	15.25 (21C)
Ethol TEC (1+15)	640	18.5 (21C)
Ethol UFG	200	3.75 (21C)
Ethol UFG	1000	7.25 (21C)
FG7 (1+3)	250	4.5 (21C)
FG7 (1+15)	250	13.5 (21C)
FG7 (1+15S)	250	7.5 (21C)
FX39 (1+9)	400	10
Gamma Plus (1+7)	400	7
Gamma Plus (1+12)	400	9.5
Gamma Plus (1+20)	400	14.5
HC-110 (Dil.B)	400/800	6
HC-110 (Dil.B)	1600	8.5
Heico OS (1+10)	400	4.25
Ilford LC-29 (1+24)	1600	9.5-10 (25C)
Microdol-X	400/800	10.5
Microdol-X (1+3)	400/800	16 (24C)
Microphen (1+1)	400/800	10
Microphen (1+1)	1600	13
Rodinal (1+25)	400/800	5
Rodinal (1+50)	400/800	10

Kodak TMAX 400 ((continued))

DEVELOPER	ASA	MIN
TG7 (1+3)	250	4 (21C)
TG7 (1+15)	250	10.5 (21C)
TG7 (1+15S)	250	6 (21C)
TMax Dev (1+4)	400/800	7
TMax Dev (1+4)	1600	8
TMax Dev (1+4)	3200	9.5
TMax RS	400/800	5 (24C)
TMax RS	1600	7 (24C)
TMax RS	3200	9.5 (24C)
Xtol	100/200	5.75
Xtol	400	6.5
Xtol	800	7.25
Xtol	1600	8.5
Xtol	3200	9.5
Xtol (1+1)	100/200	8
Xtol (1+1)	400	8.75
Xtol (1+1)	800	9.5
Xtol (1+1)	1600	10.75
Xtol (1+1)	3200	12.5
Xtol (1+2)	100/200	9.5
Xtol (1+2)	400	10.5
Xtol (1+2)	800	12.25
Xtol (1+2)	1600	13.75
Xtol (1+2)	3200	16
Xtol (1+3)	100/200	12.25
Xtol (1+3)	400	13.5
Xtol (1+3)	800	15
Xtol (1+3)	1600	17
Xtol (1+3)	3200	20

Kodak TMAX P3200

DEVELOPER	ASA	MIN
ACU-1 (1+10)	3200	18.75 (21C)
ACU-1 (1+10)	6400	22.5 (21C)
Acufine	3200	7.5 (21C)
Aculux (1+9)	1600	14
Aculux (1+9)	3200	18
Acuspeed (1+7)	6400	14
D-76	400	7.5 (24C)
D-76	800	8 (24C)
D-76	1600	8.5 (24C)
D-76	3200	11 (24C)
D-76	6400	12.5 (24C)
Ethol Blue (1+30)	3200	14.5 (21C)
Ethol Blue (1+30)	6400	20 (21C)
Ethol TEC (1+15)	3200	17.5 (21C)

DEVELOPER	ASA	MIN
Ethol TEC (1+15)	6400	22.75 (21C)
Ethol UFG	1600	5.5 (21C)
Ethol UFG	3200	7.5 (21C)
Ethol UFG	6400	10.5 (21C)
FG7 (1+3)	1600	6.5 (21C)
FG7 (1+3)	3200	7.5 (21C)
FG7 (1+15)	1600	13 (21C)
FG7 (1+15)	3200	15 (21C)
FG7 (1+15S)	1600	10 (21C)
FG7 (1+15S)	3200	14.5 (21C)
FX39 (1+9)	3200	12
Gamma Plus (1+7)	3200	6.5
Gamma Plus (1+12)	3200	9.5
Gamma Plus (1+20)	3200	13.5
HC-110 (Dil.B)	400	5 (24C)
HC-110 (Dil.B)	800	5.5 (24C)
HC-110 (Dil.B)	1600	6 (24C)
HC-110 (Dil.B)	3200	7.5 (24C)
HC-110 (Dil.B)	6400	9.5 (24C)
Ilfotec HC (1+31)	1600	9
Ilfotec HC (1+31)	3200	11.5
Microphen (1+1)	1600	13.5
Microphen (1+1)	3200	18
Microphen (1+1)	6400	21
Rodinal (1+25)	3200	8
Rodinal (1+50)	3200	16
TG7 (1+3)	1600	5.5 (21C)
TG7 (1+3)	3200	7.5 (21C)
TG7 (1+15)	1600	12 (21C)
TG7 (1+15)	3200	12 (21C)
TG7 (1+15S)	1600	10 (21C)
TG7 (1+15S)	3200	9.5 (21C)
TMax Dev (1+4)	400	6 (24C)
TMax Dev (1+4)	800	6.5 (24C)
TMax Dev (1+4)	1600	7 (24C)
TMax Dev (1+4)	3200	9.5 (24C)
TMax Dev (1+4)	6400	11 (24C)
TMax Dev (1+4)	12500	12.5 (24C)
TMax Dev (1+4)	25000	14 (24C)
TMax RS	400	8 (24C)
TMax RS	800	9 (24C)
TMax RS	1600	10.5 (24C)
TMax RS	3200	13.5 (24C)
TMax RS	6400	15 (24C)
TMax RS	12500	12 (24C)
TMax RS	25000	14 (24C)
Xtol	100/200	7
Xtol	400	7.5
Xtol	800	8.25
Xtol	1600	9.25

Xtol	3200	11
Xtol	6400	12.5
Xtol	12500	15.25
Xtol	25000	18.5
Xtol (1+1)	100/200	10.5
Xtol (1+1)	400	11.5
Xtol (1+1)	800	12.5
Xtol (1+1)	1600	14
Xtol (1+1)	3200	16.5
Xtol (1+1)	6400	19.5
Xtol (1+1)	12500	22.5
Xtol (1+1)	25000	26
Xtol (1+2)	100/200	14.25
Xtol (1+2)	400	15.5
Xtol (1+2)	800	16.5
Xtol (1+2)	1600	19
Xtol (1+2)	3200	22
Xtol (1+2)	6400	26.5
Xtol (1+3)	100/200	17.25
Xtol (1+3)	400	18.5
Xtol (1+3)	800	20.5
Xtol (1+3)	1600	23
Xtol (1+3)	3200	27

Kodak High Speed Infrared

DEVELOPER	ASA	MIN
Aculux (1+9)	NA	12
Acutol (1+9)	NA	12
D-19	NA	6
D-76	NA	11
FG7 (1+3)	NA	4 (21C)
FG7 (1+15)	NA	12 (21C)
FG7 (1+15S)	NA	6 (21C)
FX-39 (1+9)	NA	11
Fotospeed FD10 (1+9)	NA	12
Gamma Plus (1+12)	NA	12
HC-110 (Dil.B)	NA	6
ID-11	NA	12
Perceptol	NA	15
PMK (1+2+100)	NA	12
Rodinal (1+25)	NA	9
Rodinal (1+50)	NA	12
Xtol	NA	6
Xtol (1+1)	NA	8.75
Xtol (1+2)	NA	12.5
Xtol (1+3)	NA	1

Kodak Ektapan (tray)

DEVELOPER	ASA	MIN
D-76	—	8
DK-50 (1+1)	—	4.5
HC-110 (Dil B)	—	4.5
Microdol-X	—	10
T-Max RS	—	5
XTOL	—	7.25
XTOL (1+1)	—	9.5

Kodak Recording Film 2475

DEVELOPER	ASA	MIN
Acufine	1600	9 (21C)
DK-50	1000	6
Ethol Blue (1+30)	2400	10 (21C)
FG7 (1+3)	1000	5 (21C)
FG7 (1+15)	1000	12 (21C)
FG7 (1+15S)	1000	8 (21C)
HC-110 (Dil.A)	1000	4.5
HC-110 (Dil.B)	1000	9
Refinal	—	5
Rodinal (1+25)	1000	4.5
Rodinal (1+50)	1000	10
Studional (1+15)	—	6

Kodak Technical Pan

DEVELOPER	ASA	MIN
(for Very High Contrast)		
D-19	100-200	2-8
D-19 (1+2)	100-160	4-7
Dektol	200	3
Kodalith	50	3
(for High Contrast/Continuous Tone)		
D-76/ID-11	50-125	6-12
Ethol Blue (1+120)	64	6 (21C)
Ethol TEC (1+30)	100	5.5 (21C)
FG7 (1+15)	25	12.5 (21C)
HC-110 (Dil.B)	100-250	4-12
HC-110 (Dil.D)	80-125	4-8
Microdol-X	32-50	8-12
Rodinal (1+50)	25	4.5
Technidol LC	25-32	7-18
TMAX Dev (1+4)	50	4-7 (24C)
Xtol (1+2)	4	6
Xtol (1+3)	8	8 (21C)
Xtol (1+4)	12.5	10.5 (21C)
Xtol (1+5)	25	6 (21C)
(for Continuous Tone)		
Acutol (1+20)	25-50	10
C-41 (Color) Developer*	100	10 (24C)
Gamma Plus (1+12)	—	6
Gamma Plus (1+20)	—	8.5
HC-110 (Dil.F)	32-64	6-12
Rodinal (1+150)	25-64	7
Rodinal (1+300)	25-64	12
TD-3	64	17
Technidol LC	16-25	5-11

*use C-41 developer only, use B/W fixer, do not bleach.

KONICA

Konica IR 750

DEVELOPER	ASA	MIN
Aculux	NA	8
Acutol	NA	8
D-76 (1+1)	NA	8.5
D-76	NA	6
DK-20	NA	7
FG7 (1+15)	25	7 (21C)
HC-110 (Dil.B)	NA	7
ID-11	NA	6
Konicadol DP	NA	6
Konicadol Fine	NA	7
Konicadol Super	NA	6
Rodinal (1+50)	NA	5
Rodinal (1+75)	NA	9

Konica Pan 100

DEVELOPER	ASA	MIN
Konicadol DP	100	5
Konicadol Fine	100	6.5
Konicadol Super	100	6

KONICA PAN 200		
Konicadol DP	200	7
Konicadol Fine	200	9
Konicadol Super	200	10

KONICA PAN 400		
Konicadol DP	400	6
Konicadol Fine	400	9
Konicadol Super	400	9

ORIENTAL

Oriental Oripan 400

DEVELOPER	ASA	MIN
D-76	400	7.5
D-76	1600	13.5
D-76 (1+1)	800	9.5

Temperature Conversion Chart

(Courtesy of John Placko, Ilford)

64°F	66°F	68°F	70°F	72°F	75°F	77°F	80°F
5.0	4.5	**4.0**	3.5	3.25	2.5	*	*
5.5	5.0	**4.5**	4.0	3.75	3.0	*	*
6.0	5.5	**5.0**	4.5	4.0	3.25	*	*
6.5	6.0	**5.5**	5.0	4.5	3.5	*	*
7.25	6.5	**6.0**	5.5	5.0	4.0	3.75	*
8.0	7.25	**6.5**	6.0	5.25	4.5	4.0	3.5
8.75	7.75	**7.0**	6.5	5.75	5.0	4.5	3.75
9.25	8.25	**7.5**	6.75	6.0	5.25	4.75	4.0
9.75	8.75	**8.0**	7.25	6.5	5.5	5.0	4.25
10.5	9.5	**8.5**	7.75	7.0	6.0	5.5	4.75
11.25	10.0	**9.0**	8.0	7.25	6.25	5.75	5.0
11.75	10.5	**9.5**	8.5	7.75	6.5	6.0	5.25
12.5	11.25	**10.0**	9.0	8.0	7.0	6.25	5.5
13.0	11.75	**10.5**	9.5	8.5	7.25	6.5	5.75
13.75	12.25	**11.0**	10.0	9.0	7.5	6.75	6.0
14.25	12.75	**11.5**	10.5	9.25	8.0	7.25	6.25
14.75	13.25	**12.0**	10.75	9.75	8.25	7.5	6.5
15.25	13.75	**12.5**	11.25	10.0	8.75	8.0	7.0
16.0	14.5	**13.0**	11.75	10.5	9.0	8.25	7.0
16.75	15.0	**13.5**	12.0	11.0	9.25	8.5	7.25
17.25	15.5	**14.0**	12.5	11.25	9.75	9.0	7.75
17.75	16.0	**14.5**	13.0	11.75	10.0	9.0	7.75
18.5	16.75	**15.0**	13.5	12.25	10.5	9.5	8.0
19.25	17.25	**15.5**	14.0	12.75	10.75	9.75	8.25
19.75	17.75	**16.0**	14.5	13.0	11.0	10.0	8.5
20.5	18.5	**16.5**	14.75	13.5	11.5	10.25	8.75
21.0	19.0	**17.0**	15.25	13.75	11.75	10.5	9.0
21.75	19.5	**17.5**	15.75	14.25	12.0	10.75	9.25
22.25	20.0	**18.0**	16.25	14.5	12.5	11.25	9.75
22.75	20.5	**18.5**	16.75	15.0	12.75	11.5	9.75
23.5	21.0	**19.0**	17.25	15.5	13.25	12.0	10.25
24.25	21.75	**19.5**	17.5	16.0	13.5	12.25	10.5
24.75	22.25	**20.0**	18.0	16.25	13.75	12.5	10.75
25.25	22.75	**20.5**	18.5	16.75	14.25	12.75	11.0
26.0	23.5	**21.0**	19.0	17.0	14.5	13.0	11.25
26.5	23.75	**21.5**	19.5	17.5	15.0	13.5	11.5
27.25	24.5	**22.0**	19.75	17.75	15.25	13.75	11.75
27.75	25.0	**22.5**	20.25	18.25	15.5	14.0	12.0
28.25	25.5	**23.0**	20.75	18.75	16.0	14.5	12.5
28.75	26.0	**23.5**	21.0	19.0	16.25	14.75	12.75
29.75	26.75	**24.0**	21.75	19.5	16.75	15.0	13.0
30.25	27.25	**24.5**	22.0	19.75	17.0	15.25	13.0
30.75	27.75	**25.0**	22.5	20.25	17.25	15.5	13.25

INDEX

The Index of Formulas is on page vi.

A

Accelerators, see Alkalis

Acids, cautions for, avoiding strong, 133–35

Acutance, 1, 4, 39, 45 ff., 51–52, 55 ff., 73 ff., 95, 103
 Phenidone and high acutance, 57–59

Adams, Ansel, 80, 86

Adjacency effects, 51–53

After development processes, 103–10

Agitation, 31–38, 75–76

Alkalis, 26–29,
 cautions for, avoiding strong, 133–35

Astro photography, 102

B

Book of Pyro, The (Hutchings), 21, 75–76, 114, 143

Border and fringe effects, 51–52

British Journal of Photography (BJ), 44, 59

Buffering, 54

C

Charts
 film developing time, 143–64
 temperature conversion, 165

Chemicals
 dangerous mixtures of, 131
 safety, 89, 129–138
 suppliers, 139–42
 working with, 124–25

Chromogenic films, 15

Compensation and gradation, 53

Concurrent photon amplification, 93

Contrast and gradation, 2–3

Crawley, Geoffrey, 44–48, 59–62

D

Definition, *see* Acutance

Density, minimum printable, 95

Developers
 categories, 1–9
 choosing, 4
 diluted fine grain, 40–41
 fine grain, *see* Developers, solvent
 high acutance, *see* Developers, high definition
 high contrast, 86–88
 high definition, 51–63
 classifying, 55
 commercial, 56–57
 formulating, 55–56
 granularity with, 53
 Phenidone and
 speed increase with, 53–54
 speed maintenance with, 54–55
 ingredients, 19–29
 interlocks, 3–4
 low contrast, 86-87, 95–100,
 with nozrmal films, 100
 moderate fine grain, 40
 non-solvent, 51–63

 buffered, 62–63
 solvent, 39–50
 D-76 and its derivatives, 40–44
 FX solvent, 44–48
 XTOL, 49–50
 super-fine grain, 65–71
 ripening, 66–67
 tanning, 73–81
 two-bath, 83–86
 directions, 84–85
 low contrast scenes, 84
 storage and capacity, 83
 water bath, 86

Developing agents, 19–26
 ascorbic acid and derivatives, 21, 49–50, 88–89
 amidol, 21
 catechol, *see*Pyrocatechin
 chlorhydroquine (CQ), 21
 glycin, 22, 97, 116–17
 hydroquinone, 22, 25, 42, 50 n.1
 metol, 22–23, 25
 Meritol, 117
 para-Aminophenol, 23
 see also Rodinal
 para-Phenylenediamine (ppd), 23
 derivatives, 66
 developers, 65–68, 117
 Phenidone, 24–25
 and high acutance, 57–59
 and solvent developers, 49
 Pyrocatechin, 25, 79–81, 115–16
 Pyrogallol, 25, 75–79, 113–115
 post processing, 78
 tank agitation with, 76
 tray development with, 75
 Vitamin C, *see* ascorbic acid

Development procedures, 31–38

Document films, 15–16, 95–102

Draining, 33–34

Drying, 109

E

Eberhard effect, 52

Enlarging lenses, 101–2

F

Film speed, increasing, 53-54, 91–94
 concurrent photon amplification, 93
 developer additives, 94
 hydrogen peroxide, 93–94
 hypersensitization, 92–93
 latensification, 92–93
 push processing, 91–92

Film speed determination 95, 102 n.1

Films, 11–17
 chromogenic, 15
 conventional, 12–17
 document, 15–16, 95–102
 infrared, 16–17
 orthochromatic, 17
 tabular, 14–15, 58, 61–62
 transparency, 17
 uncommon roll and sheet sizes, 17

Fine grain developers, *See* Developers, solvent

Fixers, 105–7
 acid, 105
 alkaline, 106, 120–21
 fixing times and capacity, 106–7
 problems with potassium salts, 107
 sodium versus ammonium thiosulfate, 105–7

G

Gradation and compensation, 53
Gradation and contrast, 2–3
Granularity and graininess, 1–2, 53

H

Hardeners, 121
Henn, Richard, 69–70
High acutance, *see* Developers, high definition
High definition, *see* Developers, high definition
Hutchings, Gordon, 21, 76, 143
Hydrogen peroxide, 93–94
Hypersensitization, 92–93
Hypo clearing agent, 105

J

JOBO rotary processors, 34
 and PMK, 77

K

Kostinsky effect, 52

L

Landscape photography, 8
Latensification, 92–93
Lenses
 and cameras, 100–102
 enlarging, 101–2
Loading film onto reels, 34–35
Local contrast, 2

M

Mackie lines, 52
Macro-contrast, 2–3
Micro-contrast, 2-3
Minimum printable density, 95
Mixing solutions, 123–128
Monobaths, 118–19
MSDS (Material Safety Data Sheet), 131, 135
MTF (modulation transfer function), 51

N

Negative quality, 3
Non-solvent developers, 4, 51–63
 buffered, 62–63
 FX high definition, 59–60
Odorless stop baths, 104

P

Permanence, processing for, 109–10
Portraiture, 8
Preservatives, 26–28
Press photography, developers for, 9

Printable density, minimum, 95
Prints, appearance of, 6
Push processing, *see* Film speed, increasing

R

Reels, loading film onto, 34–35
Resolution, 1
Restrainers, 26, 28–29
Ripening, 66–67
Rotary processors, JOBO, 34

S

Safety, chemical, 89, 129–38
Sequestering agents, 123
Sharpness, *see* Acutance
Sheet film, tray processing for, 35–37
Solution physical developers, 4
Solutions, mixing, 123–28
Solvent developers, 4, 39–50
Speed Increasing, *see* Film speed, increasing
Stand development, 37–38
Stock solutions, 125-128
 storing, 125–26
Stop baths, 103–106, 119–20
 acid versus water, 103
 alkaline, 106, 120
 odorless, 104
 pH indicators for stop baths, 104
 and tanning developers, 104–5
 water, 103
Street photography, developers for, 9
Suppliers, chemical & equipment, 139–42
Surface developers, 4

T

Tabular grain films, washing, 108
Tanning
 defined, 73
 developers, 73–81
 and stop baths, 74, 104–5
Technical Pan, *see* Document films
Temperature conversion chart, 165
Thiosulfate, *see* Fixers
Time chart for film developing, 143–64
Toxicity, *see* Safety, chemical
Transparency films, 17
Tray processing, 35–37, 75
Two-bath developers, *see* Developers, two-bath

W

Washing, 78, 107–9
 tabular grain films, 108
Water, 29
Water bath developers, *see* Developers, water bath
Water stop baths, *see* Stop baths, water
Weston, Edward, pyro, 113–14
Wetting agents, 29, 78, 108–9